D1350056

THE QUEENS' LONDON

THE METROPOLIS IN THE DIAMOND JUBILEE YEARS OF
VICTORIA & ELIZABETH II

JON CURRY & HUGO SIMMS

The History Press

PHOTOGRAPH CREDITS

All 'then' photographs taken from *The Queen's London: A Pictorial and Descriptive Record of the Great Metropolis*, Cassell and Company Ltd, 1897.

All 'now' photographs by Jon Curry, except for:

Pages 19, 20, 21, 32, 36, 38, 41, 42, 56, 80, 85, 91, 94, 104, 105, 106, 109, 110, 118, 119, 120, 121, 136, 138, 139, 140, 141, 143, 146, 163, 165, 167, 172, 173, 182, 183, 185 by Hugo Simms.

Pages 78, 79, 96, 107, 160, 161, 162, 164, 166, 168, 169 by Ian Marrow.

First published 2012

The History Press
The Mill, Brimscombe Port
Stroud, Gloucestershire, GL5 2QG
www.thehistorypress.co.uk

© Jon Curry and Hugo Simms, 2012

The right of Jon Curry and Hugo Simms to be identified as the Author of this work has been asserted in accordance with the Copyrights, Designs and Patents Act 1988.

British Library Cataloguing in Publication Data.
A catalogue record for this book is available from the British Library.

ISBN 978 0 7524 7011 5

Typesetting and origination by The History Press
Printed in India

CONTENTS

INTRODUCTION

Snappily subtitled 'a Pictorial and Descriptive Record of the Streets, Buildings, Parks and Scenery of the Great Metropolis in the Fifty-Ninth Year of the Reign of Her Majesty Queen Victoria', the *Queen's London* was first published in 1896, and then subsequently reproduced in several versions – including a twelve-part paperback series sold at 6*d* a copy, and, in 1901, a 'final year of Queen Victoria's reign' special that appeared complete with photographs of her funeral cortège.

Our source has been the expanded second edition of the book, produced as a souvenir of the fifteenth Annual Conference of the United Kingdom Commercial Travellers' Association. With sixty-five additional scenes, plus coverage of Victoria's Diamond Jubilee procession, the book has almost 500 full-page photos, making it an unparalleled view of London at the end of the nineteenth century. Nor is it just the photos that are of value. The accompanying commentary is highly quotable, giving facts, figures, prices, and the odd caustic comment.

With just the shift of an apostrophe, *The Queens' London* brings us up-to-date and compares London in two snapshots, at the time of the Diamond Jubilees of our two longest-reigning monarchs.

The challenge we set ourselves was to take 180 of the images from the Victorian book and reproduce them as exactly as possible. The 'rules' of the now pictures were as follows: Firstly, to qualify as a suitable image there needed to remain some point of reference from the Victorian view. If the building was still there, this was straightforward, but some views required a little more application. Columbia Market in Bethnal Green was demolished in 1958, but whilst the building has been replaced by a block of flats and a primary school, the original iron railings are still there to orientate our twenty-first century picture. Secondly, we wanted to get exactly the same viewpoint of the original, even if it meant having a lamp post edge further into shot. Viewpoints in the Victorian originals came in three flavours: there were straightforward pictures taken at street level; then there were those taken from a slightly raised position, either from first-floor windows or, we imagined, from atop stepladders or a vehicle; the hardest to arrange were those taken from the upper storeys or roofs of buildings.

Applying these rules meant that a certain amount of natural selection came into play, as locations were ruled out because they were no longer there, because we were denied permission to photograph them, or because they are now completely obscured.

When locations were no longer there, our decisions were easy. The Old Welsh Harp in Hendon was pulled down around 1970 and its location is now somewhere under the southerly extension of the M1 motorway, so it was easy to see that this was not going to make a promising then and now image. We did allow a few subjects where all we had to go on was the road layout, such as Westminster Aquarium and Holloway Prison, but on the whole it was an easy call.

Gaining permission to take photographs was also potentially straightforward, but often frustrating. Many people have been very generous with their time and access to their properties, but others proved more reluctant. Excellent pictures, including London Bridge, Newgate Prison, Kew Gardens and several panorama shots, fell foul to a combination of health and safety, security and commercial restrictions. Some of these were to be expected, while others took us by complete surprise. A stunning restoration of Thackeray's House has just been completed (even the hedge looks the same) and it would have made an excellent location. However, as it is now home to the Israeli Embassy, what has changed is the large 'No Photography' sign and two armed police officers standing outside.

The nature of 'then and now' photographs means that we largely took pictures of things rather than events. *Queen's London* includes a number of social activities like Exeter Hall Gymnasium, football at Crystal Palace, and School Board classes in cookery (for the girls)

and carpentry (for the boys). None of these pictures can be used in this format, although we were able to get the modern-day equivalent of cricket at the Oval and the Sunday Market in Wentworth Street. We had hoped to add the Herne Hill Velodrome, which is a wonderful and unexpected survivor of the Victorian era, but they declined.

And then there were the trees. In the film *Funny Face*, Audrey Hepburn's character asks fashion photographer Dick Avery (Fred Astaire) why he doesn't photograph trees. 'It has to do with supply and demand,' he replies, 'You'd be amazed how small the demand is for pictures of trees.' If true, this is a shame, because we have got lots of them. Taking our photographs in early summer did offer longer daylight hours, but what it also offered was expanses of fresh, green foliage. Let no one tell you that London is not a green city. Approaching a location, the pleasure at clearly recognising a building was often tempered by the realisation, upon actually reaching the correct viewpoint, that it was obscured by a large tree. At times it felt as if the Victorian photographers had intentionally chosen to position themselves a few feet behind recently planted saplings. The tree issue eliminated a number of otherwise worthy subjects (casualties included St Pancras Church, Kensington Town Hall and the National Liberal Club). We did decide to keep some tree-afflicted locations if we thought the picture and story merited it, but they were strictly rationed.

Some of the nineteenth-century photographs are a peculiar combination of photo and art. It is a form of pictorialism, a genre of Victorian photography whereby photographers retouched their images with brushes or etching needles. Whilst many of these people had creative aspirations, the producers of the *Queen's London* have used the method more for practical purposes. Scene looking a bit sparse? No problem – sketch in a few extra people. Sky rather dull? Some textural swirls of paint will liven it up. It's Victorian Photoshop, and, true to our desire to follow in their footsteps, we occasionally used modern methods to deal with plain, white skies – although we stopped short of Photoshopping people into our pictures.

Whilst there were parallels in terms of editing photographs, other technological resources were available to us even before we set out to a location. Street View proved a valuable ally in determining the feasibility of a subject, and the websites of the various places featured were a reliable source of information at our fingertips.

Yet the Victorians did have one significant technological advance on which to draw – a new process called dry plate negated the need for portable dark rooms, so made location shooting a lot easier. It also enabled faster shutter speeds. However, the technical dissimilarities between their plate and our SLR lens did produce some striking differences of dimension and depths of field. The photograph of Cleopatra's Needle, for example, would only have been replicable by actually using the Victorian equipment (although chopping down a tree would also have helped).

As a 'then and now' book, the photos are quite literally from the viewpoint of the Victorians. Modern London is on the back foot here, and, in writing the book, it was easy to fall into a stereotype of comments along the lines of: 'Victorians cleared decrepit slums to build beautiful buildings that were either destroyed by the Blitz or 1960s' planners, and were then replaced with a bland office block.' This was sometimes the case, but it also needs to be remembered that the Victorians are holding all the aces here. The Victorian photographers chose the best of London in their day, and anything new has to compete with this legacy. They also chose the viewpoint, and things rarely look as good when they are stuck behind a tree or a lamp post (readers can insert their favourite exception to this rule here).

In his book *Lost Victorian Britain*, Gavin Stamp argues that, forty years ago, 'Victorian' was used as a pejorative term; it stood for everything stuffy, heavy and overladen with ornament. 'Victorian architecture was conventionally held to be self-evidently hideous and ridiculous, not

to be taken seriously.' Times change, and today few are going to argue that replacing Columbia Market with a block of flats, or Memorial Hall with an office block, was aesthetic progress. Neither does this mean, however, that every step is a backward one. The Lloyds building, the Gherkin, the London Eye and the new City Hall are all exciting, beautiful modern buildings. But with the viewpoint set, in most cases they get a supporting role in the camera view at best.

So, after acknowledging that the book is heavily skewed in favour of the Victorians, an obvious question might be: were we to produce a book of photographs celebrating the last sixty years, what would we have chosen? Examples of post-war rebuilding perhaps, such as the Southbank Arts Centre, born out of 1951's Festival of Britain – 'a tonic for the nation', declared the government. The BBC Television Centre? Maybe an iconic block of flats, such as the forty-year-old, Grade II listed Trellick Tower in Kensington; or an infrastructure such as the BT Tower (formerly the Post Office Tower).

Moving forward to 1980, we might have chosen the NatWest Tower. Then perhaps the Queen Elizabeth II Bridge; Princess Diana's Memorial Playground; the Globe Theatre; the Millennium Dome; Wembley Stadium; the London Eye; the Shard; Olympic Park, of course ... and many more. There might also have been some less high-profile subjects, reflecting the Victorian book's focus on philanthropic and charitable causes – for example, the Centrepoint Shelter for young, homeless people, or perhaps the protestors camped indefinitely outside the Houses of Parliament. Back in the world of commerce, we could choose Borough Market or Bluewater Shopping Centre!

How about houses of the famous – something for which the *Queen's London* had a keen eye? John Betjemin's house in Smithfield perhaps; Jimi Hendrix's in Mayfair (incidentally now the same property as George Handel's home); Gilbert and George's house in Spitalfields.

Some famous buildings would have made both books, and doubtless would again were another book published in 115 years time – though how many of our choices would be familiar to readers in 2127, we do not know.

ACKNOWLEDGEMENTS

We would like to express our sincere thanks to those who granted access to their properties to take pictures. Without their help, it would be a blander book. In particular, we would like to acknowledge the assistance from: Access Storage at Kings Cross; Alison Zahynacz at the Commonwealth Secretariat; Dan O'Neill at Business Exchange; Debbie at Ye Olde Cheshire Cheese; Francois and all at Complete Chiropractic, St Albans; Jon Surtees of Surrey County Cricket Club; Karen Willetts at Mill Hill School; Kim Stapff and Pamela Rider at Claremont Fan Court School; Laura Mayes at the Royal Chelsea Hospital; Margery Roberts and all at St Mary-le-Strand Church; Mike, Landlord of Ye Olde Swan at Thames Ditton; Nick Cressey and Matthew Power at St Mary-le-Bow; Simon Pointon at Samuel Smiths Brewery; and Tom Sharpe at Repton Park. Special thanks to Ian 'Bone' Marrow for being the third member of the photography team. Finally, we would like to thank commissioning editors Nicola Guy and Cate Ludlow, editor Jennifer Briancourt and all at The History Press for their help and guidance.

PANORAMAS OF LONDON

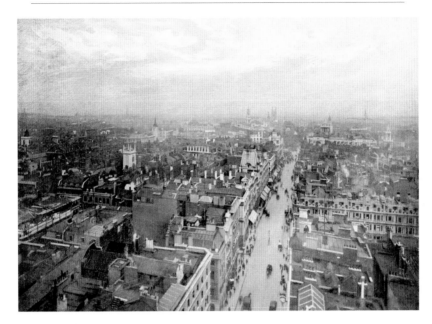

View from Bow Church, looking east

Although much easier to see in the Victorian photograph, where they still formed part of the skyline, the majority of the towers and spires are still standing and are visible if you look hard enough. Working right from the centre of the Victorian image, we have the bell tower of the Royal Exchange, the spire of St Peter-upon-Cornhill, and right next to it the larger tower of St Michael, Cornhill. To the south of Poultry is the Church of St Mary, Woolnoth and St Stephen, Walbrook.

The Goliaths of the modern city are, however, of a completely different scale. The biggest three are: in the centre, Tower 42, designed by Richard Seifert, built 1971–80 and 183m high; to its right is 30 St Mary Axe, better known as the Gherkin. Opened in 2004, it is 180m high and was designed by Sir Norman Foster; to the left is the current City of London record-holder, the Heron. At 230m tall including its mast, the building was designed by Kohn Pedersen Fox and opened in 2011. The Heron may not get to enjoy its record for long, however, as the Pinnacle – aka the Helter-Skelter – is under construction in Bishopsgate, opposite Tower 42, and when completed will be 288m tall.

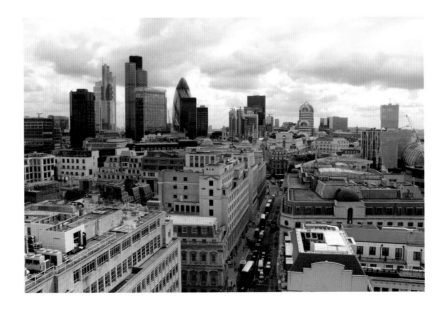

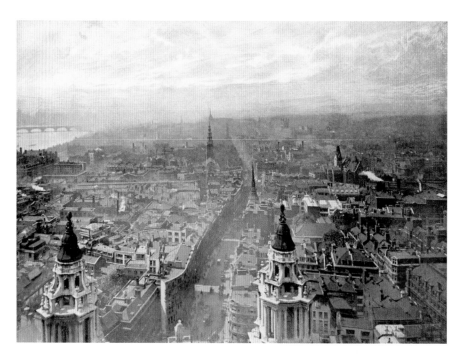

View from St Paul's, looking west

The Victorian book's commentary begins thus: 'To the right of Ludgate Hill, as we glance down it towards the foot of Fleet Street, may be seen the sharp spire of St Martin's. Further on, a little to the left of Fleet Street, the beautiful steeple of St Bride's ... casts its shadow over a cluster of neighbouring newspaper offices.'

Whilst some of their office buildings still exist, the newspaper companies themselves have generally moved eastwards to Docklands. The St Martin's in question, still clearly visible today, is the Wren-designed St Martin-within-Ludgate, which replaced an earlier church destroyed in the Great Fire of 1666. The ancient St Bride's was also redesigned by Wren, and its unique spire – the inspiration for the tiered shape of wedding cakes (and the tallest Wren steeple) – is also in the modern photograph. Compared to the 1897 version, it appears somewhat lost amongst the buildings behind it – though it's possible that this steeple, and some other notable features, have been slightly enhanced in the older image.

The slender tower behind that of St Bride's in both photographs (on the horizon in 1897) is atop the Royal Courts of Justice at the east end of the Strand. The two towers in both foregrounds are the bell towers at the front of St Paul's Cathedral.

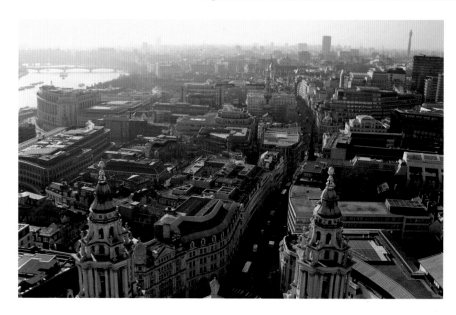

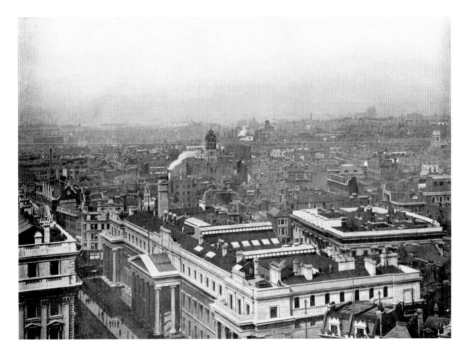

View from St Paul's, looking north-east

1897: 'The portico of the General Post Office is easily recognised in the foreground, with the Administrative and Telegraph offices across St Martin's-le-Grand, at the corner of Newgate Street. Behind the Post Office (on the right) is seen the square roof of the Goldsmiths' Hall. Near the middle of the view, marked by a flag-staff, is the characteristic tower of St Giles', Cripplegate, where Milton, Foxe, and Frobisher are buried, and Oliver Cromwell was married. To the north-east of the Goldsmiths' Hall is the Gothic tower of St Alban's, Wood Street.'

At first glance, it appears that by 2012 everything from 115 years earlier has gone. Some of the Victorian buildings do, however, still exist – especially in the murky distance – but now they are obscured by modern office blocks. The Goldsmiths' Hall is still there, restored after Second World War bomb damage – its roof is hiding low centre, to the left of the rectangular blue and brown building. More easily identifiable is the medieval tower of St Giles, atop a new post-war church. It is centre left of our modern image, taken at a slightly more northerly angle, at the base of the second tower in.

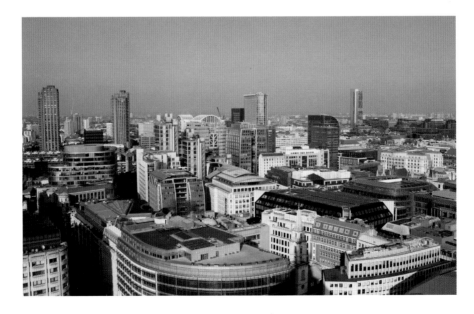

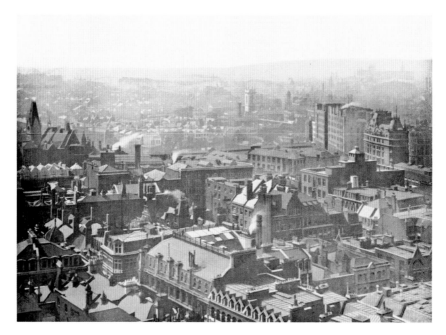

View from St Paul's, looking north-west

1897: 'In the foreground of this picture appears Paternoster Row, with Stationers' Hall Court. Then (on the left) comes the tower of the Memorial Hall in Farringdon Street, with the Inns of Court Hotel further on, in the dim distance, backed by the dome of the British Museum Reading Room. To the right of our view the lofty buildings on Holborn Viaduct are noticeable – the Imperial and Holborn Viaduct Hotels; then the cupola of the City Temple, and, a little to the left of it, the square, pinnacled tower of St Andrew's, Holborn. Nearer the centre is the First Avenue Hotel; while on the right, against the background formed by the northern heights of London, are the twin towers of Regent Square Presbyterian Church and St Pancras Station and Hotel.'

Still visible, centre right, in the modern photograph is the green cupola of City Temple and, to its left, the pinnacled tower of St Andrew's. Both were severely damaged in the Second World War and were subsequently restored. The form of St Pancras Station and Hotel can still be detected in front of the haze of north-west London. The prominent dome on the right of the modern image, on the site of Newgate Prison, belongs to the Central Criminal Court – otherwise known by the name of the street on which it exists, Old Bailey.

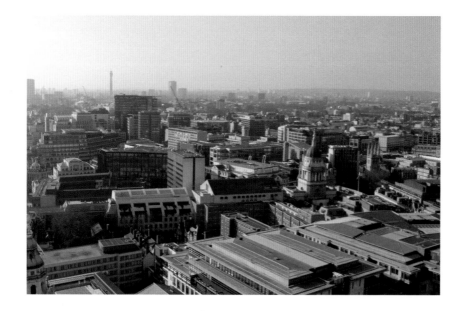

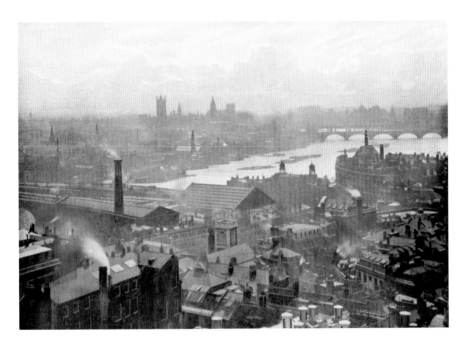

View from St Paul's, looking south-west

'One sees the tower of St Anne's, Blackfriars, in Queen Victoria Street;' begins the 1897 commentary, 'just behind it, the inclined roof of St Paul's railway station, with the London, Chatham, and Dover railway bridge and Blackfriars Bridge, and, in the mid-distance, Waterloo Bridge. At the beginning of the Victoria Embankment the curved front of the Royal Hotel stands out prominently.'

The 'St Anne's' tower, seen on the bottom edge of the modern photograph too, is in fact the Wren tower of St Andrew-by-the-Wardrobe. St Paul's Station became Blackfriars Station in 1937. It is currently being rebuilt and, when fully reopened in mid-2012, it will be the first railway station to span the Thames. The curved building on the site of the similar-looking De Keyser's Royal Hotel is the 1930s' Unilever House.

On the horizon, the Houses of Parliament's Victoria Tower is clearly visible in both photographs, left of centre. St Stephen's 'Big Ben' clock tower, encircled by the London Eye, is now mostly hidden by the South Bank studios of the London Television Centre. The smaller tower to the left is the 1920s' Oxo Tower. The original book states that: 'On the Surrey side are numerous factories [and] two shot towers.'

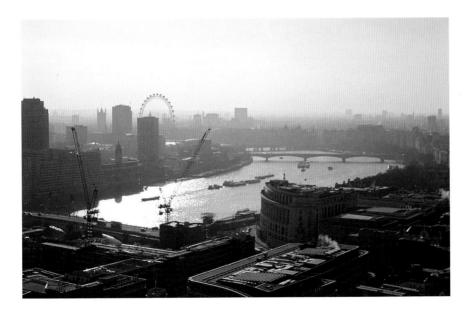

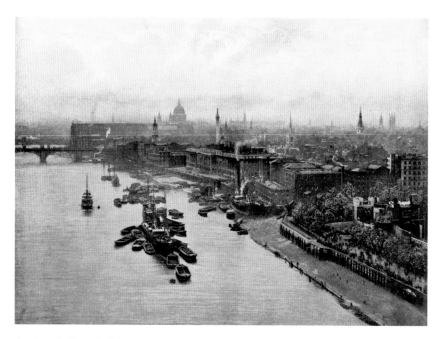

View up the river from the Tower Bridge

'Our picture shows the panorama looking towards St Paul's Cathedral, whose dome and towers are conspicuous afar off. Near at hand, to the right, is the Tower, with the Traitors' Gate; beyond it the Custom House, with its stately façade and broad quay, and the Monument rising behind; further on is Billingsgate Fish Market, with the Dutch shrimpers moored off it; then come London Bridge and the South Eastern Railway Bridge, and the roof of Cannon Street Station. The towers and steeples of a score of churches, in addition to the Cathedral, may be seen on a clear day.'

Surveying the same view as the *Queen's London* authors, many buildings remain and some changes are subtle. At Billingsgate, the building is still there but the market moved to the Isle of Dogs in 1982, making way for commercial accommodation. London Bridge remains in the same place, but the Victorian one was replaced with a newer model between 1967 and 1972. Less subtle, and an addition to the scene, is the 177m BT Tower, which opened in 1965. Taking a wider perspective, it's not what has gone that changes the view, but what has been added. The church towers and steeples which once dominated London's skyline have now largely disappeared from sight, hidden by the office blocks that surround them.

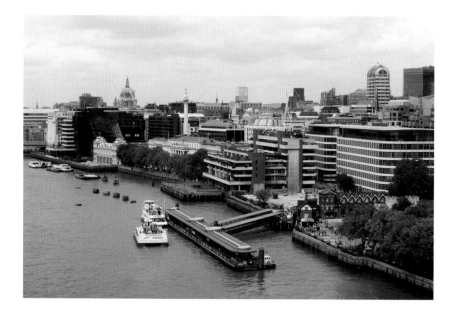

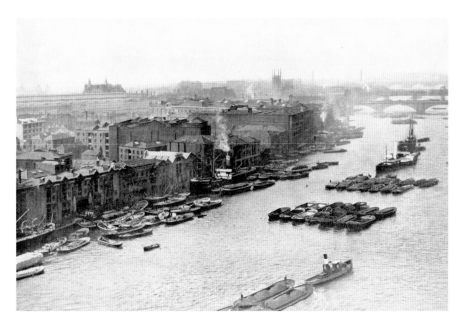

The South Bank of the Thames from the Tower Bridge

'London Bridge, the viaduct which carries the South Eastern Railway across the stream from Cannon Street Station, Waterloo Bridge, and, on the left, the long roof of London Bridge Station, with the square, pinnacled tower of St Saviour's Collegiate Church in the mid-distance, can all be identified without difficulty; but the stately towers of Westminster and the gentle outline of the hills in the far distance have to be filled in by the imagination.'

For *Queen's London*, the problem was mist; for us it is the 'More London' development that has sprung up over the past ten years. There is still no chance of seeing 'the stately towers of Westminster' (although you can spot a glimpse of the nearby London Eye), but nor can we see any more St Saviour's (renamed Southwark Cathedral in 1905).

The 13-acre 'More London' site is a major development masterminded by Foster & Partners. The first building, completed in 2002, was the 45m geometrically modified sphere that is London City Hall. The site will eventually support what the developers describe as a 'working community' of 18,000. Rising behind 'More London' is the tower of Guy's Hospital and the rapidly growing Shard. When it is completed in May 2012, the Shard will be 310m high, making it Europe's tallest commercial building.

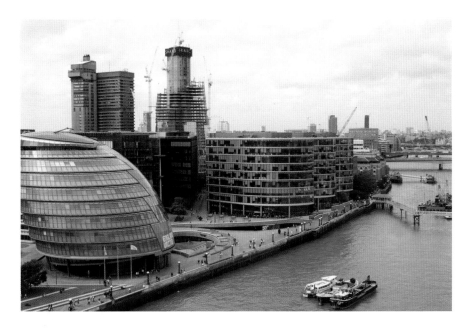

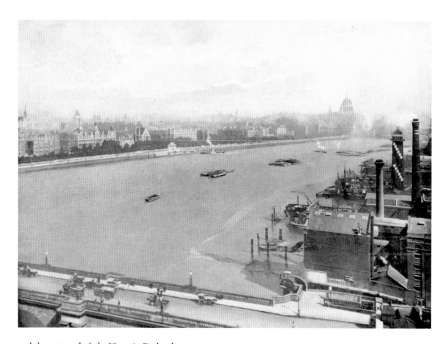

The Thames and the east end of the Victoria Embankment

Our modern photograph is a cheat. The original was taken from a long-since demolished shot tower just west of Waterloo Bridge, so instead we used the London Eye, 400m upriver.

Queen's London worked west along the North Bank, picking out highlights; first St Paul's, then the City of London School, with a spire rising from its roof. So far so good: both are still there. Next is Temple Gardens, marked by the steamer that is hugging the embankment, where we see a large block of chambers they describe as the 'Cockney Gothic library of Middle Temple'. The gardens are still there, but the library was replaced in 1958 by the Queen Elizabeth building, designed by Edward Maufe. Left again and the tower rising in the centre is the offices of the London School Board, which were controversially demolished in 1929.

Not mentioned by *Queen's London*, but more changed, is the South Bank. All of the wharfs and industrial chimneys of the Victorian picture have been swept away, and in their place is mainly the Southbank Centre for Arts. In the foreground is the green roof of the Royal Festival Hall and next to it the Queen Elizabeth Hall. Beyond Waterloo Bridge is the Royal National Theatre, IBM South Bank and the tower of the London Television Centre.

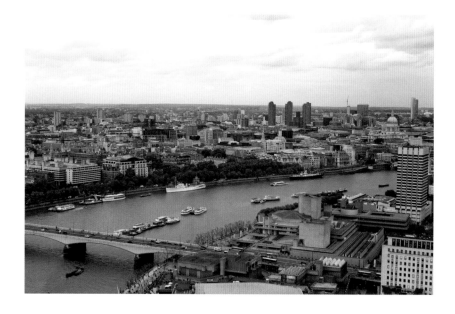

DOWN THE THAMES

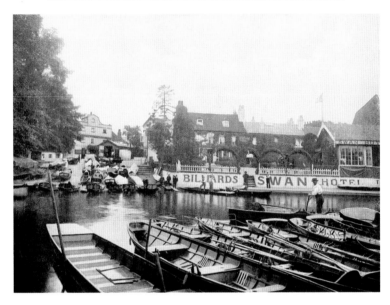

The Swan Inn at Thames Ditton

As far back as 1827, writer William Hone was extolling the virtues of this pub: 'The Swan Inn, only a few paces from the water's edge, remarkable for the neatness and comfort of its appearance, and for the still more substantial attractions of its internal accommodation, is kept by Mr John Locke, a most civil, good natured, and obliging creature.' One hundred and eighty-five years later, Ye Olde Swan is still going strong and, now as part of Greene Kings Old English Inn chain, it has recently undergone major renovation.

Both pictures are taken from Thames Ditton Island, which was no more than a picnic destination at the time of the Victorian photo. It became populated in the first half of the twentieth century and, in 1939, was linked to the mainland by the footbridge which can be seen on the left of our modern picture. Today the bridge is owned by the residents of the island (one 49th share each). Other claims to fame for Thames Ditton include a nonsense poem written in 1872 by Edward Lear:

> There was an old man of Thames Ditton,
> Who called for something to sit on;
> But they brought him a hat, and said – 'Sit upon that,
> You abruptious old man of Thames Ditton!'

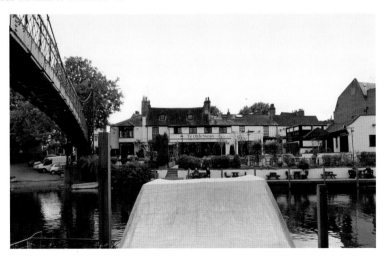

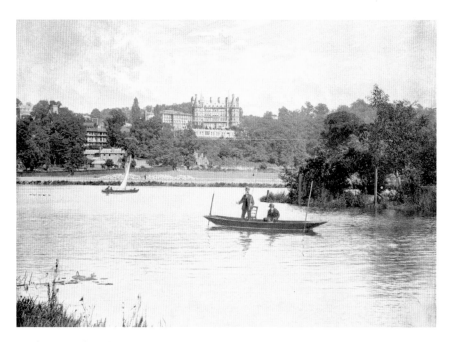

The Star and Garter, Richmond

'Just as the river is the most conspicuous object in the view from the Star and Garter,' states the first book, 'so the Star and Garter is the most conspicuous object in the view from the river. This well-known hostelry is built above the terrace on Richmond Hill ... It literally towers on its proud eminence above the finely timbered slopes, and can be seen for many a mile around.'

The original inn was built in around 1740. It was extended shortly before 1822, when it was taken over by the Ellis family and became an establishment of great repute. It was the venue for balls and wedding receptions, and over 500 meals were served up for Sunday lunches. Napoleon III had apartments in the building and Dickens regularly celebrated the anniversary of his wedding here.

The building in the Victorian view, however, is not the same one that Dickens was fond of. This 1860s' rebuild (not mentioned by the original writers) was universally disliked – a letter in *The Times* called it 'a great disfiguring wart'. Shortly before its demolition, it was used as a First World War home for disabled soldiers. The present building was built in 1924. As part of the Royal Star & Garter Charity, it still provides a home for disabled ex-service personnel.

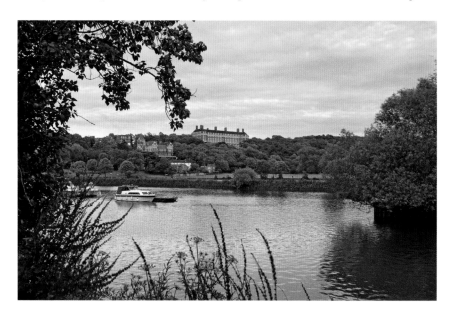

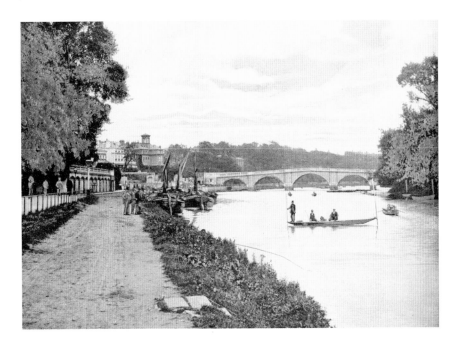

Richmond Bridge

Richmond Bridge is the oldest London bridge spanning the Thames. It was completed in 1777 at a cost of £26,000, and replaced a long-standing and occasionally treacherous ferry crossing. The money was raised by shareholders, each contributing £100. In turn, the shareholders each received a proportion of the bridge's toll takings until their death, at which point their share was added to the remaining pot.

The bridge was freed from tolls in 1859, after the death of the last shareholder – who, judging from the long time-span, either lived to about 100, or else was given his share as a christening gift. He received the full toll revenue for the last five years of his life. The alcoves in which the tollbooths stood are situated above the small arch at the left end of the bridge, more clearly seen in the modern photograph.

The bell tower, visible further to the left in both photographs, marks the site of early eighteenth-century Herring Court, some of which was incorporated into the Royal Hotel. The hotel's façade still faces the river.

The bridge was delicately widened in 1937. Apparently, it is now less hump-backed – though comparison of the two photographs doesn't obviously bear out this fact.

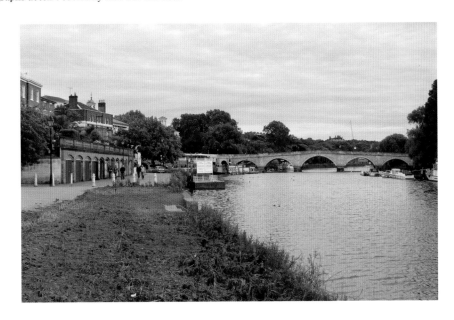

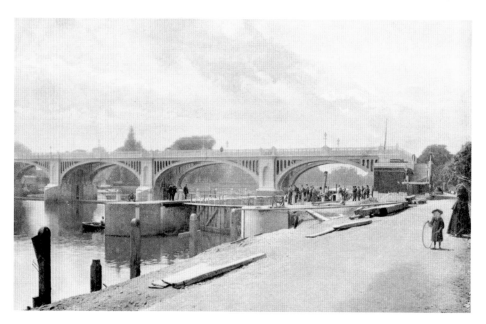

Richmond Lock and footbridge

Aided by forty-five locks, each with an adjacent weir, the River Thames is navigable from Cricklade down to the sea, a distance of 325km. The first (in terms of proximity to London) and largest of these lock and weir complexes is at Richmond. It was opened in 1894 by the Thames Conservancy (the body founded in 1857 with responsibility for the management of the Thames) to maintain a depth of water that is navigable upstream of Richmond.

Except for a period of two hours either side of high water, overhead steel sluices – each weighing 32 tons – are lowered into the river from the roof of the footbridge (one in each of the three centre arches spanning the river) to form a weir. These ensure that there is always a minimum depth of 5.5ft of water in the river between Richmond and Teddington. The effect of this weir can clearly be seen in our 'now' photo.

Richmond Lock was officially opened by HRH the Duke of York in May 1894. It was therefore appropriate that, following a £4 million refurbishment project carried out by the Port of London Authority, the current Duke of York, HRH Prince Andrew, was the guest of honour at celebrations of the system's centenary in 1994.

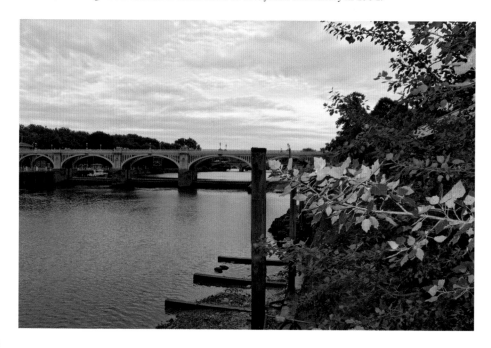

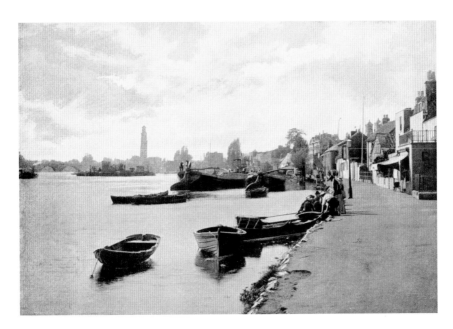

Strand-on-the-Green

'Quite one of the quaintest and least spoilt places on the Thames is Strand-on-the-Green,' declares the original book, 'a little village on the Middlesex bank, below Kew Bridge, which may be seen in the background of our picture.' The bridge can also be seen in the modern picture, now overshadowed by the tower blocks of Brentford. The standpipe tower on the right, however, is a survivor from the 1890s. Described then as 'the conspicuous tower at Brentford', it is today considered 'a lovely piece of English heritage'. Originally part of the Grand Junction Waterworks, it now marks the Kew Bridge Steam Museum.

By 1932, Strand-on-the-Green was described as 'London's last remaining village' (a claim that even in 2012 would be the cause of much debate). Today the area is more commonly called a riverside path – though a stretch of road near the bridge does still bear its name. The eighteenth-century houses on the right of the Victorian photograph – mainly hidden by trees today, apart from Tunnel Cottage (1752), with the black railings – reflect the high society popularity of the area at that time, a situation that had as much to do with its proximity to Kew Palace as its attractive vistas. After a decline in the nineteenth century, the Strand-on-the-Green is once again a 'sought after' place to live.

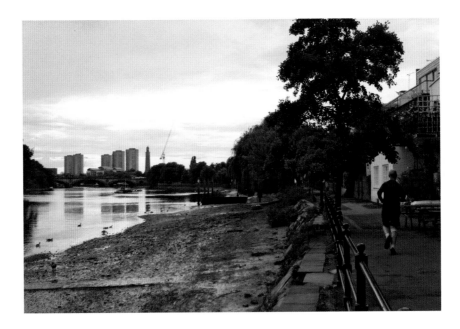

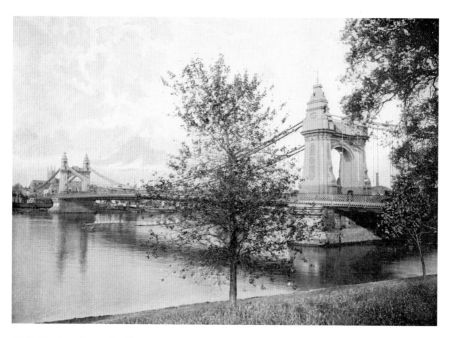

Hammersmith Bridge, from the south side

This is the second bridge to be built at Hammersmith, the first being considered too narrow and weak to handle the volumes of traffic going over by the latter part of the nineteenth century. The bridge, designed by the engineer Joseph Bazalgette, opened in the summer of 1887. Whilst much praised for its looks, writer Harold Clunn criticised its lack of girth: 'The bridge like its predecessor suffers from the drawback of being absurdly narrow for the requirements of its traffic, and it speaks very little for the judgement of our municipal authorities in 1887 that they failed to realise that a much wider structure would later become imperative.'

One of the reasons that the old bridge failed may have been the impact of spectators seeking a good vantage point for the university boat race. For example, in 1870 it was reported that 'alarmed owners witnessed over 11,000 spectators clamber all over the structure'. The current bridge has also had its troubles, with no less than three attempts made by the IRA to blow it up. The first, in 1939, was thwarted by a vigilant passer-by, and the second, in 1996, only partially exploded – but in 2000, the third attack caused the closure of the bridge for three weeks and forced the authorities to impose weight restrictions.

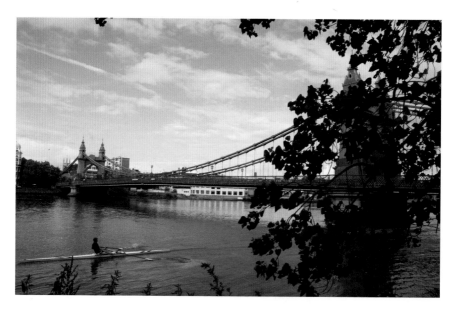

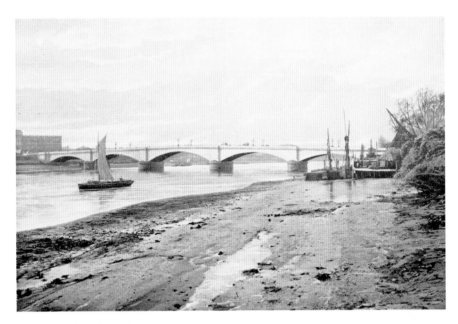

Putney Bridge from the Middlesex bank

Putney Bridge was opened by the Prince and Princess of Wales in 1886, and replaced the original wooden structure that had been there since 1729. The bridge was designed by Sir Joseph Bazalgette as part of his transformation of London's sewerage system (the bridge also replaced an aqueduct belonging to the Chelsea Waterworks Co.). Putney Bridge is 210m long and 13m wide; the bridge has a five-span structure and is built out of stone and Cornish granite. Since April 1983, it has been protected by Grade II listing status.

The buildings which can be seen beyond the bridge in our modern picture are the Putney Premier Inn and an office block called Riverbank House

Putney Bridge is probably best known as the starting point for the boat race, although pedants would note that the actual start is a few hundred yards upstream, marked by the university stone. The first Oxford v Cambridge Boat Race was held in 1829, but they didn't start using the 'modern course' of Putney to Mortlake until 1845. In Victoria's Diamond Jubilee year, Oxford – who were enjoying a rich vein of form – won by 2½ lengths as part of an unbeaten nine-year run. Overall, however, Cambridge still has the advantage, with eighty victories to Oxford's seventy-seven.

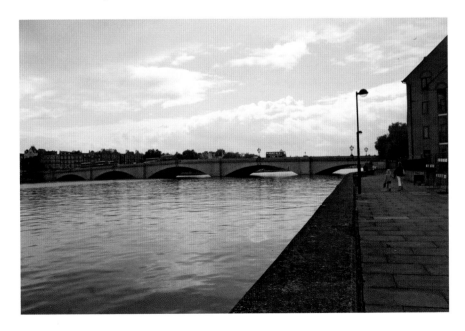

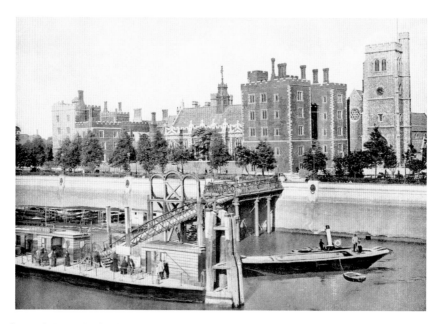

Lambeth Palace, with St Mary's Church

Just east of Lambeth Bridge, on the South Bank of the Thames, is Lambeth Palace – the London residence (for six centuries and more) of the Archbishops of Canterbury. Little seems to have changed over the intervening years, albeit now the buildings are somewhat obscured by more than 100 years of tree growth along the Albert Embankment. The chapel and Lollards Tower were gutted by an incendiary bomb on 10 May 1941, leaving restoration work that took the rest of the twentieth century to complete.

To the right of Lambeth Palace is the medieval tower of St Mary-at-Lambeth. The tower is all that remains of the original church, the rest having been rebuilt in 1852. The church was deconsecrated in 1972 and risked demolition until, in 1977, the rediscovery of the tomb of seventeenth-century plant hunters, the John Tradescants, led John and Rosemary Nicholson to save the church and found the Museum of Garden History (now the Garden Museum).

The original picture was taken from the Lambeth suspension bridge, built in 1862 and then pulled down in 1929 to be replaced by the current Lambeth Bridge. This was a positive move for writer Harold Clunn, who claimed that the original was 'reputed to have been the cheapest and ugliest bridge ever built'.

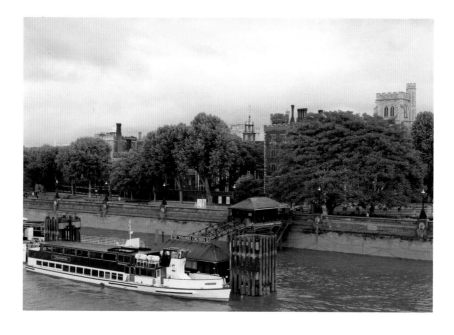

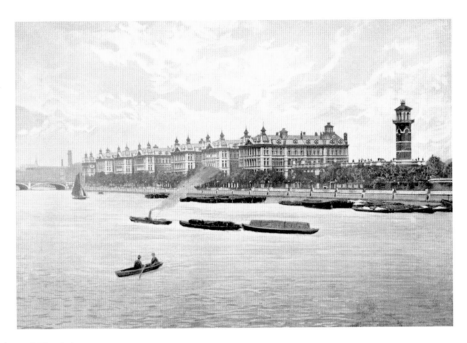

St Thomas's Hospital

'Indubitably the finest hospital yet erected' enthused the *Queen's London*, describing St Thomas's, completed in 1871 at a cost of £500,000. This was one of the first new hospitals to adopt the 'pavilion principle', popularised by Florence Nightingale. Six separate ward buildings, linked by low corridors, reduced the risk of infectious diseases spreading.

In the 1890s St Thomas's had 600 beds, and treated 5,000 in-patients and 80,000 out-patients per year. It has grown somewhat and today, while the bed number has only increased to 845, it sees a lot more patients. The hospital is one half of the Guy's and St Thomas' NHS Foundation Trust, which in 2010 reported that the two hospitals between them treated 76,000 in-patients and 604,000 out-patients.

The hospital site was severely damaged during the Second World War, with half of the ward blocks destroyed. Some reconstruction began in the 1950s, but it was the 1960s before a comprehensive redevelopment programme began. In the 1970s, this continued programme caused public upset (not least from their parliamentary neighbours opposite) and plans for a second tower block were halted. The three remaining Victorian ward pavilion blocks were refurbished in the 1980s, but this is not immediately obvious from our modern photo as the embankment trees have grown in the last century to the point that the hospital is almost completely obscured.

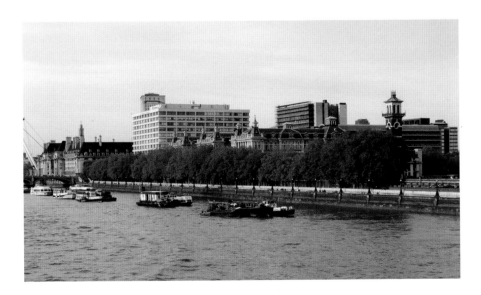

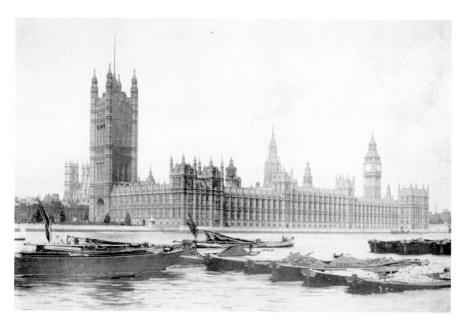

The Houses of Parliament

Our view of the present-day Palace of Westminster has changed little over the years. The palace was designed by Sir Charles Barry in the Perpendicular Gothic style, and was completed in 1860 at a cost of £2 million. It is a colossal structure with more than 1,100 rooms spread over its 8-acre site; at the time of completion, the Victoria Tower – standing 102m tall – was the highest in the world.

The Palace of Westminster was damaged by bombs on fourteen occasions during the Second World War and, during raids on 10 and 11 May 1941, the House of Commons was completely destroyed. Sir Giles Gilbert Scott was commissioned to rebuild in the tradition of the old chamber, and the work was completed in 1950.

The *Queen's London* authors make a telling comment on the expected relative roles of men and women at the time: 'By the riverside is the Terrace where, in summer, legislators seek fresh air and entertain ladies at afternoon tea.' Whilst this book was published in the same year that the National Union of Women's Suffrage Societies was formed, it was to be more than twenty years before women were given the vote, or Countess Constance Markievicz would become Britain's first female MP.

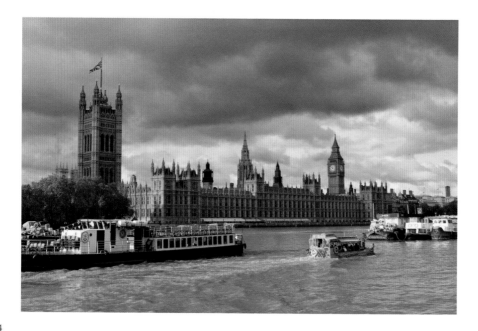

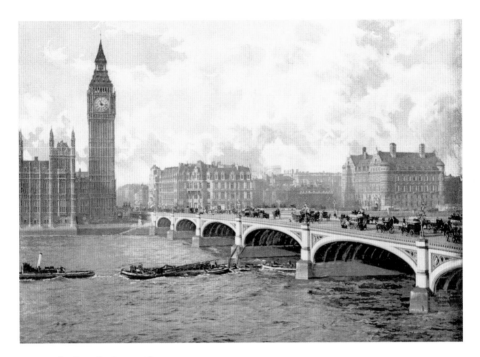

Westminster Bridge from the Surrey side

Everything in the original photo is a product of the Victorian age, including the wide and handsome Westminster Bridge, designed by Thomas Page and opened in 1862. To its left is the instantly recognisable clock tower of the Houses of Parliament, universally known by the name of its bell, Big Ben.

In the middle is St Stephen's House, home of the eponymous club founded under the patronage of Benjamin Disraeli in 1870, and the club of choice for Conservative politicians ever since. In 1960, the building was sold to the government for offices. Most redevelopment schemes in this area have had to incorporate the existed listed building, but in this case the passing of the London Underground Act required the site to be cleared to facilitate building of the new Jubilee line station. Designed by Michael Hopkins & Partners, Portcullis House was opened by the Queen in 2001.

On the right are the Norman Shaw Buildings, again used as parliamentary offices. The larger building was built between 1887 and 1890 as the Metropolitan Police headquarters known as New Scotland Yard. Norman Shaw South followed between 1902 and 1906. Built in the baronial style, the buildings initially attracted some fierce criticism, with MP Sir William Harcourt comparing the premises unfavourably with the 'Crosse & Blackwell' jam and pickle factory facing it across the river.

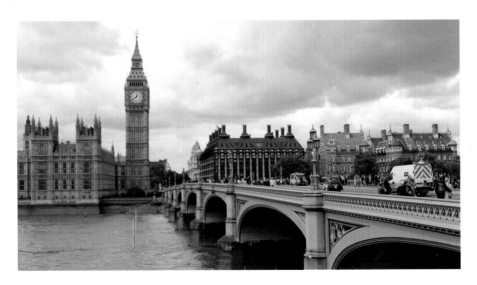

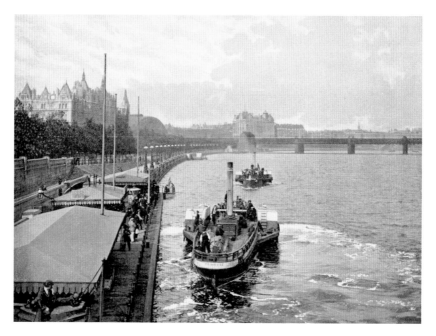

The Victoria Embankment, from Westminster Bridge

During the first half of the century, the number of London households increased from 136,000 to 306,000, and just about every new sewer built emptied into the river. As a consequence, by the 1850s the Thames was truly toxic, and it was clear that something had to be done.

Building the Victoria Embankment was the largest of Joseph Bazalgette's great works. Construction involved reclaiming 37 acres of land from the Thames for a new road – which runs between Westminster and Blackfriars Bridges, a distance of more than a mile. Work on the Victoria Embankment began in 1864 and took six years to complete. It was opened by the Prince of Wales on 13 July 1870.

Whilst it is easy to orientate our picture using the steps down to Westminster Pier, the lamps along the embankment and the arches of Hungerford Bridge, much has changed. More than a century of growth has left the National Liberal Club and Charing Cross completely obscured by trees, whilst further down the river the opulent Hotel Cecil (centre of the picture) was pulled down in 1930 to be replaced by the art deco-styled Shell Mex building. The monument which can be seen on the embankment in our modern photo is the RAF memorial, *Per Ardua Ad Astra* (Through Adversity to the Stars).

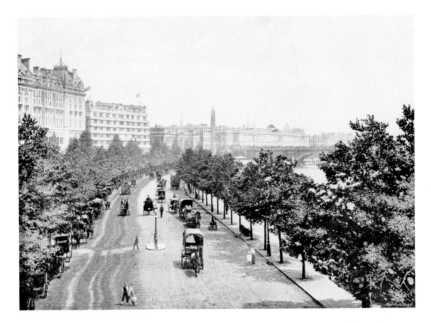

Victoria Embankment from Charing Cross Station

The building of the Victoria Embankment sought to address two fundamental issues in London: sanitation and transportation. The new sewerage system diverted effluent away from the Thames whilst the construction of the Victoria Embankment (and the accompanying Albert Embankment on the south side), narrowed the Thames making if deeper and flow faster, which consequently kept it cleaner. Construction also presented a unique opportunity to build an underground railway without demolishing some of London's most expensive properties. The new rail line from Westminster to Blackfriars was to become part of the undergrounds Circle line. Above ground the embankment provided a new thoroughfare which effectively bypassed the hideous congestion of the Strand and Fleet Street.

Just the tip of Cleopatra's Needle is now visible rising above the plain trees, which have also obscured all the buildings along this section of the river bank.

The original Waterloo Bridge shown in the Victorian image was opened on 18 June 1817, the second anniversary of the Battle of Waterloo. This served as a crossing for more than 100 years, but in 1923 two of its piers settled alarmingly and after a period of time when a temporary bridge was put in place alongside, it was demolished in 1936 to be replaced by the one seen today.

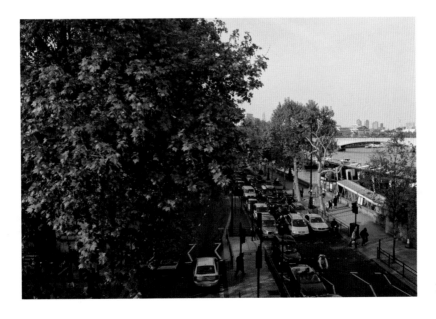

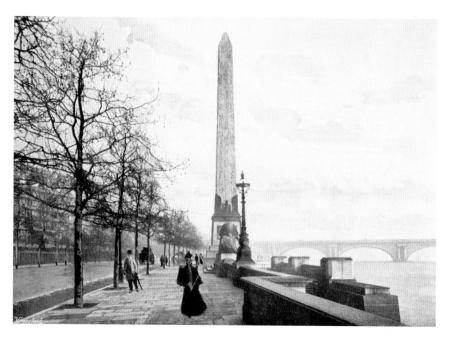

Cleopatra's Needle

The now obscured granite obelisk was cut from Egyptian quarries in about 1500 BC. When it was presented to the British nation in 1819, it had been lying in the sands of Alexandria 'prostrate for centuries' according to its pedestal's plaque. It was deemed so implausible for the obelisk to be moved to England, that many considered the gift merely academic.

It wasn't until fifty-eight years later that the finances and the ingenuity were in place to transport the Needle in an iron cylinder to London. A gale in the Bay of Biscay almost sank the ancient cargo – at one point it was abandoned – and six seamen died attempting to rescue it. Their names are commemorated at the base of the Needle. The obelisk was finally placed into position on Victoria Embankment in 1879. Prior to the final positioning, two time capsule jars were put into the base. They contained, amongst other items, a railway guide, a copy of *The Times*, coins and photographs of beautiful women.

The sphinx visible in both photographs is one of a pair guarding the Needle. Originally they were positioned facing outwards, as one might expect. They were repositioned either to protect London from the Needle's unearthly powers, or because Queen Victoria thought they looked better turned around ... or because of a building contractor's error. Take your pick.

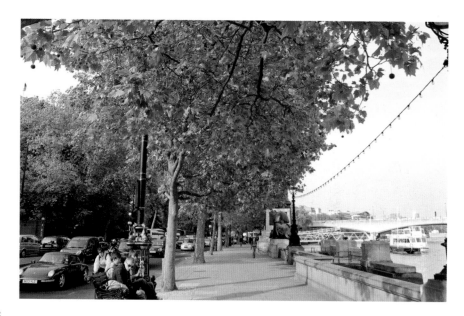

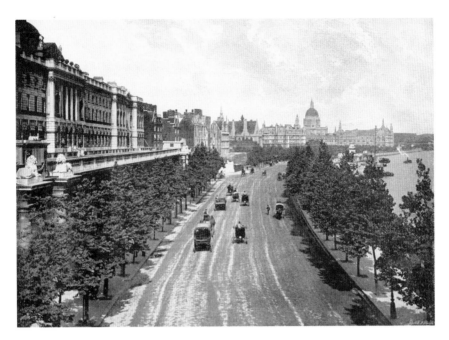

The Victoria Embankment, from Waterloo Bridge

The *Queen's London* authors were undoubtedly enthusiasts for this 'engineering triumph': 'The Victoria Embankment, as viewed from Waterloo Bridge, quite surpasses anything that is seen beside the Seine or the Tiber. Its magnificent sweep from the Houses of Parliament to St Paul's is one of the finest sights in the whole of London, and cannot fail to impress every observer.'

If only this picture had been taken 50m across on Waterloo Bridge, we would have seen the dramatic changes to the skyline in the City of London. As it is, eagle-eyed readers may see the faintest glimpse of St Paul's Cathedral between the tree canopies that span the road. Behind the dense foliage that has grown up, we would see that many of the Victorian buildings along this stretch of the embankment remain today. The 240m-façade of Somerset House is still there, as is Sion College Library and the City of London School. The iconic London School Board offices, built in 1874 (seen in the centre of the picture where there is a gap in the trees), were demolished in 1929 to be replaced by Herbert Baker's Electra House.

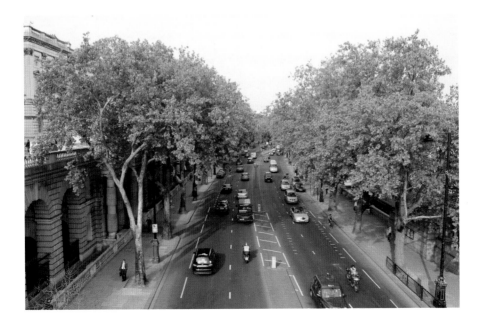

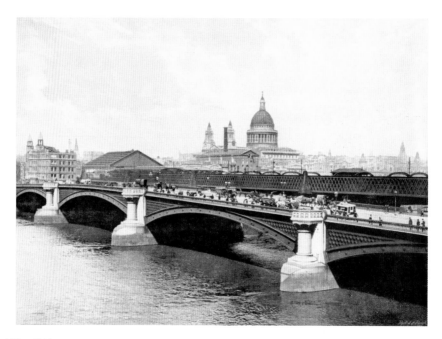

Blackfriars Bridge

It is clear from our modern photo that whilst much of the original image remains, looking at the cranes, much is changing. Blackfriars Bridge replaced an earlier stone version pulled down in 1863 due to subsidence; the new bridge was opened by Queen Victoria on 6 November 1869. Originally 80ft wide, it was widened to 110ft in 1909 to provide additional space for the London County Council tramways, thus making it the Thames's widest bridge.

At the time of the Victorian photo, there were two railway bridges running alongside the road bridge. One was built in 1864 as part of the road bridge project for the new St Paul's Station (renamed Blackfriars in 1937), and operated by the London, Chatham & Dover Railway (LCDR). The other bridge came twenty years later for the Holborn Viaduct Station Co. By the mid-twentieth century, the LCDR Bridge was considered too weak to carry modern trains and was eventually dismantled in 1984.

In 2008, a three-year project started to completely redevelop Blackfriars Bridge and railway station. When it is completed in Jubilee year, Blackfriars will become the first railway station to span the Thames, with a roof over the entire platform length, and a new entrance on the South Bank providing access to the Tate Modern and the surrounding area.

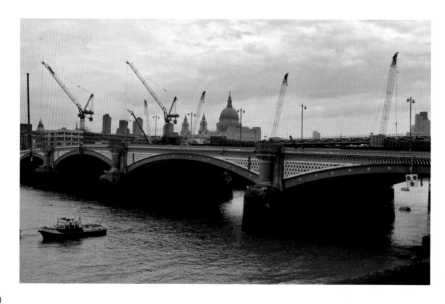

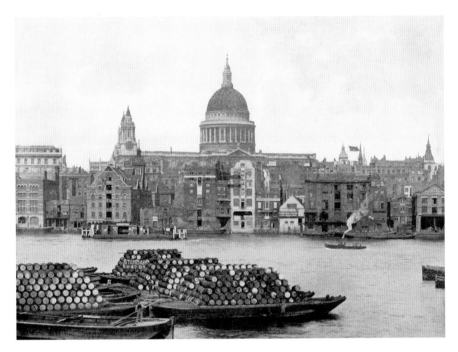

The Thames and St Paul's from Bankside

Taking thirty-three years to build, from 1675 until 1708, Christopher Wren's masterpiece St Paul's is the only cathedral in the country to have been designed, built and completed by a single architect. Given the damage suffered by buildings all around during the Blitz, it is perhaps surprising that the cathedral is still here at all. Not only has St Paul's survived, thanks to a £40 million restoration project finished in time for its 300th anniversary in 2008, the cathedral looks better than its soot-blackened Victorian self.

What has changed beyond recognition is the commercial river traffic. *Queen's London* points towards the 'heavily-laden barges, which are always plentiful at this part of the Thames' and 'the closely huddled wharves that hide the body of the Cathedral' as 'striking evidence, of the busy trade carried on hereabouts'. Today, that commerce has all gone; the wharves have been pulled down (in this case replaced in 1986 by the red brick of the new City of London School), whilst instead of the barges of the Victorian photo we now have the Thames Clipper commuter boats. The other striking difference is the Millennium footbridge, which, after a literally wobbly start, has become a great addition to this stretch of the river, linking St Paul's to the Tate Modern Art Gallery on the South Bank.

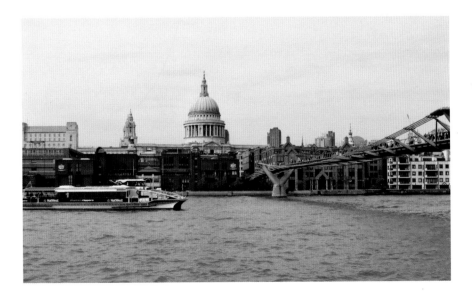

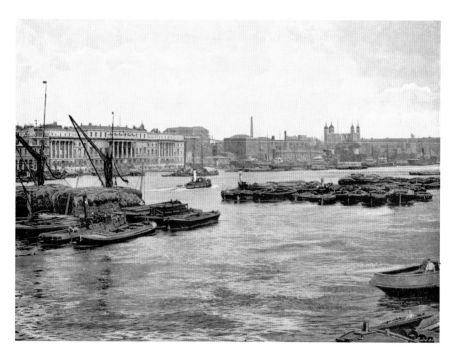

View down the Thames, from London Bridge

Whilst it is easy to orientate this view, much has changed in the past 115 years. Working from left to right: the fish market moved from Billingsgate to the Isle of Dogs in 1982, but the building still stands protected by Grade II listing and is now an event management centre. Also still standing, next downstream we have the Grade I listed Custom House, 480ft of stone Ionic frontage, now all but obscured by trees. Next is Sugar Quay, a seven-storey, 20,000sqm office block built for Tate & Lyle in 1970. In January 2011, the City of London Corporation granted permission for Sugar Quay to be demolished and replaced with a nine-storey, 31,000sqm office and retail development. Interestingly, in considering the application, this view from London Bridge was one of several 'strategic' views, as defined within the London View Management Framework (LVMF). Moving east, Three Quays is already a building site, as construction is underway for 141 apartments and 930sqm of retail space. Finally, we have the Tower of London, which is a World Heritage Site. Here, a combination of tree growth in front and the much higher Thomas More Square development behind make our modern view of the Tower much less impressive than its Victorian counterpart.

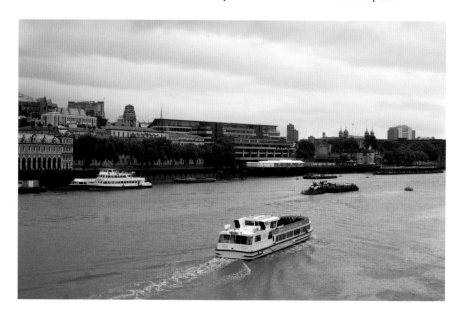

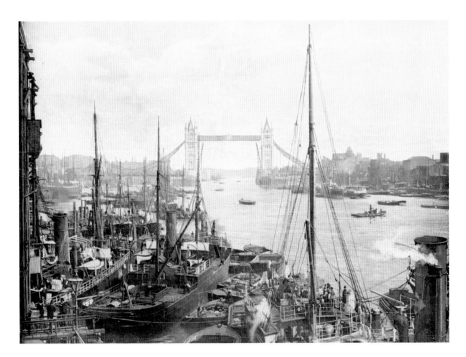

The Tower Bridge

Now one of the most recognisable London landmarks, in 1897 'The' Tower Bridge was only three years old and, in the opinion of the Victorian writers, 'is of somewhat peculiar construction ... The centre span of 200 feet is divided into two, each half being pivoted and furnished with a counterpoise, and hauled upward and back against the towers when the waterway is opened; the bridge is shown thus opened in the view.' These days the bridge lifts around 1,000 times a year.

Before Tower Bridge was built, London Bridge was the most easterly bridge. East London's nineteenth-century population growth, however, necessitated a new bridge to ease the often tortuous journey across the river. It needed to take into account the fact that the area to the east of London Bridge was a busy port (as can be seen in the early photograph outside Billingsgate Market) frequented by tall ships, and so a lifting bridge became the focus of the design.

Pedestrians originally used the high walkways – though, due to lack of use, they closed in 1910 (until 1982), as people preferred to wait on the bridge for it to close rather than climb up the stairs laden with their belongings.

The domed glass structure in the corner of the modern photograph is the new City Hall, completed in 2002.

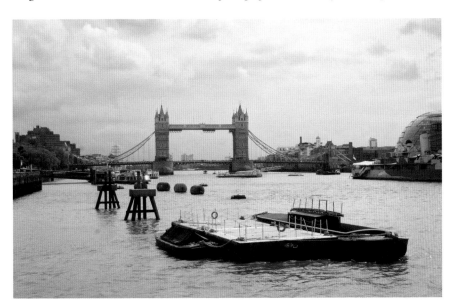

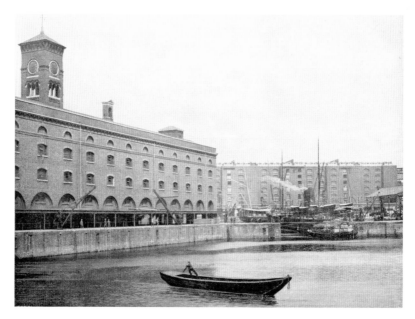

St Katharine's Dock

Built between 1824 and 1828 at a cost of £1.3 million, St Katharine's Dock occupies 24 acres to the east of the Tower of London. To make way for the new docks, 1,250 houses were cleared from slums with discouraging names such as Dark Entry and Cat's Hole, and 11,300 people were made homeless without compensation. The soil which was excavated from the site to make the docks was taken upstream, to help reclaim the marshland around what is now Pimlico.

As they were too small to take vessels greater than 700 tons, the docks were never very successful and, in 1864, they became part of London Docks. In 1868 the docks were closed, sold to the GLC (Greater London Council) for £1.5 million, and in the years that followed became the first to be converted for other uses.

The building to the left of our picture is a converted warehouse, originally built in 1852 and now known as Ivory House. This houses a mix of residences, retail and restaurants. At the time of writing, a four-bedroom apartment in the Ivory House is up for sale for £3 million. The large buildings in the background of our picture are the Thomas More Square development, 50,000sqm of office space, which was completed in 1991.

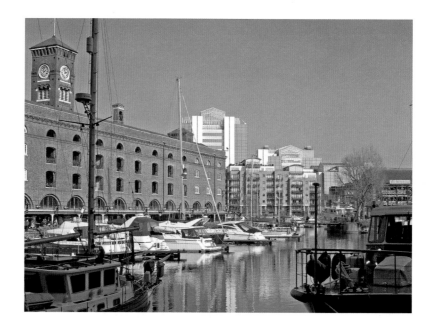

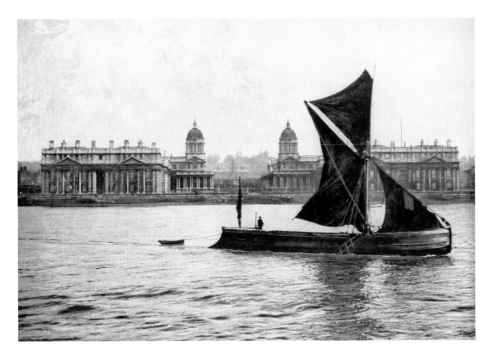

Greenwich Hospital (from the North Bank)

Whilst still captioning it as Greenwich Hospital, by the time of our Victorian photo the building had already completed its 175-year term as a naval hospital and, for more than twenty years, had been host to the Royal Naval College, which moved here from Portsmouth in 1873. The Royal Naval College stayed for 125 years, before closing in 1998 and handing over to the current residents of the Grade I listed buildings: University of Greenwich and the Trinity College of Music.

In 1997, UNESCO (United Nations Educational, Scientific, and Cultural Organisation) designated Maritime Greenwich – which apart from the college includes the Queen's House, the Royal Observatory and Greenwich Park – to be London's third World Heritage Site. In their statement of significance, they pronounced it to be: 'a unique ensemble of buildings and landscape of exceptional artistic value, the work of a number of outstanding architects and designers,' and they described the Royal Naval College as: 'the most outstanding group of Baroque buildings in Britain.' One hundred years earlier, the authors of the *Queen's London* were a little more grudging in their praise, saying it was: 'best seen from the river, whence the less worthy portions are invisible.'

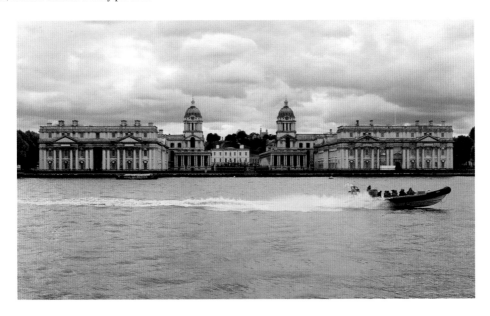

Woolwich, from the river

'The Arsenal chimneys are prominent features of our view,' states the original book, 'while on the common to the right rises the Royal Military Academy.' This last assertion caused some confusion when attempting to line up our photograph. The church clearly prominent in 1897 (less so in 2012 – during the summer at least) is the eighteenth-century St Mary Magdalene. As the image suggests, it has a west tower with its nave, extended in 1894, stretching eastwards. Woolwich Common is directly behind the church, so surely the academy buildings are hidden from view. It seems more likely that the buildings to the right are in Charlton. Whilst it's arguable whether our photograph extends as far west as the original view, the riverside blocks of flats do, and now hide the background hills.

Prior to Woolwich's association with the land military and ammunition manufacture, it was selected by Henry VIII as the location for the Royal Dockyard. It closed in 1869. Twenty years later, continuing a tradition going back centuries, a free ferry crossing was established. It still runs, just out of shot on the left. There are currently three ferries, all built in 1963. The one docked on the right of our view is named after the trade unionist and politician, John Burns, who led the successful dock strike of 1889.

WESTMINSTER

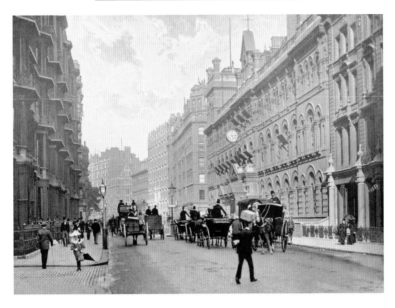

Victoria Street, Westminster, with the Army & Navy Stores

Opened on 6 August 1851, Victoria Street was a truly modern thoroughfare. Much of the road was taken with tall mansion blocks, which was still a new way of living for Victorians. During the Blitz, Victoria Street was hit directly on at least eleven separate occasions, and, looking at the modern photo, little survives today.

On the left are office blocks used by Westminster City Council and the Department for Communities and Local Government. The large block beyond these is Windsor House, built on the site of the Windsor Hotel and used by Transport for London. Nestled in front of Windsor House is a rare survivor, the Albert Tavern, built in 1867 and listed from 1973. Its curious location led one online reviewer to describe it looking 'like a Chippendale chair in Ikea, surrounded as it is by grim 1970s office blocks'.

On the south side of the road, the Army & Navy Stores was a victim of redevelopment rather than bombing. Bought out by House of Fraser in 1973, the store was completely rebuilt in 1977. The Army & Navy name has also passed into history now, following a rebrand and refurbishment in 2004.

The other survivor is Artillery Mansions, opened in 1895 and the last substantial new block of flats built in Victoria Street.

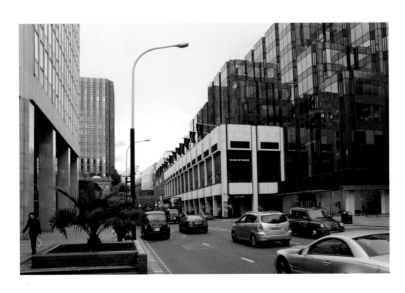

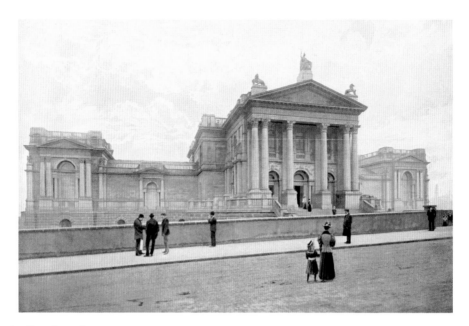

National Gallery of British Art

The National Gallery of British Art, built on the site of a prison, opened in the summer of 1897 (it was only included in the Victorian book's second edition). Known for many years as the Tate Gallery, it is now the Tate Britain. Sir Henry Tate was a sugar refiner – after his death his firm became Tate & Lyle – who financed the cost of the building, 'as a thank-offering for a prosperous business career of sixty years'. He was a modest man who gave generous donations of money, usually anonymously, to unfashionable causes that often reflected his concerns for the welfare of working people.

The building initially contained seven galleries, and housed sixty-five paintings from Tate's own collection and pictures from the National Gallery, amongst other collections. Although the modern photograph disguises the fact, the gallery has been extended several times – most recently for its 2000 re-launch as Tate Britain. The more modern and contemporary art of its collection became the basis for the Tate Modern in the Bankside Power Station.

The original Tate building now contains over thirty galleries, concentrating on British art from 1500 to the present day, thus allowing Tate Britain to legitimately proclaim, 'Henry Tate's vision of a national gallery devoted exclusively to the national school has now finally been fully realised.'

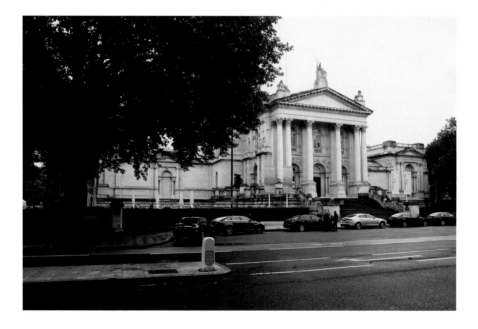

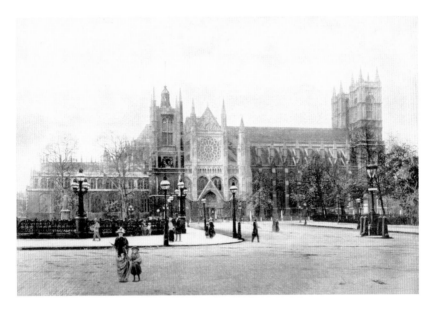

Westminster Abbey, from the north

'It is impossible,' the *Queen's London* authors inform us, 'to get a view of the whole length of Westminster Abbey without including St Margaret's Church.' Nowadays (from this side), between St Margaret's and the trees of Parliament Square, it is hard to get much of a view at all.

Founded more than 1,000 years ago, the building of the abbey in its present form was started by Henry III in 1245. Virtually every king and queen since 1066 has had their coronation in Westminster Abbey, and seventeen are buried here.

In addition to royalty, a host of the great and good are buried or commemorated: the list of prime ministers includes Pitts Elder and Younger, Palmerston, Gladstone, Churchill and Attlee. Newton, Watt and Faraday are amongst many scientists, whilst Poets' Corner commemorates writers from Chaucer to D.H. Lawrence. The most visited grave, however, is not of a royal or a famous person; in fact, we do not even know their name. The tomb of the Unknown Warrior is occupied by an anonymous soldier brought back from France and buried on Armistice Day, 1920, as a representative of the many thousands lost with no known burial site.

Back on Parliament Square, the statue in the centre of our modern photo is of South African politician and military leader Jan Smuts.

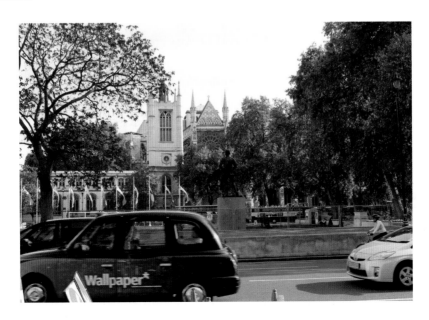

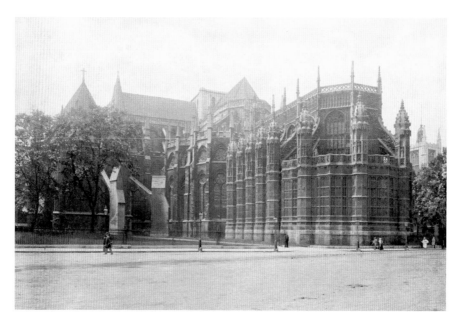

Henry VII's chapel, Westminster Abbey

The penultimate great addition to the abbey (the final being Hawksmoor's completion of the West Towers in 1745) was the building of the Lady Chapel by Henry VII between 1503 and 1519. With the total bill estimated at £14,000, Henry had spent extravagantly on the work – but the result was worth it, and today the chapel is perhaps the finest surviving example of Tudor architecture. Writer Arthur Mee, in typically enthusiastic mood, wrote: 'We are spellbound as we come to it. [It has] a roof of stone that hangs like a miracle of enchantment, seeming to be floating in air, a weight of many tons that seems to have no weight at all. We may envy those who have not seen it, for the first sight of such a wonder is an impression to last a lifetime.'

Apart from the ubiquitous tree growth, there are two obvious additions to the modern photograph. The first is the security barrier that now encircles the Houses of Parliament. The barrier was originally made from concrete blocks, and was put in place in 2003 to prevent terrorist bomb attacks. In 2005 the blocks were replaced with the permanent steel barriers seen here. The second addition is Sir William Reid Dick's statue of King George V, grandson of Victoria and grandfather of Elizabeth.

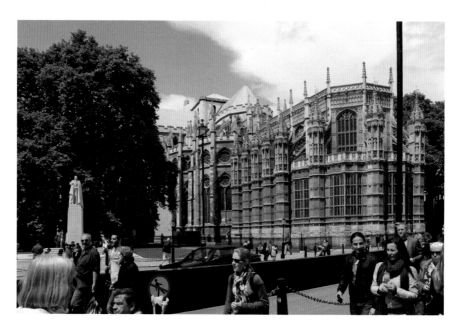

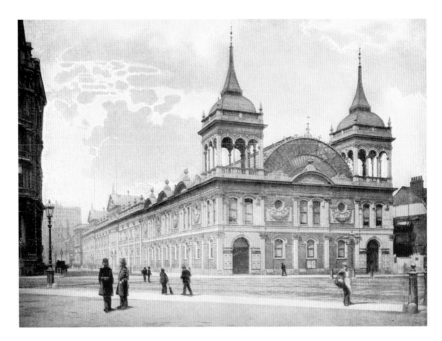

The Royal Aquarium, Westminster

The Royal Aquarium was opened in 1876, and quickly evolved into a combination of winter gardens, music hall and variety performances, side shows and restaurants. A single programme from 1890 included trapeze artists, marionettes and performing elephants – and the Aquarium boasted that at no other place in the world could so many sights be seen. In fact, given the name, surprisingly the only thing not on offer was fish.

Regrettably, the building did not enjoy a long life. It was too big and expensive to run, and lapsed into decay before being demolished in 1902. In its place, Central Hall, the chief Methodist church, was built between 1905 and 1911. This has been the venue for historic events – including the suffragettes' meeting in 1914, a speech by Gandhi in 1932, and the very first General Assembly meeting of the newly formed United Nations in 1946.

The design competition for the hall, which stated that the building should be non-Gothic, non-intimidating, and not look like a church, was won by Messrs Lancaster and Rickards of London with their Viennese baroque design. Sir John Betjeman praised the hall, saying, 'The dome of Central Hall is a splendid foil to the towers of Westminster and the pinnacles of the Houses of Parliament.' Others have been less kind, comparing it with an old-fashioned blancmange.

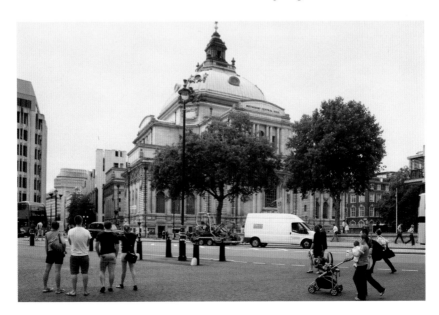

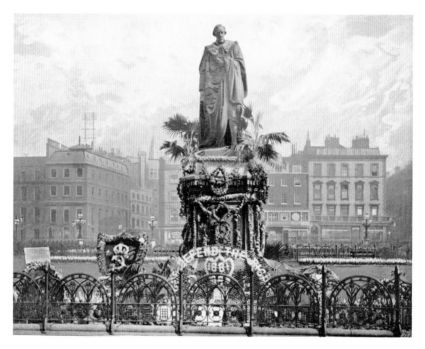

Lord Beaconsfield's statue on Primrose Day

The dilemma here was whether to take a photograph of the statue in its new location, or a statue-less one from the same spot as the Victorian picture. Formerly in front of Parliament Square, facing south, since the 1940s Beaconsfield has been on the west side of the square, facing the Houses of Parliament. The buildings behind the statue in the 1890s were demolished in 1910, so we decided on an image of the statue.

Lord Beaconsfield was Prime Minister Benjamin Disraeli. Primrose Day falls on 19 April, the day of his death in 1881. 'Every year,' says the 1897 book, 'the statue is beautifully decorated with primroses ... the primrose being regarded by the Earl's political admirers as his favourite flowers.' There being no evidence to suggest that this tradition had been discontinued, we decided to take our photograph on Primrose Day 2011. At that time, however, the square was fenced off for security reasons. Lord Beaconsfield stood imprisoned and primrose-less.

Whether the tradition has been completely discontinued or just temporarily deterred by security fences is unclear. An organisation called The Primrose League, set up in 1883 (the year of the statue's unveiling), beholding Disraeli's name and honouring the Conservative cause, finally ceased to exist in 2004.

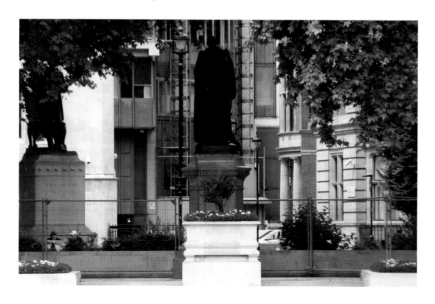

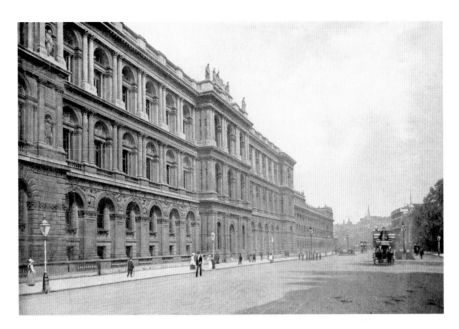

Whitehall, with the Home Office, from the corner of Parliament Street

The Foreign and Commonwealth Office was, at the time of our Victorian photo, only twenty years old and still fulfilling its original function of accommodating four government departments (Foreign, India, Home and Colonial Offices). Over the years, however, the Foreign Office has squeezed the others out and now occupies this whole enormous building.

Sir George Gilbert Scott designed the government buildings in the Italian style, after his original preference for the Gothic had been overruled. The building stretches from Whitehall to St James's Park and is built around a 4-acre courtyard.

From the parapet of the Foreign Office, the seated statue of Britannia, flanked by a lion and a unicorn, looks down on the cenotaph, which was designed by Sir Edwin Lutyens and completed in 1920. The memorial is crafted from Portland stone, and was erected to commemorate the fallen from the Great War. The inscription is simply 'The Glorious Dead'.

Beyond the cenotaph we can also see a much more recent memorial, dedicated to the women of the Second World War. The 7m-high bronze sculpture was unveiled by the Queen in 2005. The building on the right of the street, with the distinctive domes, is the old War Office building, completed in 1906.

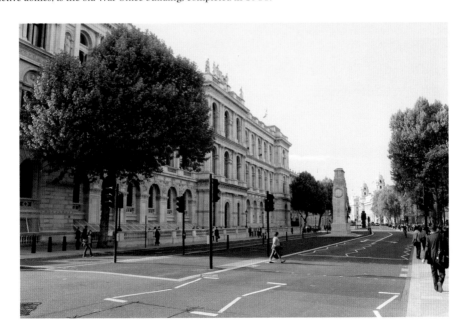

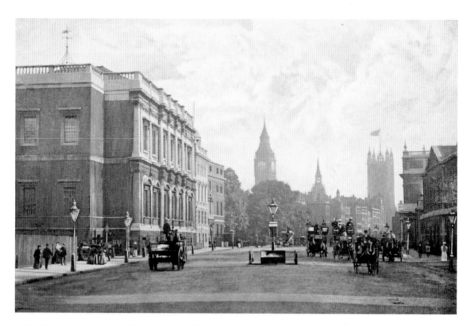

The Royal United Service Institute Museum, with Whitehall

To the left of our picture, on the south corner of Horse Guards Avenue and Whitehall, is the Banqueting Hall, all that remains of the former Royal Palace of Westminster. Built by Inigo Jones in 1622, the palace was home to the kings of England from Henry VIII to William III.

At the time of our Victorian photo, the hall had just been transferred to the Royal United Service Institute for its museum. The museum is lovingly described by Arthur Mee in his 1937 book *London, Heart of the Empire and Wonder of the World*. 'It is difficult to exaggerate its varied interest,' he wrote – and indeed, if you wanted to see the skeleton of Napoleon's favourite horse, the top hat Wellington took to the Battle of Waterloo, or the saw used to amputate Nelson's arm, then this was the place for you.

It was therefore bad news for fans of military bric-a-brac when the museum closed in 1962. Good news for everyone else, however, as, after renovation, the Banqueting Hall opened to the public the following year. Since 1992 this now Grade I listed building has been run by the charity Royal Historic Palaces.

The Victorian photo shows the site north of the Banqueting Hall cleared ready for the construction of the War Office, built by William and Clyde Young (1899–1906).

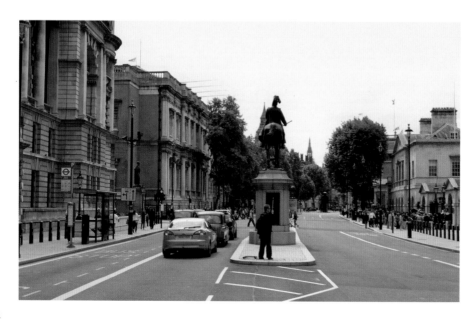

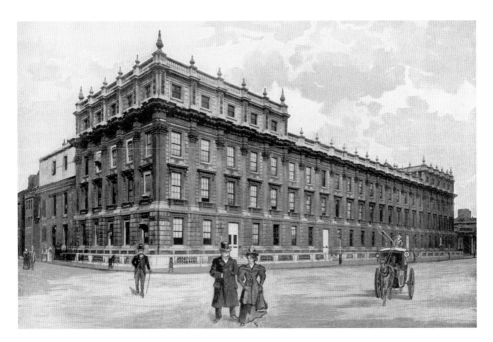

The Treasury, Whitehall

The 1897 book states that the Treasury 'was originally built by Sir John Soane, but has been altered and provided with a new façade by Sir Charles Barry'. What it doesn't mention is that Soane's building was built around features of many older ones – including walls of Henry VIII's tennis courts. Remains of Tudor and later buildings were additionally incorporated into the façades. Barry also incorporated details of Soane's façade into his own, which faces Whitehall – aspects of Soane's original still exist on the section that faces along the adjoining street. That street, on the left of both photographs, is Downing Street, 'which leads to the house that Mr Gladstone and other Premiers have successively occupied', states the Victorian book, seemingly referring to the prime minister of the time – although Gladstone actually resigned from his fourth and final premiership in 1894. The black gates visible in the modern photograph were erected in 1990 for security reasons, though the following year their presence could do nothing to prevent mortars being fired into the street by the IRA.

The building is currently occupied by the Cabinet Office. The Treasury has been housed in Great George Street, on the north side of Parliament Square, since 1940.

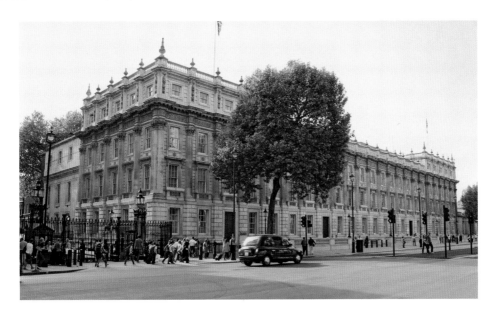

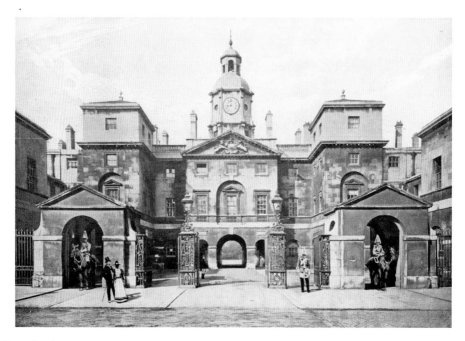

The Horse Guards

Writing about the Guardsmen, the 1897 book states how 'the curious generally halt to take stock of them, and audibly to criticise them'. Now, two brown notices, one on each box, probably go some way to deterring such behaviour. They warn: 'Beware. Horses may kick or bite!' Very little else has changed in 115 years. The public may still walk through the central arch to St James's Park – although, now as then, only members of the royal family are allowed to drive through it. Its lowness prompted satirical artist Hogarth to draw the royal coach emerging with a headless driver holding the reins.

Close examination of the clock in the modern photograph does, however, reveal changes. Numbers to indicate the minutes have been added outside the Roman numeral hours, and there is another, subtler, addition. At the hour of two is a black mark, for it was at this time in January 1649 that Charles I was beheaded outside the nearby Banqueting House, having first come through the Horse Guards area. Only seven years earlier, he had commissioned the first guards to live there and protect his palace, 'a Court of Guards in the Tiltyard before Whitehall'.

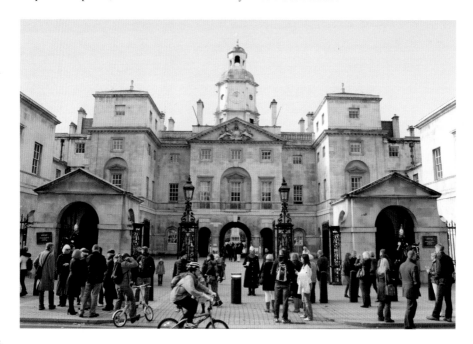

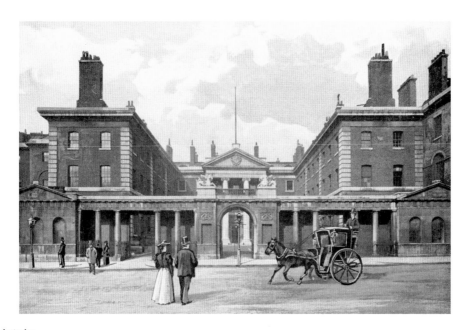

The Admiralty

The building behind the stone screen is the Old Admiralty, known as Ripley House after its architect Thomas Ripley. It was completed in 1728. The screen (which replaced a brick wall that was removed for street widening) was designed by Robert Adam, with completion in 1761.

The Victorian writers thought the building 'not particularly impressive'; they weren't the only ones. The architect James Elmes mused that the central columned portico 'rather disgusts than pleases. Happily,' he continued, '...this clumsy pile is concealed from view by a very handsome screen.' He admitted, though, that the architect 'was compelled to violate every rule of architectural proportion and carry his columns to the roof of the building' because of an unforeseen problem with a lack of light reaching the upper windows.

In the Victorian photograph there are two entrances for vehicles. These were opened up in 1828 at the order of the Duke of Clarence (then Lord High Admiral) so that his carriage could drive more easily into the courtyard. Nearer to the central arch, the two pedestrian entrances, having been open before, were closed off by 1897. They were reopened in the early 1930s.

Today the building is assigned to the Cabinet Office. The current Admiralty is behind the old one, facing Horse Guards Parade and St James's Park.

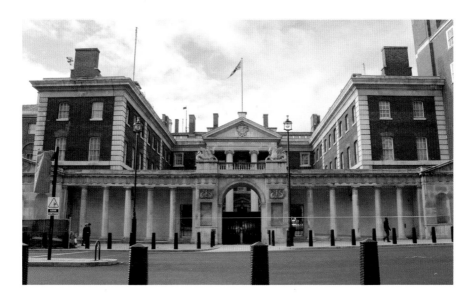

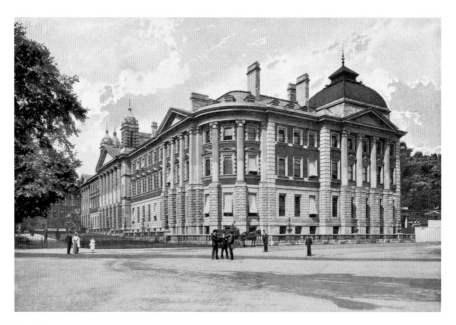

New Admiralty Offices

The Victorian photo shows the first completed phase of what were, then, the brand new Admiralty Offices. Completed in 1895 to supplement the existing ones, the offices now cover the whole of the north side of Horse Guards Parade.

New Admiralty Offices were designed by the Halifax firm of Leeming and Leeming in the Italian Palladian style, using a redesign of their previous competition scheme for a much larger Whitehall Office complex. During the Second World War, the buildings were severally damaged in bombing raids, but were fully restored by 1958. In 1974 they were given Grade I listing protection.

To the left of our modern photo is the Admiral Citadel, an art deco concrete bunker built between 1940 and 1941 as a bomb-proof operational centre. In 1955, the question of what to do with 'the ugliest building in London' was debated in parliament. 'It is clear,' said MP Roger Hesketh, 'that there is no possibility of removing the Citadel altogether. For one thing, it is extremely solidly built; for another the Admiralty still want it. But, if it is to remain indefinitely, while creepers may serve as a good temporary disguise, they cannot provide a permanent solution.' Looking at the current picture more than fifty years on, it would appear that Virginia creepers were indeed the permanent solution.

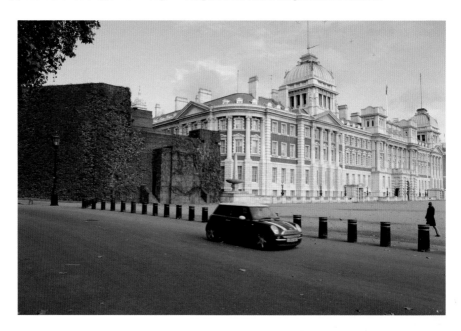

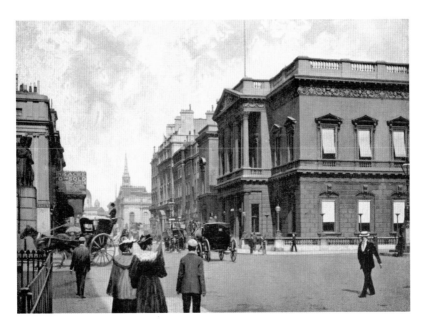

The United Service Club, at the corner of Waterloo Place

The United Service Club at 116 Pall Mall was built by John Nash in 1829 for military officers. In 1858 it expanded, purchasing 117 Pall Mall, and the building was extensively remodelled by Decimus Burton to 'match' his Athenaeum Club on the opposite side of Waterloo Place. The United Service Club closed in 1976 as a result of financial difficulties, but the Grade I listed building, now occupied by the Institute of Directors, remains almost unchanged from our Victorian photograph. The only exterior change was made in 1929/30, when the mansard roof was reconstructed to provide squash courts and additional bedrooms.

Comparing the two photographs, the monument, on the left of the photograph, to the Crimean Campaign is no longer visible, as explained by a plaque on its base:

The Guards' Memorial was pulled down in the year of our lord 1914 and was re-erected 30 feet north in order to permit the erection of the Florence Nightingale and Sidney Herbert statues.

The dome of the National Gallery is now fully visible, as both the theatre and its colonnade (which used to partially block the view) are long gone. St Martin-in-the-Fields is still there, but the Victorian view of its spire has been obscured since 1906 by Oceanic House in Cockspur Street, the one-time offices of the White Star Line Co.

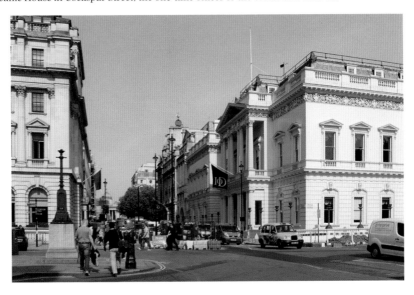

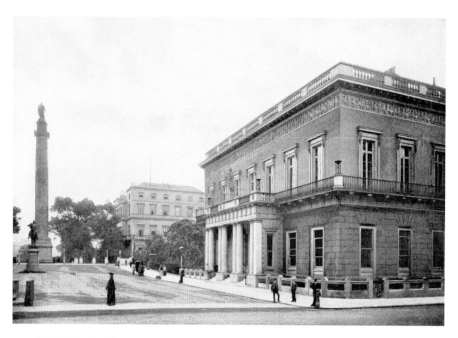

The Athenaeum Club in Waterloo Place

On the west side of Waterloo Place is the Athenaeum Club, one of the most prestigious and intellectual clubs in London. The Athenaeum was founded in 1824, and its clubhouse was built in 1830 to a design by Decimus Burton. The distinctive frieze that runs around the building is a copy of the one on the Parthenon, and the golden statue above the entrance is of Athene, goddess of wise counsel, war and heroic endeavour. The only change to the building happened shortly after the Victorian photo was taken, when an attic storey was added in 1899.

Out in the middle of Waterloo Place is the Duke of York column. While just 6m shorter than that supporting his naval contemporary Nelson, it falls a long way short in the fame stakes. The memorial was completed in 1834, nine years before Nelson's, and offered the advantage of an internal staircase leading to a viewing gallery at the top. At first glance, the equestrian statue in front of the York column is the same in both photos, but look again. In the recent photo, we see Edward VII by the Australian-born Bertram Mackennal, sculpted in 1924. To make room for him, Field Marshal Napier (seen in the Victorian photo) was relegated to the north end of Queensgate in 1920.

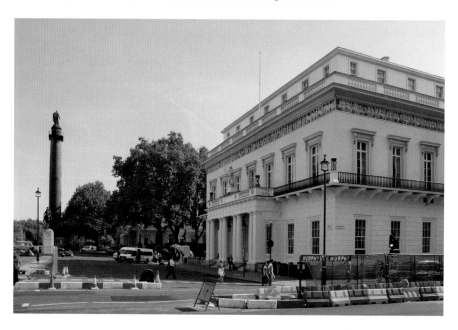

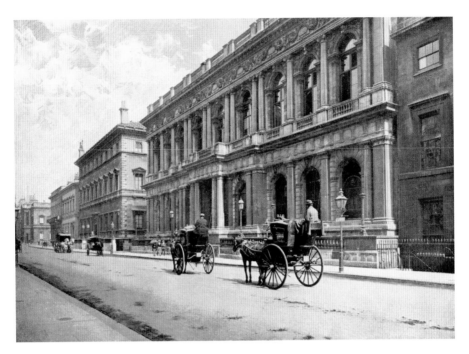

Pall Mall: the south side

This photo shows a row of gentlemen's clubs. From the right, we have: The Royal Automobile Club, built between 1908 and 1910 in the French Renaissance style, which replaced the old War Office seen in the Victorian photo. Most prominent in the Victorian photograph is the Carlton Club, 'the most important and exclusive of the Conservative clubs'. Built in 1855 and modelled on Sansovino's Library in Venice, it was originally faced with Caen stone – but this did not cope well with London smog. The building was refaced with Portland stone in 1923, but then faced a bigger problem than smog in 1940 when it received a direct hit from an incendiary bomb and was gutted. The building we see in the current photo is the abstracted classical façade of No. 100 Pall Mall. 'For once,' wrote Gavin Stamp in his book *Lost Victorian Britain*, 'a fine Victorian building was replaced by a really good 20th Century one.' Next in line and still there today is the Reform Club, built by Charles Barry in 1841; adjoining this is the Athenaeum. Finally, on the left of the picture and the far side of Waterloo Place, is the United Service Club.

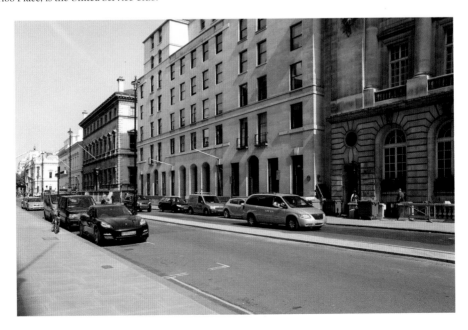

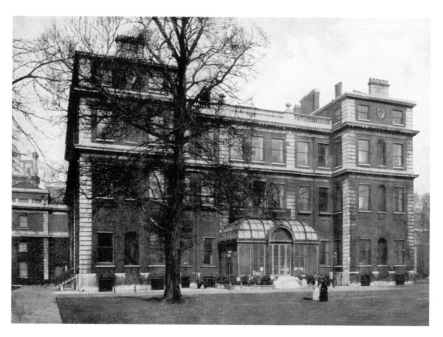

Marlborough House

Aside from the removal of the glass porch and the fact that it now looks a lot cleaner (it was extensively renovated between 1989 and 1993), little has changed between our two photographs.

Marlborough House was commissioned by Duchess Sarah, wife to the first Duke of Marlborough. She appointed Sir Christopher Wren as architect in preference to Sir John Vanbrugh, who at the time was building Blenheim Palace for her husband. Work started in 1709, but, before the two-year build was finished, Sarah had fallen out with Wren and dismissed him, choosing to oversee completion of the project herself (a situation readers who have ever watched the television programme *Grand Designs* will be all too familiar with!).

The house remained the London home of the Marlborough family until 1817, when the government bought it for Princess Charlotte and Prince Leopold of Saxe-Coburg. In 1861 through to 1863, further extensions were made in preparation for its new occupant, Albert Edward, Prince of Wales. The works, which included the addition of two attic storeys, were designed by Sir James Pennethorne. In 1865, the future George V was born here.

In September 1959, the Queen placed Marlborough House at the disposal of the British government as a Commonwealth Centre, and today it houses the Commonwealth Secretariat and the Commonwealth Foundation.

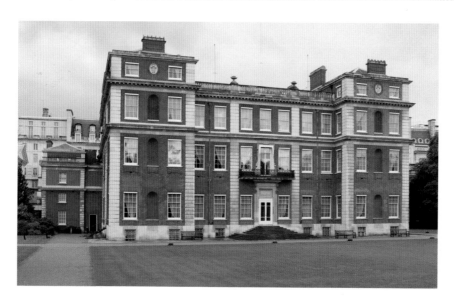

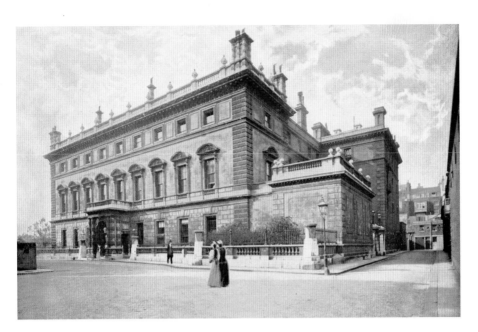

Bridgewater House

This is Bridgewater House, completed in 1854 and designed by Charles Barry. It was commissioned by Francis Egerton, 1st Earl of Ellesmere. The building replaced Cleveland House, which the Earl had inherited and deemed to be in too dangerous a condition to live in. He was a great patron of the arts – so keen was he to share his passion, that he opened a picture gallery in the building three years before it was completely built.

At the time of Elizabeth's accession, Bridgewater House was being used as office space. After restoration due to Second World War bomb damage, the house was sold by the 5th Earl of Egerton. It is now privately owned again and, until 2003, was the residence of the late Greek shipping tycoon John Latsis.

The large block of stone seen in the bottom left corner of the Victorian image (now replaced by the large corner of a handsome building called Selwyn House) is in all probability a foundation stone of the same building. Either that, or the remnants of the previous building. At the time the first photograph was taken, Selwyn House was either being built or was about to be built. Up until 2010, it was the London headquarters of Pilkington Glass.

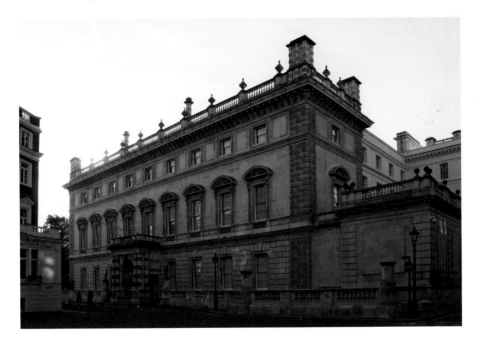

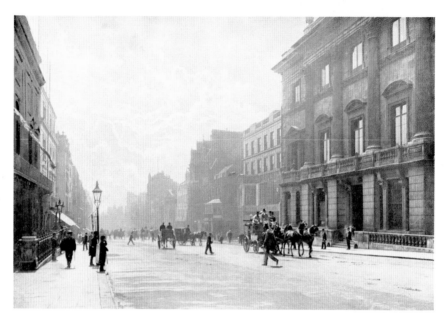

St James's Street, Piccadilly, looking south

Since the early eighteenth century, St James's Street has been celebrated for its gentlemen's clubs and classy shops. Buildings in both images reflect this history.

The white building (centre-right in the modern photograph) is No. 54, currently the home of Swaine Adeney Brigg, makers of luxury leather and equestrian goods. The extensive glass frontage on the ground and first floors gives a clue as to the building's nineteenth-century usage – around the same time that the old photograph was taken, the building became the London showroom for the top-quality coach-builders, Hoopers. Like a lot of coach-building companies coping with the advance of the new automobile, Hoopers was delving into new technology, producing chassis for companies like Rolls-Royce and Daimler. In 1904 they built a Daimler chassis for Edward VII. The company was still there in the 1950s, Rolls-Royces and Daimlers shining out from behind the ground-floor windows, whilst coaches from bygone years were displayed upstairs.

The imposing building dominating the right of both pictures is No. 50 St James's Street. In 1896 it was occupied by the Devonshire Club. Prior to then, from the time it was built in 1827 it was the aristocratic gambling house, Crockfords. The Duke of Wellington, despite not gambling, was a member. As recently as 2009 it was still a casino and private club.

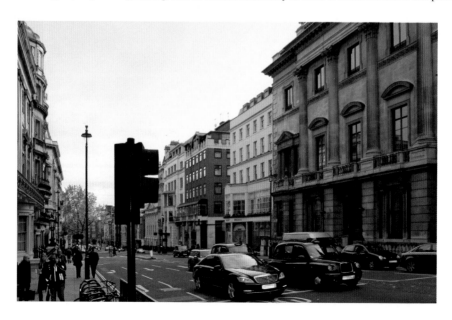

WEST END

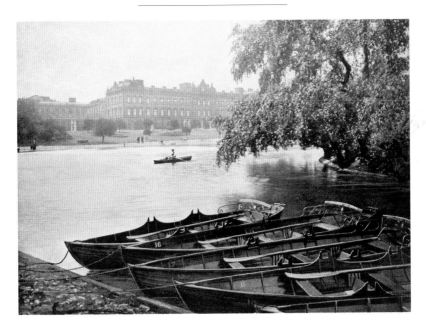

Buckingham Palace from St James's Park

After not a little research, we decided that – unlikely as it may seem – our photograph is taken from the same viewpoint as the Victorian one. The lake (originally a collection of ponds, transformed into a long stretch of water in the seventeenth century at the request of Charles II) was shortened in 1911 to make way for the gardens surrounding the Queen Victoria Memorial, which stands in front of the palace now.

Victoria was the first monarch to live in the palace, moving there three weeks after her accession. Neither George IV (the initial instigator for building the palace), nor his brother William IV, lived long enough to see its protracted completion. It was built on the site of Buckingham House, one of George III's residences.

By 1897, the frontage of the palace (this whole east-facing front was only added in 1847) was deteriorating and discoloured by London's soot. It was replaced in 1913 by Portland stone. It took a year to prepare but only three months to reface, a job done whilst the then monarch, George V, was in Sandringham.

Twelve years earlier, upon the death of Victoria, it wasn't only the outside of the palace that needed rejuvenation in the opinion of the new King Edward VII – 'Get this tomb cleaned up', was his instruction.

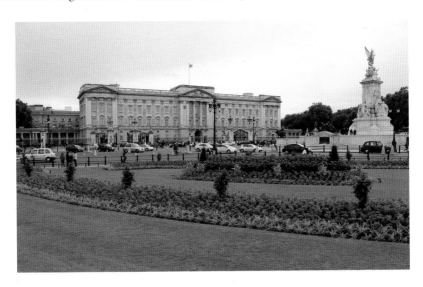

Devonshire House

The town house of the Dukes of Devonshire was designed by William Kent and built for the 3rd Duke around 1737 at a cost of £20,000 – on the site of a previous house, which had burned down. Nothing remains today except the ornate gates, which have moved 50m down the road and are now used as an entrance to Green Park. The house had been sold by the 9th Duke of Devonshire to pay death duties, and, after it was demolished, the present Devonshire House was built by architects Carrère and Hastings.

In the context of Queen Victoria's Diamond Jubilee, Devonshire House is worthy of a special mention because, on 2 July 1897, it was the venue for a 'marvellously gay and sparkling' party attended by the Prince and Princess of Wales. A gushing *Times* report enthused that, 'Of all the private entertainments for which the Jubilee has provided the occasion, none is comparable with the magnificent fancy dress ball given last night at Devonshire House by the Duke and Duchess of Devonshire.'

The cyclists in our modern photo are riding 'Boris bikes', a public bicycle-sharing scheme named after London's current mayor. Launched in July 2010, users pick up or drop off one of the 5,000 distinctive blue bikes at 345 docking points around the city.

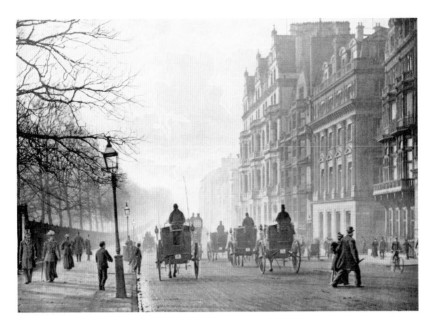

Piccadilly with the Green Park

In 1897, many of the grand houses on the north side of the newly widened Piccadilly Road were clubs. Halfway along, the large palatial building with the three spiked domes was the Junior Constitutional Club, for 'members professing Conservative principles'. Next door was the Badminton Club, established in 1876 for 'gentlemen interested in coaching and field sports'. Then came the New Travellers' Club, a 'social and non-political' club which had, until recently, counted among its members Oscar Wilde – he had resigned his membership in 1895 from Holloway Prison.

The building on the edge of frame was the Junior Naval and Military Club. Some sources suggest that this club only existed in the 1870s. In fact, national archive records hold mortgage details for the club at this address between 1890 and 1925. This contradiction reflects the transient and itinerant nature of the numerous clubs existing in London in the latter part of the nineteenth century.

In 2012, all these buildings are still there. The Junior Constitutional Club, at 101-104 Piccadilly, is now the Japanese Embassy. The rest of the buildings, though, are empty. Many of these, and similar former club premises, are now owned by elusive offshore trusts. Add to that the confusing legal and financial situations involving these old buildings and it becomes easier to understand why they remain uninhabited.

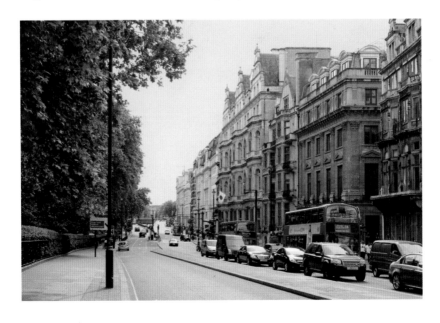

Regent Circus and Oxford Street, looking east

Regent Circus, now known as Oxford Circus, has a familiar look in the Victorian photo, but in fact it has changed completely. The identical six-storey buildings which now stand on each corner were designed by Sir Henry Tanner and built over a period of fifteen years, from 1913 to 1928. The original picture was taken shortly before the underground network reached Oxford Circus. The Central London Railway (Central line) was opened in 1900, and in 1906 the Baker Street & Waterloo Railway (Bakerloo line) was added.

Peter Robinson (rebranded in the 1970s as Topshop) has been an ever-present in Oxford Street since it was founded in 1833. Keen-eyed readers may be able to make out their name near the roof-line of the building, on the left-hand side of the street; when the last of Tanner's buildings was completed in the north-east corner of the Circus (Nike World in our current photo), this became their new home.

In 2009, Oxford Circus received a £5 million facelift, which incorporated the introduction of diagonal crossings, based on those used in Tokyo. Opening the new crossing, London Mayor Boris Johnson described it as: 'A triumph for British engineering, Japanese innovation and good old-fashioned common sense.'

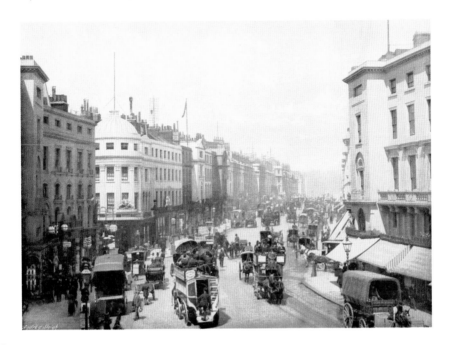

Regent Street

Built between 1816 and 1820, Regent Street travels north from Piccadilly Circus in a curve known as the Quadrant, before continuing in a straight line through Oxford Circus and on to link with Portland Place. The view in these pictures is taken from near the top of the Quadrant, looking north towards Oxford Circus. The Quadrant had originally been furnished with a colonnade which extended across the width of the pavement, but shopkeepers complained that it drew attention to the 'ladies of the night who plied their trade in the shadows of the columns', and it was dismantled in 1848.

Queen's London considered Regent Street to be 'the most fashionable street of shops in London ... where everything is to be had of the very best, but at the highest prices. Ladies especially patronise this fine street, those who cannot afford to shop here flocking to it to see what is sold in the best West End houses.' The truth is, however, that by the end of the nineteenth century Regent Street was showing its age, and was in need of modernisation as the needs of retailers changed and businesses required larger units. The Nash terraces were demolished and rebuilding began. Much of the new building work was delayed by the outbreak of the First World War, but, by the mid-1920s, it was completed, and the only surviving original Nash building was All Souls' Church.

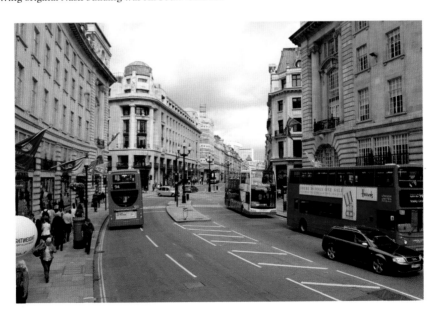

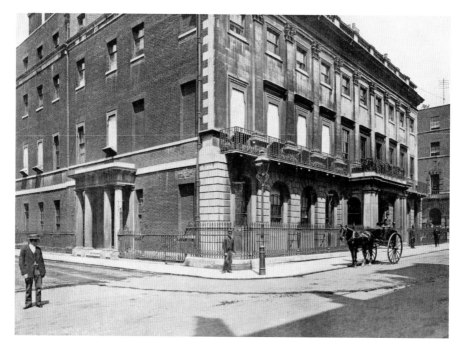

Uxbridge House

Since 2007, the London flagship store of American fashion retailer Abercrombie & Fitch, Uxbridge House, is situated on the north side of Burlington Gardens, between Old Burlington Street and Savile Row. The house was built for the 1st Earl of Uxbridge and was home to first him, and then his son, the 1st Marquis of Anglesey. The Marquis had a long and illustrious career in politics and the military, so perhaps it is unfortunate that he is most famous for having his leg shot off by a cannon at the Battle of Waterloo. Upon his death in 1854, the house was sold, and operated for many years as a bank; firstly as the western branch of the Bank of England, and from 1933 as a branch of the Royal Bank of Scotland. In preparation for this change of use, architect Philip Charles Hardwick made a number of alterations, including the addition of the wide stone Doric portico we can see on the Burlington Gardens frontage. When the two photographs are compared, it is clear that the entrance porch in Old Burlington Street has moved. Strangely, it's the modern image that shows the original location of the doorway, which was moved during the 1860s, and then moved back in 1934.

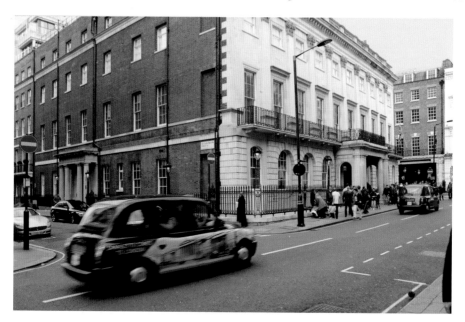

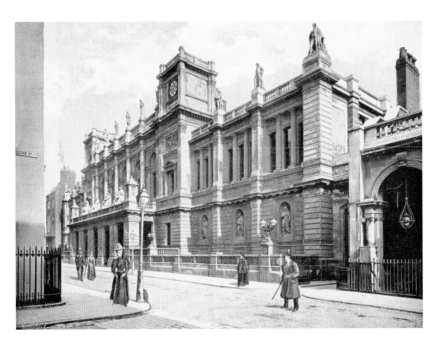

London University

Aside from some minor modifications at street level, little has changed in our view of the London University building also known as No. 6 Burlington Gardens.

Whilst founded in 1836, it took more than thirty years for the London University to get a home to call its own. No. 6 Burlington Gardens was designed in the Renaissance style by James Pennethorne, and, in the pouring rain on 11 May 1870, was opened by Queen Victoria. The four statues which can be seen over the portico are those of Milton, Newton, Harvey, and Bentham, representing the faculties of Arts, Science, Medicine, and Law, in which the university originally granted degrees. The statues along the roof-line represent men (and they are all men) of great learning, from the time of Plato to the contemporary Sir Humphry Davy.

In 1900, the university moved from this site to the Imperial Institute building in South Kensington, and, after brief occupation as offices for the National Antarctic Expedition, the building was made over, early in 1902, to the Civil Service Commission. From 1970 to 1997, No. 6 was used as the Museum of Mankind, before becoming an extension to the Royal Academy of the Arts. Most recently, in 2009 it became the London headquarters for the Haunch of Venison art gallery.

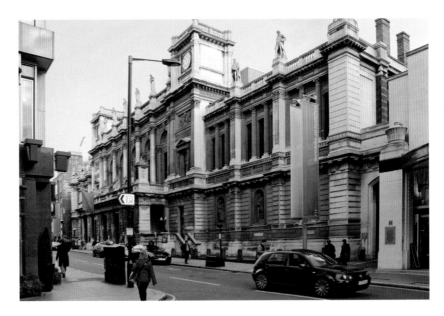

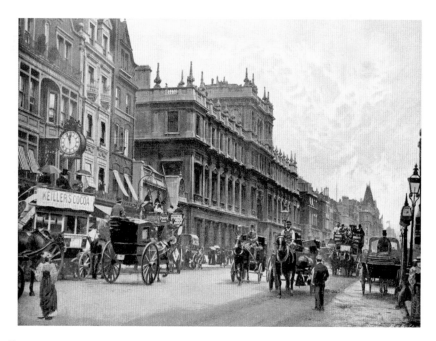

Burlington House

Today, Burlington House is most famous as the home of the Royal Academy of Arts, and the site of their annual summer exhibition. The original house was completed in 1667 as home to the 1st Earl of Burlington, but was then repeatedly enlarged and remodelled over the years. In 1854 it was purchased by the British government for £140,000, and, following much public debate, was made the home of the Royal Academy and other learned societies.

The Piccadilly frontage of Burlington House (seen in our photographs) was completed in 1872 in the Italian Renaissance style, and is the product of an expansion plan needed to accommodate the societies: the Geological, Chemical and Royal Societies occupied the east wing, whilst the Royal Astronomical, the Society of Antiquaries, the British Association, and the Linnean Society were allocated the west wing (to the left in this photo). In 2004, the societies successfully went to court to avoid eviction by the government, which had become unhappy about their rent-free existence.

Little else in this stretch of Piccadilly remains today. On the block east of Burlington House, Nuffield House was built as a commercial development in 1937; beyond that, the St James's Restaurant and St James's Hall were demolished in 1905 to make way for the Piccadilly Hotel (now Le Meridien Hotel), which was completed in 1908.

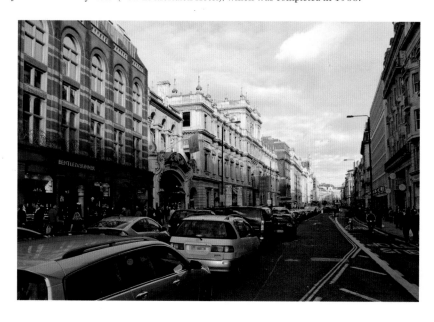

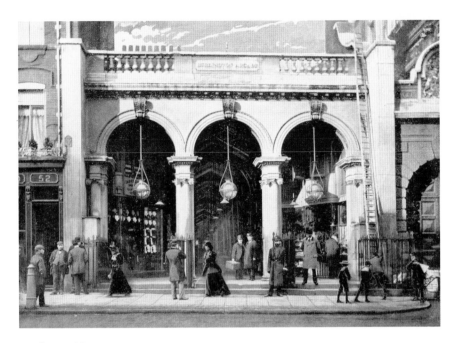

Burlington Arcade, Piccadilly

Burlington Arcade houses a double row of shops, connecting Piccadilly with Burlington Gardens. Originally built in 1819, it is Britain's longest shopping arcade. Whilst the façade has changed greatly over the years, with a second storey added in 1911 and the three arches being replaced by a single span in 1931, much about Burlington Arcade has stayed the same.

Reporting on plans for the arcade in 1817, the *Gentleman's Magazine* reported it would be 'for the sale of jewellery and other fancy articles' intended 'for the gratification of the public'. Fast forward to 2010 and little has changed, with the *Sunday Times* reporting that the forty-seven shops in the arcade sell 'cashmere jumpers, antique watches and fine perfumes'.

For their part, the authors of the *Queen's London* felt there was something not quite British about the arcade: 'From the first, many of the shops have been occupied by foreigners (who are more familiar in their own countries with Arcades than are Englishmen)'. Whilst it is hard now to see the truth in this stereotype, it is the case that in recent years ownership has been in foreign hands. In 2004, the arcade was bought by a Bermudan trust for £65 million, and they in turn sold it in 2010 to American investors for £104 million.

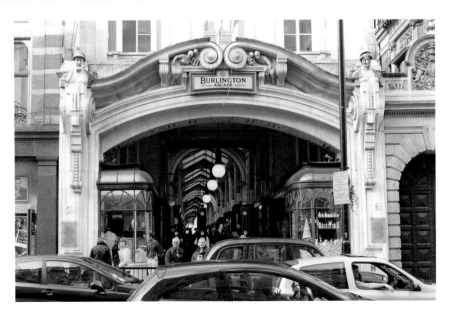

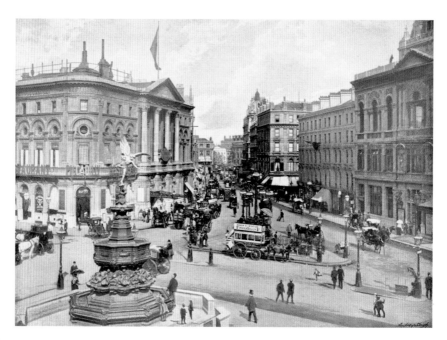

Piccadilly Circus

Piccadilly Circus was formed in 1819, as the intersection between Piccadilly and John Nash's new Regent Street. When first built, the buildings were all set back and curved to form an elegant circle. This elegance was lost forever in the 1880s, when the Metropolitan Board of Works demolished the north-east segment to make room for Shaftesbury Avenue.

As can be seen, the junction is currently undergoing further upheaval, with a £10 million revamp intended to improve traffic flow. When completed in 2012, two-way traffic will return for the first time in almost fifty years, and the Circus will also get new footpaths, lighting and the removal of railings.

On the left of the picture is the London Pavilion, now home to the Trocadero. On the south side of the Circus is the Criterion Building, originally built in 1873 and now covering an area totalling 30,000sqm on a 0.4 hectare rectangular site. The building's most high-profile tenants are: Lillywhites, whose store opened in 1923; the Criterion Restaurant, which opened to the public in 1873; and the Criterion Theatre, which opened a year later. The unusual thing about the Criterion Theatre is that it is subterranean. Even theatregoers with seats in the Upper Circle have to go downstairs to reach them.

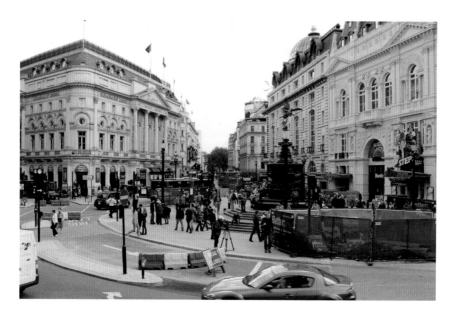

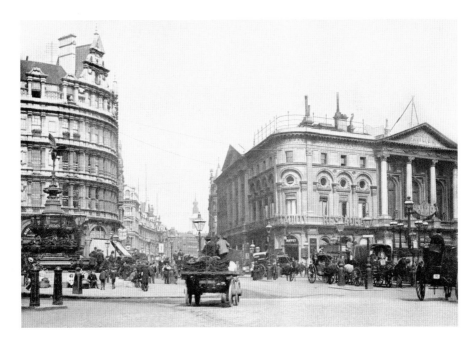

Shaftesbury Avenue from Piccadilly Circus

The main difference between these two images is that Eros has moved. It was originally unveiled in 1893 – 'a fountain erected to the memory of the philanthropist Lord Shaftesbury', states the Victorian book. It was removed in 1925 because of work on the new tube station being built underneath, and spent seven exile years in Embankment Gardens. It returned briefly, before spending the Second World War in Egham. Strangely, no bombs fell in Piccadilly Circus proper during the war. As Mrs Robert Henrey notes in her memoir of living in the war-torn West End, *London*, 'You could have spent the whole war seated on the Eros plinth without suffering a scratch.'

Of the two large buildings either side of the avenue, it is the one on the right that appears to have survived the interim years. The façades, however, hide the truth. Behind the latter's modern neon signs, there still lurks the 1897 building – the chimney can be seen peering over the top. By contrast, it is only the façade of the other building that has survived. The interior was gutted in 1986 to make way for the present Trocadero Centre. Up until that time it was latterly a cinema, and before then a theatre and a music hall – the London Pavilion seen in the Victorian photograph.

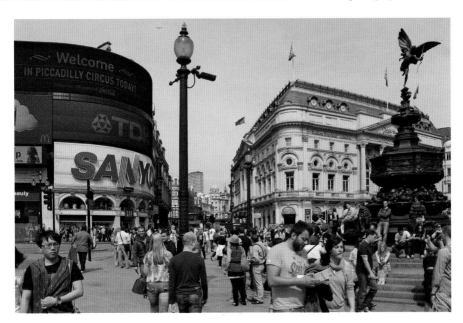

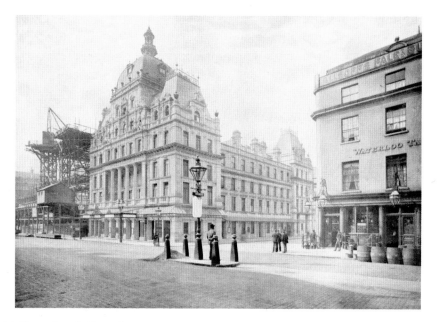

Her Majesty's Theatre from the Haymarket

There has been a theatre on this site since 1705; the current one, built in the French Renaissance style by C.J. Phipps, is the fourth. Her Majesty's was financed by actor/manager Sir Herbert Beerbohm Tree, who is famed for founding the Royal Academy of Dramatic Art.

In 1901, following the accession of King Edward VII, the theatre was renamed His Majesty's, but then reverted back when Elizabeth came to the throne in 1952. The theatre is now part of Andrew Lloyd Webber's 'Really Useful' theatre group, and his musical version of *The Phantom of the Opera* has been running there continuously since 1986.

Next to the theatre (in the Victorian building), work is underway for the Carlton Hotel, which was built by the same architect. The Carlton opened in 1899, and is perhaps now best remembered for the apprentice pastry-chef, Nguyen Tat Thanh, who worked there in 1913. It turned out that his future did not lie in catering, and Ho Chi Minh, as he is better known, went on to lead Vietnam.

The Carlton closed in 1939 and was destroyed the following year in the Blitz. New Zealand House now stands on the site, home to the New Zealand High Commission. The listed building comprises four podium floors surmounted by a fourteen-storey tower, 78m high.

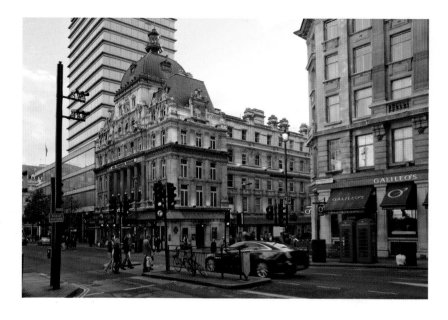

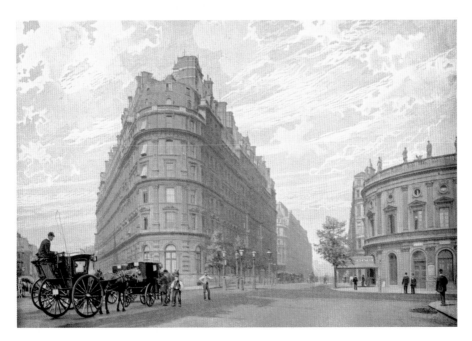

Hotel Metropole in Northumberland Avenue
This is definitely not a vantage point that has improved over the years – much of our view, since the Victorian photo was taken, has been obscured by a combination of the underside of the upstream Golden Jubilee footbridge and tree growth.

The tall, triangular building in the centre is the Hotel Metropole, which opened in 1885 and has had a chequered life alternating between hotel and government requisition. Most recently, it came back into private hands in 2007 as the Corinthia Hotel. Amongst early claims to fame, in 1896 the Hotel Metropole was the rallying point for the first London to Brighton run. Known as the 'Emancipation Run', it was a celebration of the recently passed Locomotives on Highways Act 1896, which had increased the speed limit to a dizzying 14mph.

To the right of the picture, we can still just about see the Avenue Theatre, which opened in 1882. In 1905, the Avenue was badly damaged by the collapse of part of Charing Cross Station, and reopened in 1907 as the Playhouse Theatre. Between 1951 and 1976, the theatre was taken over by the BBC as a recording studio for live performances of radio shows, such as the Goon Show and Hancock's Half Hour. It also hosted live performances by The Beatles and The Rolling Stones.

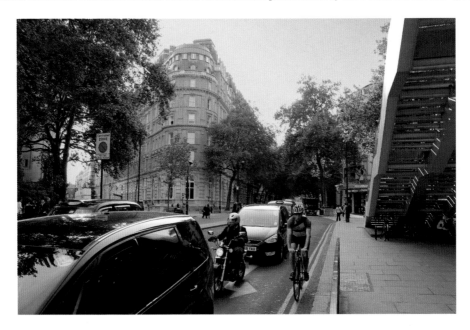

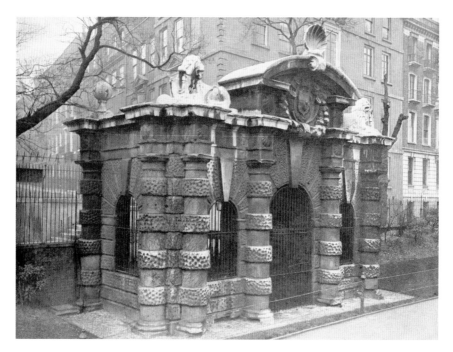

The Old Water Gate

The Old Water Gate, now called York Watergate, is in Victoria Embankment Gardens at the foot of Buckingham Street. Its current name reflects not only the building it fronted, York House, but also its former situation on the shores of the River Thames. Now, as in 1897, it is removed from both. When York House (a thirteenth-century building) was demolished in the 1670s, only the Watergate, built in 1626 and attributed to Inigo Jones, amongst others, was spared. Paintings as late as the 1860s show the Thames lapping at the base of the gate. It was later that decade that 37 acres of river were built upon, and converted into the Victoria Embankment.

Buckingham Street, to the left, leads to the Strand. For many centuries, mansions such as York House lined the southern side of the thoroughfare, their gardens descending to landing steps and gates on the river. In fact, the name 'Strand' is derived from an old English word for shore. In our modern photograph, the building visible behind the gate, on the corner, was built in 1906. However, the range of town houses beyond it, going up to the Strand, are all survivors from the first photograph – the two nearest houses were built in around 1675.

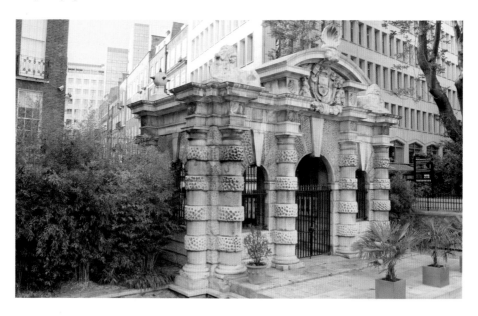

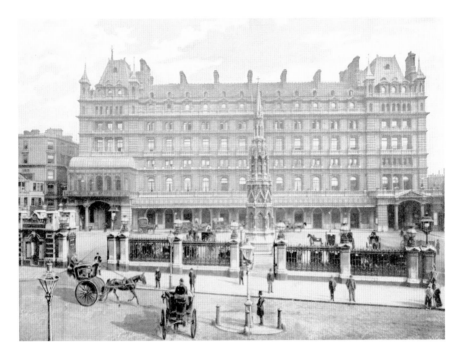

Charing Cross Hotel

The Charing Cross Hotel was built in 1863 by Edward Barry, and was one of the first buildings in London to be faced with artificial stone. When comparing the two photographs, the building looks similar but the roof-line has changed. This is the result of bomb damage suffered in the Second World War; the upper floors were completely rebuilt in 1951, replacing the original mansard roof. The building is now a four-star Guoman hotel, which has recently undergone a major refurbishment.

The cross in front of the hotel is a replica of the last of the twelve Eleanor Crosses, erected in 1290 to mark the funeral cortège route taken by Eleanor, wife to Edward I. The original Charing Cross was located at the top of Whitehall, but was destroyed in 1647 at the demand of parliament and was later replaced with a statue of Charles I, which still stands on the site. The replica we see in both pictures was made in 1863 at a cost of £1,800, based upon drawings of the original. Over the years, the condition of the cross had deteriorated, until in 2008 it became necessary for English Heritage to add it to their Risk Register. A ten-month project to repair and restore the cross to its former glory was completed in August 2010.

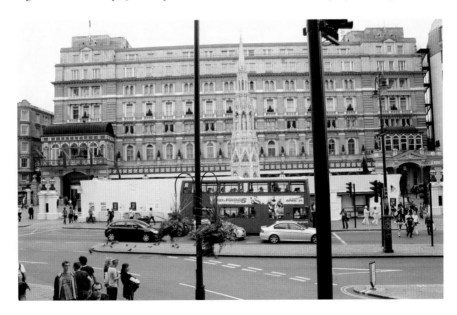

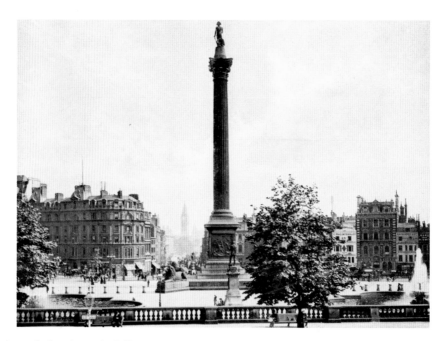

Trafalgar Square, looking down Whitehall

One of London's most famous landmarks, Nelson's Column, stands 51m high in the centre of the square. The fountains either side were installed in 1845, but were completely remodelled in 1939. Originally they were fed from two wells which provided, in the opinion of Charles Dickens Jr, a 'ridiculous insufficiency of their jets of water', so doubtless he would approve of the much more powerful electrically driven pumps used today.

Prominent in the middle of the Victorian photograph, but no longer there, is Hamo Thornycroft's statue of General Gordon (aka 'Gordon of Khartoum'), erected in 1888. The statue was moved in 1943 to allow a Lancaster bomber to be parked in the space, as part of the National Savings Committee's 'Wings for Victory' week. Gordon sat out the rest of the war in Buckinghamshire, before finally returning to London in 1953 to take up residence in Victoria Embankment Gardens.

In the foreground, we can just see the effect of the £50 million redevelopment work carried out in 2003, which pedestrianised the north end of the square and added a new flight of stairs from the National Gallery (from where our pictures have been taken). In the background, looking beyond the square lies Whitehall, and in the distance the distinctive shape of the clock tower of the Houses of Parliament.

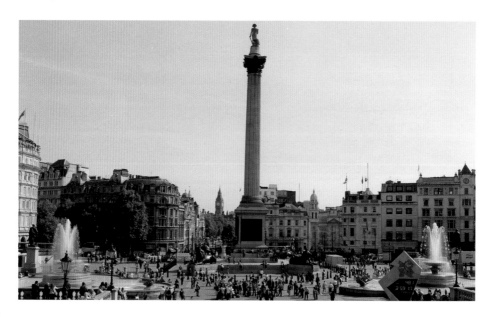

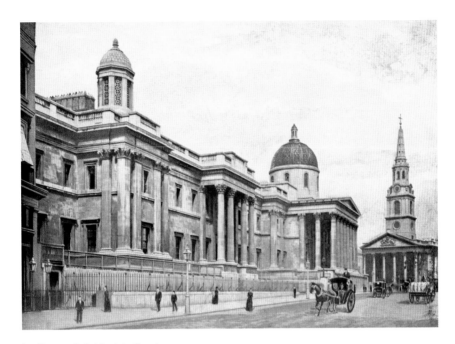

The National Gallery, with St Martin's Church

In 1824, the government voted to spend £60,000 purchasing thirty-eight pictures for a new national art collection. In 1831, William Wilkins drew up plans for a gallery to house them, and two years later work started. The gallery was completed in 1837 but has been extended on several occasions since.

With scaffolding up due to renovation work, the National Gallery is not looking its absolute best right now, but the truth is that even at it most pristine it has not attracted universal praise. Writing in 1937, Arthur Mee expresses a fairly common view of the National Gallery: 'From a distance its small central dome and the tiny domes at the ends look like pepper pots.' He does, however, grudgingly qualify his criticism: 'When we approach and mount its steps beneath the stately Corinthian columns, we feel that it is not unworthy of the loveliness within.'

On the right is the Church of St Martin-in-the-Fields, built 1721–6 by James Gibbs on the site of an earlier church. St Martin's is rightly proud of their work with the homeless and disadvantaged. During the First World War, vicar Dick Sheppard gave refuge to soldiers on their way to France. He saw St Martin's as 'the church of the ever open door', and established a policy which continues to this day.

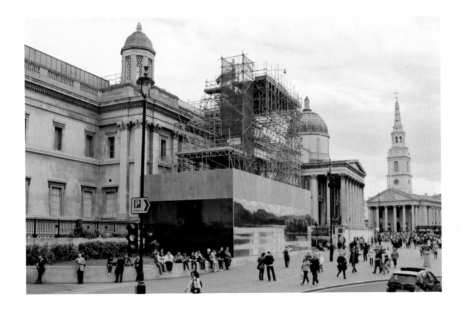

The National Portrait Gallery, from St Martin's Place

At the time of the *Queen's London*'s publication, this building was still brand new, having opened its doors for the first time on 4 April 1896. Philanthropist William Henry Alexander donated £80,000 to fund the building, whilst the government provided the new site. Sadly, both the architect, Ewan Christian, and the gallery's first director, George Scharf, died shortly before the building was completed.

Our picture shows the gallery's main entrance in the east wing. The *Queen's London* authors were less impressed with the north façade, which they considered to be 'plainer and heavier, and generally less attractive'. Apart from the growth of trees, the most obvious difference between the two images is the memorial to Edith Cavell (1865–1915). Cavell was a British nurse in the First World War who helped hundreds of Allied soldiers escape from German-occupied Belgium. She was caught by the Germans and was executed by firing squad on 12 October 1915, causing outrage in the press.

Created by sculptor Sir George Frampton and unveiled by Queen Alexandra on 17 March 1920, the monument is made in grey granite, stands 12m high and carries the inscription 'Faithful unto Death'. The statue of white marble, chosen as an emblem of purity, shows Nurse Cavell standing erect in her nurse's uniform.

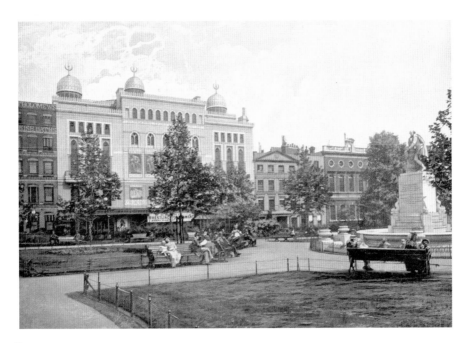

Leicester Square

Only the 1874 statue of Shakespeare has survived the years. The building dominating the left-centre of the Victorian view is the Alhambra Theatre, built in 1854. The theatre became noted for staging circus acts, music and ballet. The dancing gained a reputation for risqué performance and, in 1870, the theatre's dancing licence was temporarily withdrawn after one high foot-raise too many. In the 1880s, it was to the Alhambra that Jerome K. Jerome and his fellow two 'Men in a Boat' adjourned after aborting their rainy Thames journey home from Oxford.

In this 1896 photograph, wrestling was the entertainment – though this year also saw the venue used regularly by early film pioneer Robert W. Paul to show off his new moving pictures. One of them (arguably the first British narrative film), *The Soldier's Courtship*, was filmed in the same year, on the roof of the building. The following year, Paul set up three cameras along Whitehall and made a film of the Queen's Diamond Jubilee procession. The theatre's final use in 1936 was as a film set. It was demolished to make way for the Odeon Cinema. To the Alhambra's right is Hawkes & Sons, makers of musical instruments. This building was demolished in 1897 and replaced by the present building, currently the home of the Moon Under Water pub.

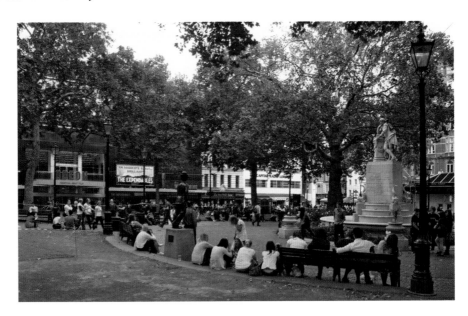

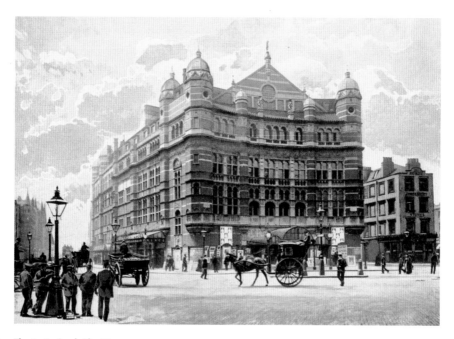

The Palace Theatre in Cambridge Circus

Designed by T.E. Collcutt for impresario Richard D'Oyly Carte, the Royal English Opera House opened on 31 January 1891 with the premiere of Sir Arthur Sullivan's opera *Ivanhoe*. Carte wrote on opening night: 'Whether [the experiment] will succeed or not depends on whether there is a sufficient number of persons interested in music and the drama who will come forward and fill the theatre.' There wasn't, they didn't and the following year the theatre was sold and renamed the Palace Theatre of Varieties. More recently, the Palace Theatre has hosted a number of long-running musicals, including *Les Misérables*.

Comparing the two photographs now, the theatre seems to have changed little – but this is an example of appearances being deceptive. The theatre experienced severe bomb damage during the Second World War, and was further mutilated in the 1950s by the shaving away of its terracotta ornament. In 1983, Andrew Lloyd Webber purchased the freehold for £1.3 million, and in 1988 a two-year restoration programme started on the exterior of the building.

The pub to the right of our 'now' photo was built the year after the Victorian photo was taken. After several name changes it became the Spice of Life, and over the past fifty years has had a rich and varied musical history.

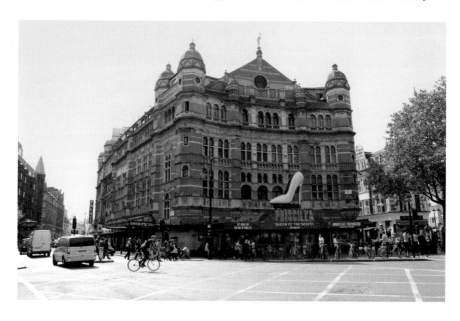

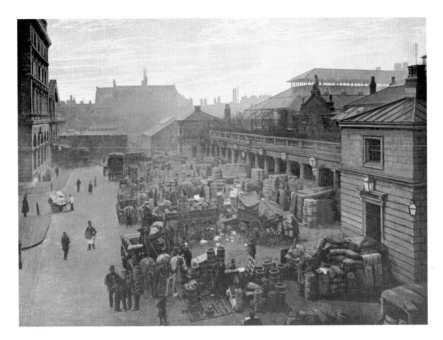

Covent Garden Market

The first fruit and vegetable market opened at Covent Garden in 1656, but the buildings in our pictures are much more recent, dating back to 1831.

It seems that the market was always struggling for space. *Queen's London* reported it as 'quite inadequate for its purpose', and in 1937 Arthur Mee wrote that 'Covent Garden is a mess which has survived a score of schemes for its rebuilding'. All proposals were, however, resisted by locals and it took an Act of Parliament in 1962 to instigate change. The market was moved to Nine Elms in Battersea, and in 1974 Covent Garden closed.

Initially, buildings were allowed to fall into disrepair, but announcement of redevelopment plans led to a public outcry, and the Secretary of State for the Environment listed over 250 buildings to protect them. In 1980, Covent Garden reopened with the market buildings converted into small units, and the square's new life as the self-claimed 'entertainment centre of London' had begun.

As can be seen in our current-day photo, working right to left, the main market buildings, the flower market (now the London Transport Museum) and the old Hummums Hotel have all survived. The shed squatting is the middle of the picture, promoting Tommy Hilfiger's 'modern take on all things preppy', is a thankfully temporary addition.

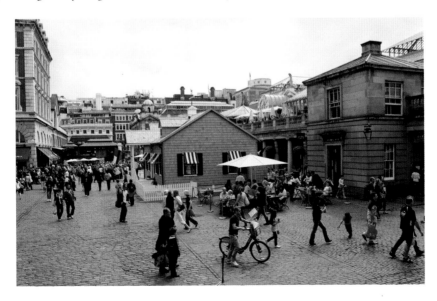

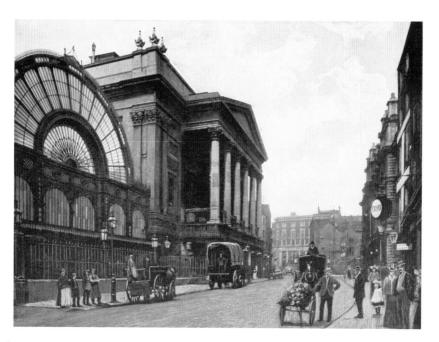

Covent Garden theatre

Bow Street's Covent Garden theatre (the Royal Opera House) is the third of its kind, the first two being destroyed by fire. The early photograph was taken at the end of a successful eight-year period, when the theatre was run by the actor, producer and dramatist Sir Augustus Harris – 'the father of modern pantomime'. Apart from playing host to the leading singers of the day, the theatre was also used for fancy dress balls and public meetings. Furthermore, Harris installed electric lights.

The frieze that wraps around the upper part of the theatre originally adorned the second theatre, and survived the 1855 fire that broke out during the latter stages of a rowdy masked ball. That second theatre was wider, so the frieze had to be rearranged to fit the new one.

The glass-domed building next to the theatre, formerly called the Floral Hall, was built at the same time as the current theatre and, for many years, was part of the adjacent flower market. Recently, the derelict hall was redeveloped and incorporated into the Opera House itself. In 2007 it was renamed the Paul Hamlyn Hall.

The building in the background of the Victorian picture, where Bow Street meets Long Acre, was the premises of coach-maker Edwin Kesterton.

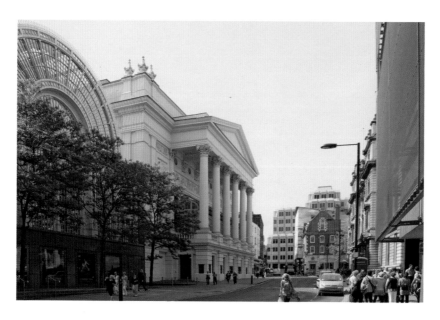

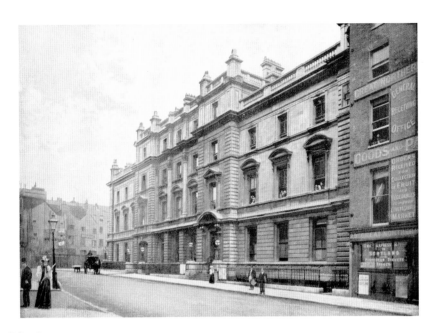

Bow Street Police Court

The date in the stonework above the door of Bow Street Police Court is 1879. In fact, this was a little optimistic and the building was actually completed in 1881. For 125 years, the four magistrate courts within this building have witnessed thousands of cases, including many famous ones. Dr Crippen, Emmeline Pankhurst, the Kray twins and Jeffrey Archer have all passed through the cells here; and, a year before the Victorian picture was taken, the court would have heard from Oscar Wilde, charged with gross indecency following his arrest at the Cadogan Hotel. Wilde was eventually sentenced to two years of hard labour (coincidentally the same amount of time served by Jeffrey Archer).

The last case was heard in July 2006, and the Grade II listed building has now been sold to Irish development company Edward Holdings, for about £25 million – not a bad return for a building which originally cost £38,400. In November 2008, Westminster Council passed planning consent for the courts to be converted into a '76 bedroom hotel with restaurant, bar and associated facilities and museum/interpretive centre with 16 sleepover cells'.

The building on the right of our picture, which was a 'General Receiving Office', is now home to the Design Council.

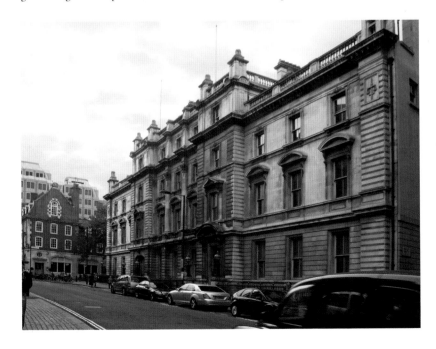

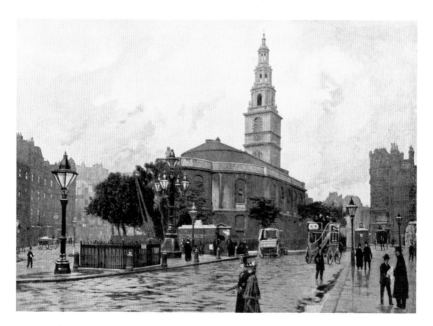

St Clement Danes, Strand

The subject of our modern photograph at the east end of the Strand isn't the black railings in the foreground, beneath which are public ladies' toilets, nor the five-lantern lamp post behind it (both of which have survived from the early photograph) but the church that lies mainly hidden behind a line of trees. This is St Clement Danes. There has been a church here for over 1,000 years. The present one was designed by Wren and built in the early 1680s – the previous church survived the Great Fire, but was shortly afterwards deemed to be unsafe. The steeple, which can be seen peering out over the twenty-first-century foliage, was added in 1719. The church's interior was gutted in the Second World War and restored in the 1950s. The tower and the outside walls, however, were mainly unscathed.

But what of the toilets? They lie a short walk away from Britain's first public loos, opened in 1852 outside No. 95 Fleet Street. The one in our photographs (and a gentlemen's toilet which is obscured) was opened a few years later. In 2002, this was the scene of a ceremonial laying of a giant Victorian penny (one penny being the public toilet entry fee for many years) to commemorate the 150-year anniversary of the original lavatories.

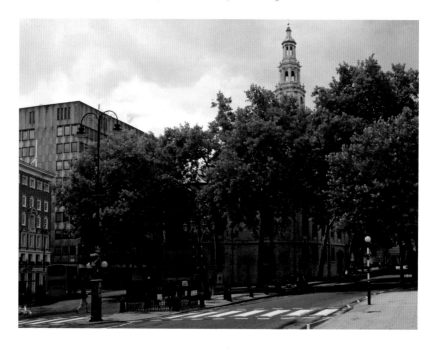

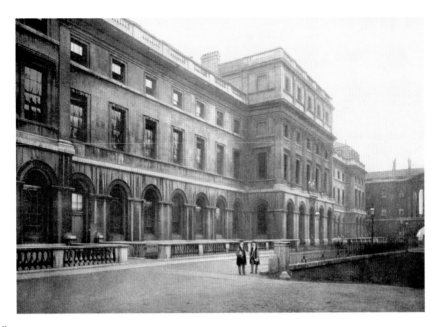

King's College

King's College, situated between Strand and the Thames, was founded in 1829 by a group of prominent churchmen and politicians, who desired an alternative to the new, but 'godless', University College London. The college building, by Robert Smirke, was completed in 1831.

On the right of the modern image, building work is being carried out on next-door Somerset House – in 2009, the news broke that the college, 'after 180 years of coveting the East Wing of Somerset House, and after many false starts ... has finally got its hands on it'. The modern improvements carried out by the college involve the refurbishment of all six floors and allowance of public access.

Throughout the 1800s, relations between the college and the Crown offices that occupied the wing were often strained. At one point, windows were added that overlooked the college courtyard. When the college complained, they were told that there was no restriction for 'Her Majesty from opening windows in Somerset House whenever she may think proper'.

Subjects taught at the college's inception included modern languages, history, surgery and the philosophy of law. By 1849 the college was promoting the new idea of evening classes. Today, many of the nineteenth-century subjects have been maintained. More recent courses, amongst a vast array, include psychiatry, digital humanities and midwifery.

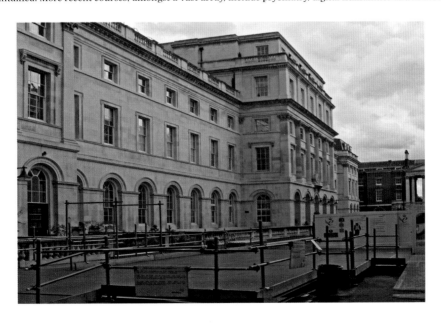

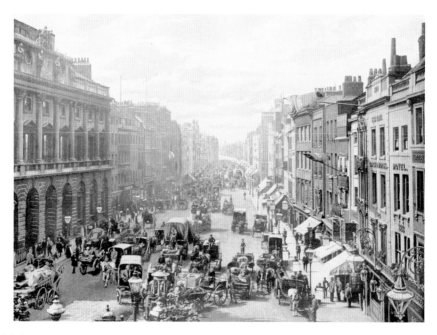

The Strand, looking west

'No better idea of the Strand can be obtained than from the church of St Mary-le-Strand, whence this view is taken,' proclaims the Victorian tome. Regarding the southern side, at least, the same can be said today. Somerset House still dominates the left of the view. A little further along, the grey-turreted building, substantially redeveloped in the 1980s, is No. 142 Strand. It was at this address in the mid-nineteenth century that an ambitious young publisher called John Chapman opened the doors of his family home to writers with unconventional or radical book ideas. One creative associate was Karl Marx. Another, who lodged at the house, was an unknown writer called Marian Evans. Whilst harbouring unrequited love for Chapman, she helped him run the left-wing journal *The Westminster Review*. Subsequently, she left London, changed her name to George Eliot and her career took off.

Nelson's Column is visible mid-distance in both photographs. The houses on the right in the Victorian image were all replaced during the twentieth century. Nearest to us now is the south-west wing of Bush House, occupied by HM Revenue & Customs. Beyond it, undergoing major renovation, is the shell of the Marconi building, from where the BBC made its first broadcast in 1922.

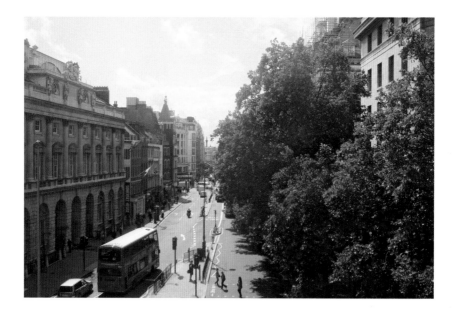

THE CITY

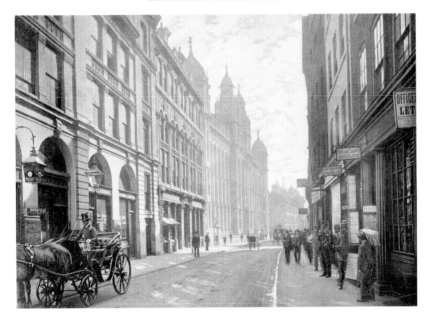

The new Public Record Office, Chancery Lane
The Public Record Office Act was passed in 1838 to 'keep safely the public records', and the Public Record Office in Chancery Lane was built 1853–5 as a place to do exactly that. Designed by Sir James Pennethorne, and extended with the Chancery Lane frontage we see in the photo (by Sir John Taylor, 1891–6), the building was noted for its fire-proof construction. The building has individual modular document cells built of wrought iron, with shallow arched brick vaults and cast-iron girders.

Early in the twentieth century, the facility started to be pressured for space, and a Record Commission of 1912 predicted that accommodation would be outgrown within five years. They were right, but a series of temporary solutions were found and it was not until 1977 that the new office was opened at Kew. In 1996, the Public Record Office vacated the Chancery Lane buildings altogether and, following a £35 million refit, Kings College Library moved in.

If John Taylor were to return today, he would easily recognise not only his own Perpendicular Gothic building, but much of the street, as no less than ten of the properties in Chancery Lane are protected by Grade II listed status.

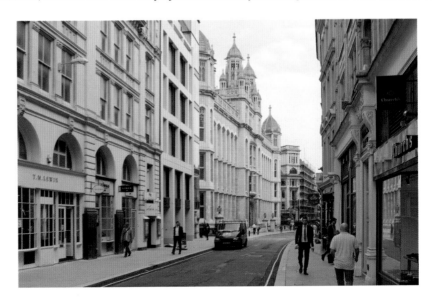

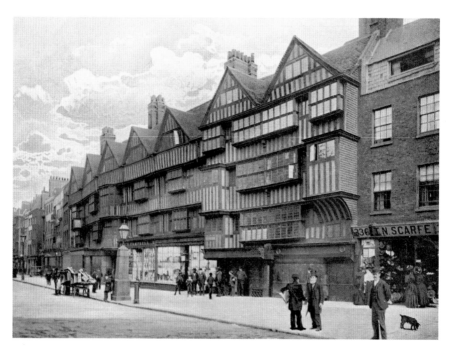

Old houses at Holborn Bars

These sixteenth-century 'old houses' on High Holborn, which came within a few feet of being consumed by the Great Fire of London, had only been recently renovated when the Victorian photograph was taken. In 1886, an ancient form of fire-protective plastering was removed to reveal what is the only Tudor half-timbered building that survives in the city. Behind the façade lies Staple Inn, now the home of many solicitors' offices. Under the fifth triangular window along is an original gateway that takes one into the inn.

In 2012, as also in 1897, the street level of the building is occupied by shops, the fronts of which are from the early part of the nineteenth century. The building nearest to us in the Victorian view – the shop premises of I.N. Scarfe – did not survive much longer, and was replaced by the present building in 1903.

The granite obelisk visible on the street in both photographs was placed there in the mid-nineteenth century and marks the city boundary. The original lantern atop it has now been replaced by a gilded griffin. There is an identical obelisk on the other side of the road, which marks the beginning of the London Borough of Camden.

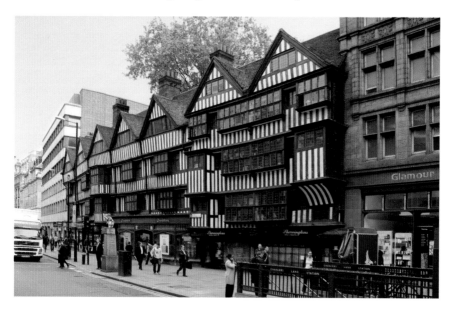

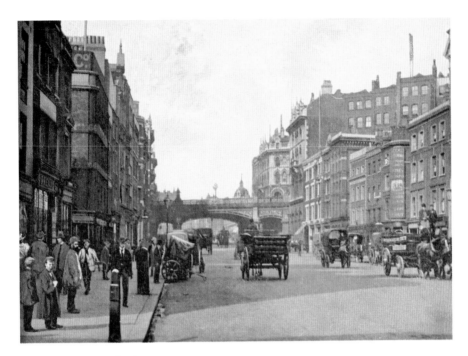

Holborn Viaduct, from Farringdon Street

The Holborn Viaduct was completed in 1869 after six years' work and at a cost of well over £2 million. Its purpose was to bridge the Fleet Valley by connecting Holborn with Newgate Street, or, in the words of the Victorian book, 'to avoid the inconvenient descent of Holborn Hill'. It continues, 'Everybody admits that the Viaduct is a triumph of engineering skill, but a great deal of it – the accommodation, for instance, of gas – and water-pipes – is not visible.' It was opened by Queen Victoria. The only other structure, apart from the viaduct, to make it into both views is the building immediately in front of the viaduct on the right. Two of the ground-level arches presently lead into an Indian restaurant. The third, as it did in 1897, contains a staircase that leads one up to Newgate Street.

The 1897 book tells us that the dome in the distance belonged to the Central Markets, the official name of Smithfield Market. This dome was atop the poultry section – which was destroyed not by enemy action, but by fire in 1958. All the original buildings on the left of the street have gone, possibly victims of the twentieth-century road-widening scheme.

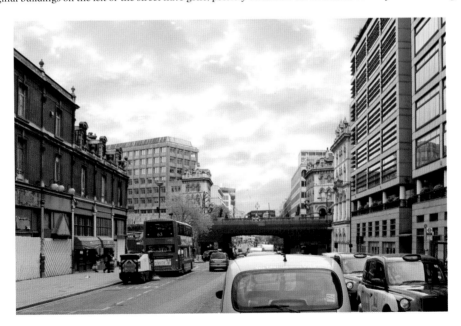

Dr Johnson's house

The renowned Dr Johnson had seventeen London residences, and the four-storey building in centre-left of both photographs is the last of them to survive. The house, in Gough Square off Fleet Street, was built in 1700. Johnson lived there from 1746 to 1759, writing his dictionary in the fourth-floor garret. It's possible that it has not been used as a private residence since. At some point during Victoria's reign it was a guest house. By 1897 we can see that the premises had become a printer's and stationer's – but maybe not for much longer. 'Offices to be let' says the poster in the window. Whether the people in the photograph are moving in or out is unclear, although a further sack on its way out of the door does suggest the latter.

By 1911 the house was in an awful state of repair, though the heritage of the building was no great secret – the plaque commemorating its importance is visible between the ground-floor windows to the left of the door in both photographs. A local MP, Cecil Harmsworth, was horrified to see such a significant building in this dilapidated state, and set about restoring the property to its former eighteenth-century glory. It opened as a museum in 1913 and is still open as one today.

In Ye Olde Cheshire Cheese

Ye Olde Cheshire Cheese is down an alleyway off the north side of Fleet Street. It was built after the Great Fire, which destroyed the pub previously on the site. There have been many alterations since then, though this room, the Chop Room, is one of the oldest ones.

'According to tradition,' states the 1897 book, 'Goldsmith and Dr Johnson used to dine here ... and the corner to the right of our picture, beside the fireplace, is pointed out as the favourite seat of the lexicographer.' The dark portrait above this seat (on which there appears to be a box of Pear's soap) seems to have the silhouette of Dr Johnson, whose likeness can clearly be seen in the modern photograph. A 1910 photograph of the same room also shows Johnson's portrait, though it's possibly not the same one. The clock is different, though the benches have survived, and also the chair on the right – which is in exactly the same place (we didn't move it there!).

The pub is now much sought after by tourists and pub-connoisseurs. The 1897 book states: 'The Cheshire Cheese is chiefly frequented by regular customers, who find compensation for the hard benches and sawdust-covered floor in the old-world appearance of the place, and in the excellence of the special dishes for which the house has long been famous.'

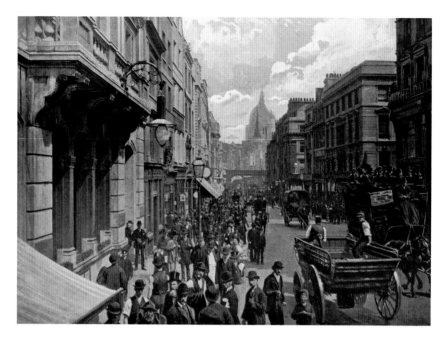

Fleet Street, looking east

Queen's London describes the view down Fleet Street as 'the headquarters of London journalism, in a characteristic state of bustle'. In the original photograph, on the left, can be seen the office of the *Daily Telegraph*, marked with an 'electric lamp', and on the right the office of the *Daily Chronicle*, whilst further down, discernible by the figure of Atlas, are the offices of *The World*.

The absence of bustle in our modern image is principally down to the fact that the photograph was taken at the weekend – but even on a weekday, activity will no longer be related to news-gathering. After 300 years as the home of journalism, the mass exodus from the 'Street of Shame' to the Docklands started in 1986 with the departure of the *Sun* and the *News of the World*, and ended fifteen years later when Reuters relocated from No. 85 Fleet Street (on the extreme right of our modern photo).

On the site of the old *Daily Telegraph* building is Peterborough Court, the thirteen-storey home of the Goldman Sachs European Headquarters. Next door, the building with the black glass frontage is the *Daily Express* building, built in 1932 by Sir Owen Williams. The now Grade II* listed building is one of the finest examples of art deco architecture in London.

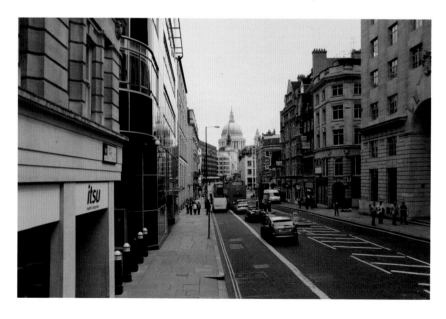

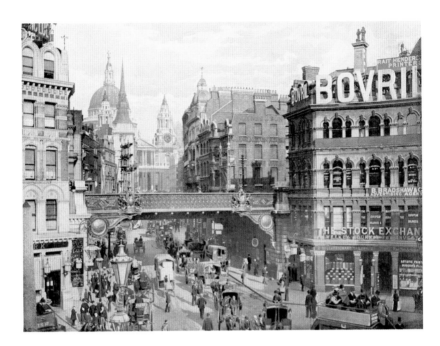

Ludgate Circus

Formed by the meeting of Fleet Street, Ludgate Hill, Farringdon Street and New Bridge Street, the circle of Ludgate Circus was constructed between 1864 and 1875. The view we see here is looking east from Ludgate Circus, past the railway bridge towards St Martin's Church and St Paul's Cathedral.

The railway bridge which connected Holborn Viaduct Station to the new Ludgate Hill Station was built in 1865 by the London, Chatham & Dover Railway Co. In 1878, one commentator let rip: 'Of all the eyesores of modern London, surely the most hideous is the Ludgate Hill Viaduct.' If the writer was hoping that the bridge would come down, they were in for a long wait. Ludgate Hill Station closed in 1929 but the bridge was not dismantled until 1990, to enable the subterranean construction of the City Thameslink Station.

The huge Bovril advertising hoardings on the south-east corner survived well into the 1920s, but now all of the buildings to the right of our picture have been replaced by Procession House, a 10,000sqm office development completed in 1999. The north-east corner of Ludgate Circus has fared rather better, although the King Lud pub which occupied this site for 135 years didn't quite make it, closing in 2005.

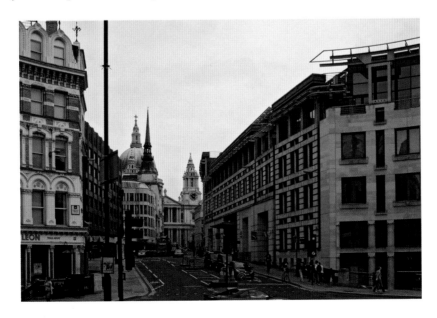

The Memorial Hall, Farringdon Street

The Memorial Hall was designed by John Tarring in the Gothic style, and built in the 1870s on the site of the old Fleet Prison. The hall has significance for both the political left and right. On 27 February 1900, a group calling itself the Labour Representation Committee, which included delegates from sixty-two trade unions, passed a resolution stating that it was in favour of establishing an independent party in parliament to represent the interests of the working masses. Whilst the significance was not recognised at the time, this vote heralded the birth of the Labour Party. A very different political meeting was held in 1947, when more than fifty nationalist groups came together to form Union Movement and invited Sir Oswald Mosley to be their leader.

In 1969, the Memorial Hall was knocked down to be replaced by 9,248sqm of bland office block called Caroone House. This, in turn, was demolished in 2004 and replaced in 2007 by 17,165sqm of bland office block called Ludgate West. With the Memorial Hall gone, we have to rely on the building to the left of our view to orientate the picture. Standing at the corner of St Bride Street, in 1897 this was a bank and now it is let as offices.

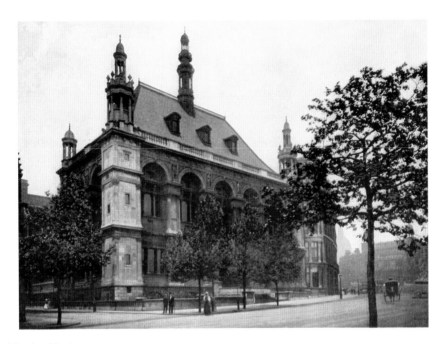

The City of London School

In 1897 this building, built at the Blackfriars Bridge end of Victoria Embankment in 1883, was the City of London School. The school can be dated back to 1442 when John Carpenter, Henry V's Town Clerk of London, bequeathed property to enhance the education of four boys. The school led a nomadic existence for many years and the pupils were not housed in their own building until 1837 in Milk Street, just the other side of St Paul's Cathedral (the main dome of which can be seen in both photographs).

The sunken roadway visible in the modern photograph is the entrance to the Blackfriars Underpass that was cut into the embankment in the 1960s. At that time, the school was still in situ. In 1986 it moved into new buildings a few hundred yards further east along the river, now nestled close to the Millennium Bridge.

The old school currently fronts offices of the financial services firm J.P. Morgan. The building to its right in the modern photograph is Unilever House, which replaced De Keyser's Royal Hotel (seen in the early photograph) in 1931.

Old boys of the school include the writers Kingsley Amis and Julian Barnes, the former prime minister H.H. Asquith, the former England cricket captain Mike Brearley and the humorist Denis Norden.

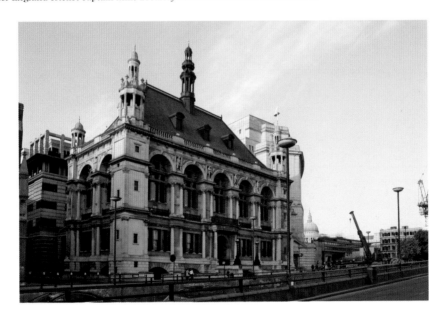

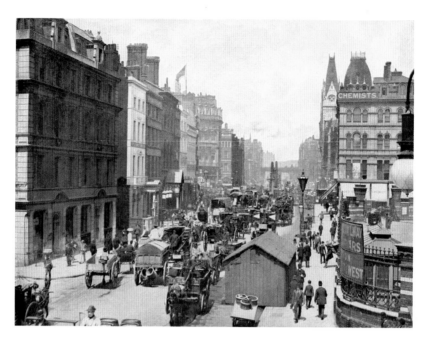

New Bridge Street, Blackfriars

'New Bridge Street,' informs the Victorian book, 'is a busy thoroughfare leading from Blackfriars Bridge to Ludgate Circus, at the east end of Fleet Street.' The street was built over the sewer formerly known as the Fleet River in 1764, at the same time as the first Blackfriars Bridge was being built.

The west of Ludgate Circus is marked in both images by the building in the centre – the letters 'KS TOURS' can be distinguished at the top of the building in the early photograph. From 1873 to 1926 this was the headquarters of the travel agents Thomas Cook Ltd. The ground floor currently houses a clothes shop. There are two obelisks visible in the centre of the Victorian Ludgate Circus. One of these was disposed of before it slid into the gentlemen's toilets below, but the second was saved and can still be seen in nearby Salisbury Square.

The turreted building in the old photograph, to the left of the chemist's sign, is the former Congregational Memorial Hall. It survived until 1969, but many of the Victorian buildings were destroyed in the Blitz. One survivor, however, is the building to the left of Thomas Cook. It was a pub shortly after Ludgate Circus was completed in 1875 and, now called the Albion, has remained so since then.

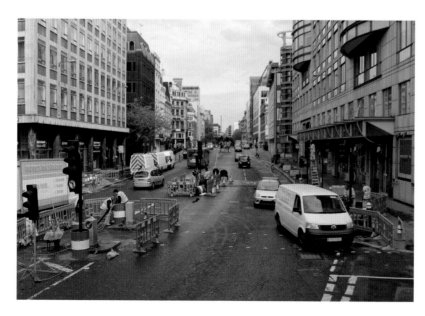

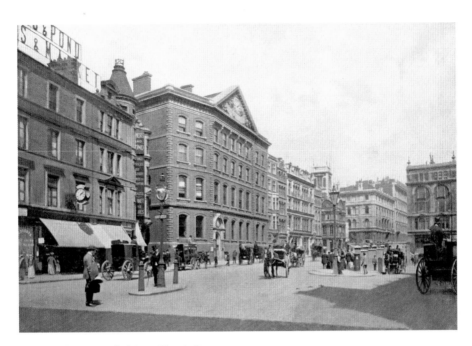

The Times office, and western end of Queen Victoria Street

At first this street scene looks completely different, but in fact there are two clear points of reference to orientate the modern photo. At the bottom of the Victorian picture is the long shadow of the railway bridge crossing Queen Victoria Street, and secondly the church tower of St Andrew-by-the-Wardrobe and the two buildings beyond it. These buildings are the British & Foreign Bible Society, built in 1868, and the General Post Office building, built in 1890 as a mail sorting house then reborn in 1902 as the Faraday Building, home to the first telephone exchange. Everything in between has been replaced by the new corporate headquarters for Mellon Bank, which was completed in 2003 by the architectural practice of Skidmore, Owings & Merrill. This 33,000sqm financial centre was restricted to six storeys, on account of its position on one of the strategic view corridors which protect long-distance views of St Paul's Cathedral. One of the buildings replaced by the Mellon development was old offices of *The Times* newspaper, and behind it the presses in Printing House Square. The *Queen's London* reported that members of the public were able to go and watch the paper being produced, as long as they provided a 'written application, accompanied by a note of introduction or a reference'.

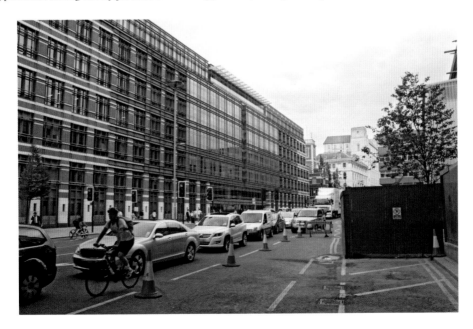

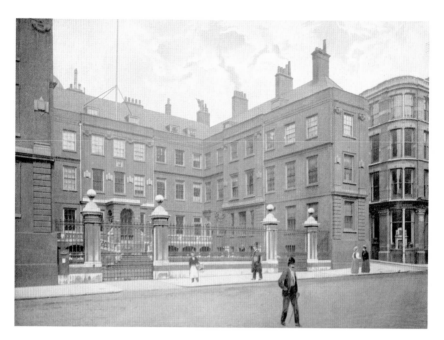

The College of Arms

The College of Arms is situated due south of St Paul's Cathedral on Queen Victoria Street – the curve of the cathedral's dome is just visible above the centre of the college in both images. Its function, according to the Victorian book, is to preserve 'the pedigrees and armorial bearings of old families, and in granting, for a fee, arms to new ones'.

The college provides this same service today, for English, Welsh, Northern Irish and Commonwealth families (although not Scottish, the clan system being entirely the responsibility of Scotland). Their website makes clear that: 'There is no such thing as a coat of arms for a surname.' People of the same surname will often be entitled to completely different coats of arms, and many people of that surname will be entitled to no coat of arms; coats of arms belong to individuals.

The 1683 building in our photographs was built with its entrance on Benets Hill, after its predecessor was burned down in the 1666 fire. Its existence was threatened by the 1860s' creation of Queen Victoria Street, but after protests it was saved – although re-modelling work resulted in the loss of its south-east and south-west wings, amongst other less drastic alterations. The new gates, formerly resident at Goodrich Court in Herefordshire, were erected in 1956.

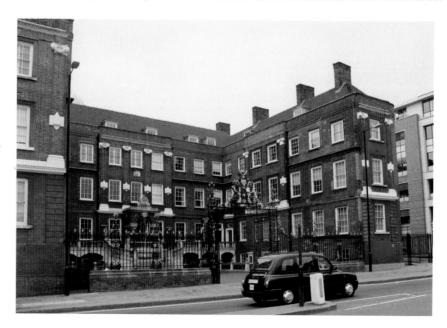

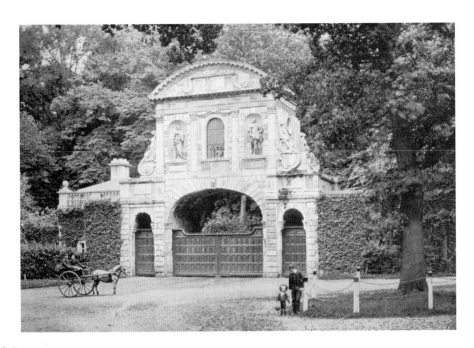

Temple Bar

This is a strange 'then and now' picture, with the Temple Bar gate almost unchanged but the locations of the two pictures more than 15 miles apart.

Temple Bar is the last surviving gateway to the City of London. Built by Wren in 1670, it stood at the junction of the Strand and Fleet Street for just over 200 years, until the pressures of nineteenth-century London life required its removal as part of a road-widening scheme. In its place, the Temple Bar Memorial was erected in 1880, and can still be seen there today. The Corporation of London had not wished to get rid of the gate, but was unclear what to do with it; consequently, for a decade it lay in pieces in a yard off Farringdon Road. In 1888 it was sold, and all 400 tons of stone were carted up to Hertfordshire, where it was reassembled as the gateway to Theobalds Park. Here it remained for over a century, gently sliding into ruin. In 1976, the Temple Bar Trust was formed with the mission to return the gate to the City of London. It cost £3 million and took twenty-eight years, but in November 2004 Temple Bar was officially opened by the Lord Mayor of London in its new home at Paternoster Square.

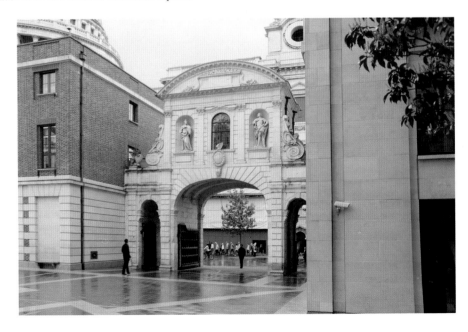

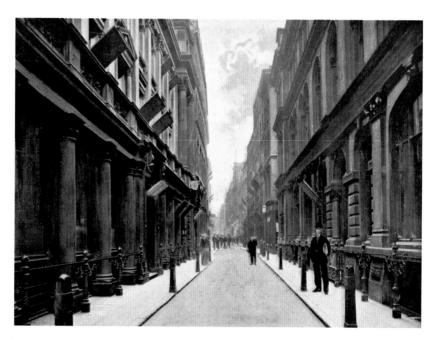

Paternoster Row

The Second World War destruction of the centuries-old area of London next to St Paul's Cathedral called Paternoster Row is often viewed as something of an architectural disaster. It is a surprise, then, to read that in the opinion of the Victorian writers, 'the Row, alas, has been built out of all recognition'.

Both photographs look eastwards, from the corner of Ave Maria Lane and Amen Corner. In 2012 Paternoster Row is called Paternoster Lane, and leads into the modern plaza that is Paternoster Square. The large sculpture on the right of today's picture doubles as a cooling vent. Near its position in the Victorian image stood the Chapter Coffee House – it's the building next to the man standing in the road, on the corner of a small alleyway called Paul's Alley. The Coffee House was a renowned establishment. Elizabeth Gaskell, writing in 1857, said that a century earlier it was 'the resort of all the booksellers and publishers, and where the literary hacks, the critics, and even the wits, used to go in search of ideas or employment'. When she visited, however, she described Paternoster Row full of 'dull warehouses ... if they be publishers' shops, they show no attractive front to the dark and narrow street'.

The 1940 bombs that necessitated complete rebuilding are said to have destroyed 6 million books.

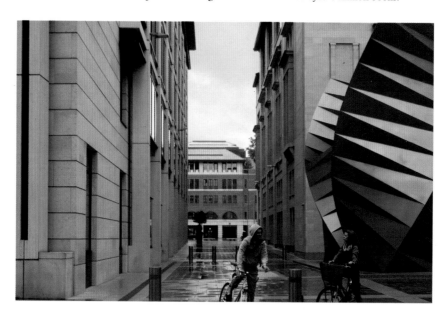

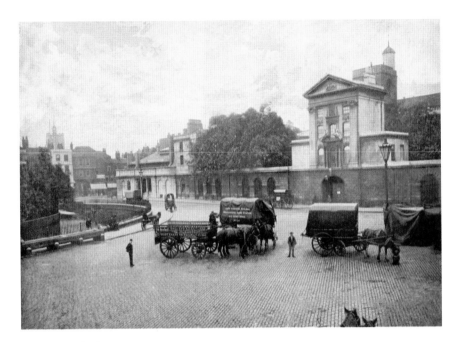

St Bartholomew's Hospital – the west entrance

St Bartholomew's Hospital, south-east of the Smithfield Market, was founded in 1123 and is the oldest hospital in London. The gateway that dominates both photographs was built in 1702. The statue above the entrance is of Henry VIII, who helped re-establish the hospital towards the end of his reign, though not before dissolving the adjoining priory.

The latter part of the 1800s was a time of great progress for the hospital, which reflected the advances in medicine at the time. Between 1875 and 1893, St Bart's appointed for the first time an anaesthetist, an aural surgeon and a pathologist, and opened a nurses' school and an electrical department. In 1897, the building to the left of the gate was the casualty and out-patients' department. Now newly refurbished, it houses the hospital's Centre for Reproductive Medicine and Sexual Health Service.

On the left of both images is the edge of the Smithfield Rotunda Garden; it has been a public garden since 1872. From 1133 until 1855, for three days from 24 August, the site and the surrounding area were the home of Bartholomew Fair, immortalised in Ben Jonson's early seventeenth-century play of the same name. In 1305, festivities kicked off a day early with the hanging, drawing and quartering of William Wallace.

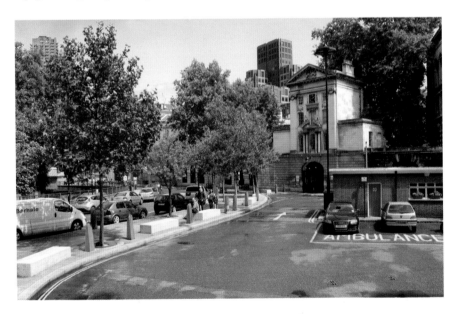

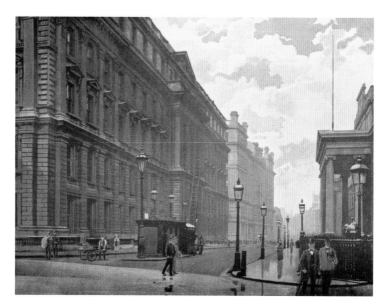

St Martin's-le-Grand: view of the Post Office buildings
In 1897, St Martin's-le-Grand, running northwards away from the nearby St Paul's, was closely associated with the General Post Office. The headquarters was in the building on the right of the early photograph, the lifespan of which only barely exceeded Victoria's reign – it was opened in 1829 and demolished in 1912. Its inception, however, heralded the beginnings of the A1, the road from London to Edinburgh that starts at this junction. In 1830, of the twenty-seven coaches leaving London nightly to deliver letters around the country, twenty left from here. In early January 1840, crowds heaved into the building to send letters by the new penny post method.

In the centre of both views is one GPO building that has survived. When the Victorian photograph was taken, it was only a couple of years old. Its purpose then, says the text, was 'for the accommodation of the Central Savings Bank, and of the Postmaster-General and other high officials'. It is now owned by a Japanese financial conglomerate. The building on the left in the Victorian image was built in the early 1870s, and housed the Administration Office and the Telegraph Department. In 1896, Guglielmo Marconi first publicly transmitted radio signals from its roof. The modern building on the same site is the headquarters of British Telecom.

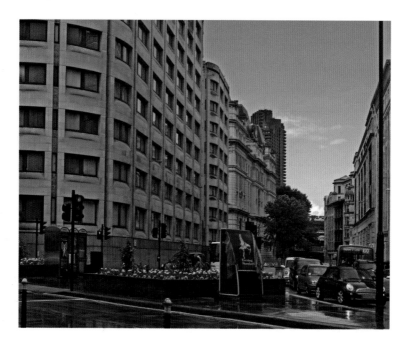

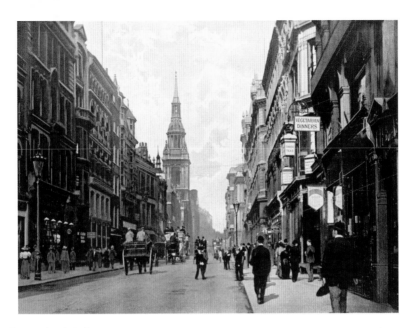

Cheapside with Bow Church, looking west

Cheapside was extensively damaged during the Blitz, and particularly during the 'Second Great Fire of London', a name used to refer to one of the most destructive air raids over the nights of 29 and 30 December 1940. The raid and the subsequent fire destroyed an area greater than that of the 1666 Fire of London.

The apparent sole survivor in our current-day photo is the Church of St Mary-le-Bow. The church was rebuilt in 1671 after the Great Fire, and, with a tower 235ft high, is considered to be one of Wren's masterpieces. The view is, however, deceptive, as much of the building was destroyed by a German bomb on 10 May 1941. In 1950, it was designated as a Grade I listed building; restoration began in 1956 and in 1964 the church was re-consecrated.

According to tradition, only those born within the sound of Bow bells are properly called 'cockneys', so, using this strict definition, the first post-war cockney was not born until 1961 when the bells were reinstalled.

On the right-hand side of the street can clearly be seen a sign advertising 'Vegetarian Dinners'. Whilst vegetarianism may seem like a much more modern idea, the Vegetarian Society held their first meeting in 1847, and by 1897 had a membership of about 5,000.

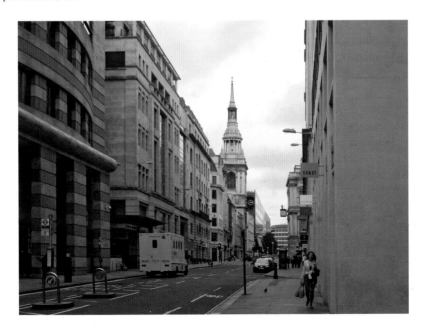

The Guildhall

The Guildhall in the City of London has seen many changes since building work began in 1411 (replacing an earlier building that may have been there since the eleventh century), although the hall's Gothic porch, completed in 1430, has survived through it all. The modern Guildhall website relates that, 'in an era when the Lord Mayor of London rivalled the monarch for influence and prestige, this was where he and the ruling merchant class held court.'

The building suffered much damage in the 1666 fire, although the outside walls survived. The turrets at the corners were added in the 1860s. The hall was severely damaged again in the Second World War, though the medieval portions of the hall survived relatively intact.

The left-hand building in the Victorian photograph was the Guildhall Police Court, 'where a man has evidently been summoned to answer a charge of cruelty to the horse standing in the square', supposes the Victorian book. The poster on the right, on the old library, is advertising a Grand Ball for the cause of Twickenham's Metropolitan and City Orphanage. The library was rebuilt in the 1980s, its position readjusted because of the discovery of the foundations of Roman London's Amphitheatre.

Nowadays, the hall is still the City of London Corporation's home. It also hosts banquets for foreign heads of state and royal occasions.

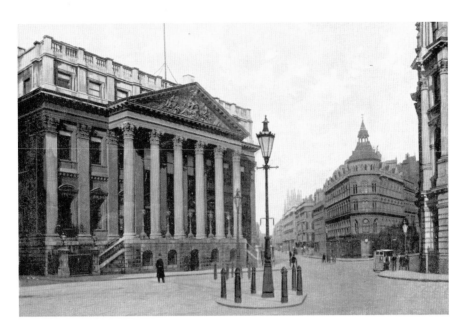

The Mansion House at early morning

The daybreak time of this photograph provoked a wistful description from the Victorian writers: 'It is necessary to get up very early in the morning to see the Mansion House so deserted as it appears in this view ... There is no time like sunrise, or soon afterwards, for seeing the beauties of London; for then the attention is not constantly distracted by the noise of traffic and by jostling crowds, and the atmosphere is often surprisingly clear.' We are also told that the figures standing on the corner of the street, where an entrance to Bank tube station is today, are at a coffee-stand. The equally sparse modern photograph was taken on a Saturday afternoon.

The Mansion House is the official year-long residence of the Lord Mayor. Sir Crisp Gascoyne was the first mayor to move into George Dance's new building in 1752, although work on the interior continued for a short while longer. The flight of steps on the left, states the 1897 book, lead to the police court. There are eleven cells beneath the building – ten for men and one for women. The leading suffragette Emmeline Pankhurst was confined in the latter cell.

On 22 January 1901, it was from a Mansion House window that the Lord Mayor announced the death of Queen Victoria.

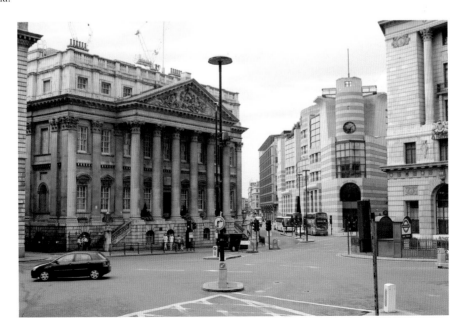

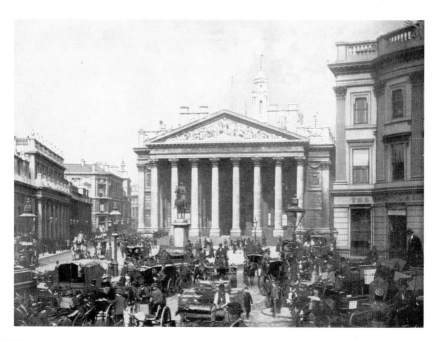

The Royal Exchange

In the opinion of the Victorian writers: 'Few edifices in London are more imposing than the Royal Exchange, with its stately Corinthian portico.' This building, opened by Queen Victoria in 1844, is the third exchange to occupy the site – the first was proclaimed open for the merchants of the city by Elizabeth I in 1570. Both previous exchanges were the victims of fire – the first one of 1666's Great Fires.

At the Victorian exchange, the book continues, 'business is transacted of an afternoon, the attendance being greatest on Tuesdays and Fridays'. Despite this part-time approach to the working week, the open space in front of the exchange was considered 'perhaps the busiest in all the City'. The equestrian statue overlooking this open space is of the Duke of Wellington. He rides the same as a victorious Roman general, without saddle or stirrups.

The Royal Exchange survived the bombs of the Second World War, though trading ceased to exist within it. In 1953, to celebrate the Coronation of Elizabeth II, the newly established Mermaid Theatre performed Shakespearean plays in the courtyard. Nearly forty years later, the Queen visited to open the newly refurbished building. Since 2001, the Royal Exchange has been a centre of 'luxury shopping and dining ... home to many of the world's finest luxury brands'.

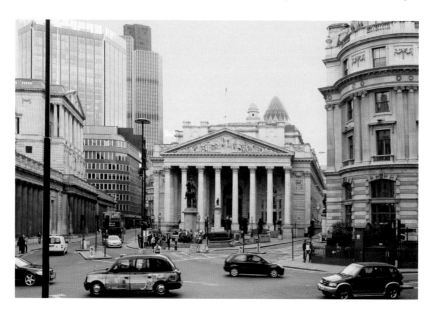

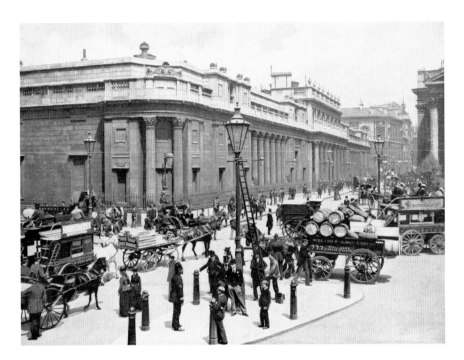

The Bank of England

The Bank of England – based on the idea of a public loan – was founded in 1694, as a result of William III's realisation that he was fast running out of money to finance his fight against the French. The bank first appeared in physical form in 1734, on the same Threadneedle Street site of the present building. At the end of the eighteenth century, the building was rebuilt to extend to the 3.5 acres of space it has covered ever since. This structure, designed by Sir John Soane, survived until the 1920s and '30s when, over a fourteen-year period, it was rebuilt again.

The outer wall of Soane's building, known as the curtain wall, was retained – from the street it looks as if the bank has merely had layers placed on top. The original book notes that, 'For the sake of security, there are no windows in the outside walls.' During times of national financial turmoil, it was not uncommon for the bank to be attacked.

It is claimed that, in 1897, 'Every day 15,000 new bank-notes are printed.' In the 2009/10 tax year, over 375,000 banknotes were produced every day.

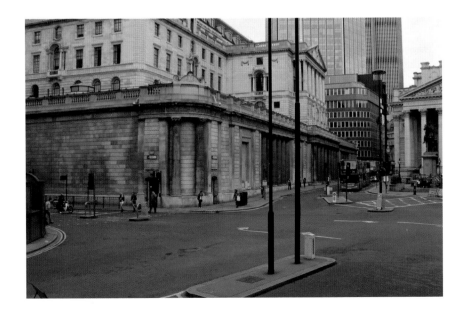

Queen Victoria Street

Queen Victoria Street, completed in 1871, was the seventh and final spoke of the streets that radiate out from Bank, providing both a new road and an extension to the District line which was laid at the same time. Once completed, the City of London had assumed a street pattern which still largely remains today. There is also much familiar about this view from Mansion House, looking up towards the city.

To the left we have the Church of Saint Mary Aldermary (St Mary the Elder). The original church was one of eighty-nine destroyed by 1666's Great Fire. It took thirteen years before finances became available and the church was rebuilt, the last of Wren's churches within the City of London built in the Gothic style.

To the right of the picture stands Albert Buildings, completed in 1869; immediately behind is Bucklersbury House, completed in 1958. Described by architectural critic Ian Nairn as 'the null point of architecture', it is set to be demolished and replaced with a new development called Walbrook Square.

In the background of the modern photo is Tower 42, still known to many as the NatWest Tower. Completed in 1980 at a cost of £72 million, Tower 42 was the first skyscraper erected in the City of London.

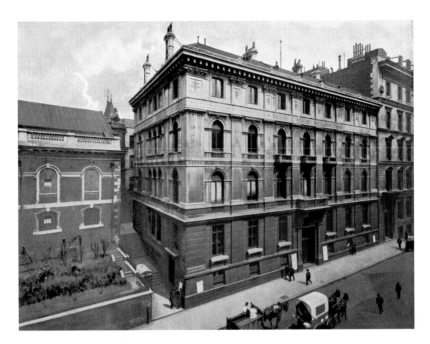

The British and Foreign Bible Society's house

The British and Foreign Bible Society (BFBS) was founded in 1804 with a mission 'to encourage a wider circulation of the Holy Scriptures at home and abroad'. For more than 200 years it has done this by translating and printing the Bible in phenomenal numbers.

The BFBS commissioned this building as their new headquarters in 1868 and were based here for 117 years, before deciding to relocate to Swindon. In 2006, the Church of Scientology purchased the building for £23 million, as the new base for their UK headquarters.

The church on the left in our pictures is St Andrew-by-the-Wardrobe, which acquired the unusual name from its proximity to the Great Wardrobe, the building where King Edward III kept his state robes. Burned to the ground in the Great Fire, this was the last of the churches to be rebuilt by Wren. St Andrew's was destroyed for a second time during the Blitz, but was restored again in a faithful reconstruction completed in 1961. Neither the building nor its location are particularly glamorous, and even the church's own website acknowledges that it is easy to overlook: 'Like a well-bred lady fallen on hard times, the church waits with quiet dignity for someone to stop and pass the time of day.'

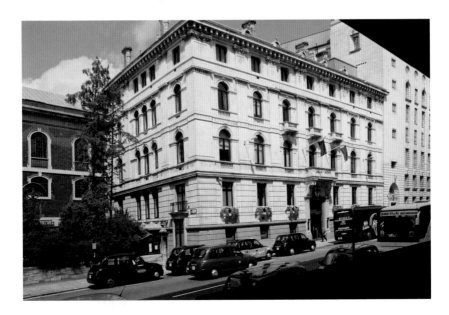

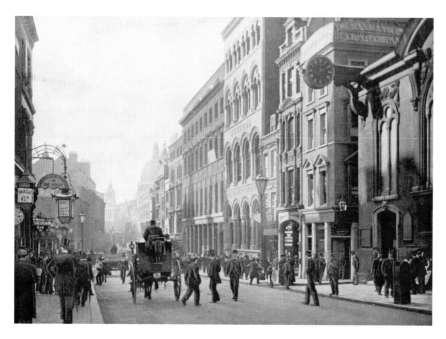

Cannon Street, looking west

The Victorian book's initial subject of interest is the Wren-designed St Swithin's Church, the building on the right of the old picture with the clock. Incorporated into a wall of the church was the London stone, 'believed to be that from which distances on the British roads were measured during the Roman occupation', though its origin is uncertain – William Blake, for example, believed it was the site of Druid executions. The church was destroyed in the Blitz, but the stone survived and its location can be seen in the modern photograph. It lies behind the street-level iron grille visible at the front of the building, far right: until recently the Bank of China.

Two buildings further along is another survivor; 103 Cannon Street, built in 1866, is currently an All Bar One bar. In 1897 it was a home of the General Assurance Co. In the modern photograph, building work has opened up our view of St Paul's Cathedral.

The pub on the left of the Victorian image was the Dyers Arms. It's not clear whether the 'Umbrellas recovered in one hour' (or is it re-covered?) sign belongs to the pub, the adjacent Cannon Street Station or an entirely separate establishment.

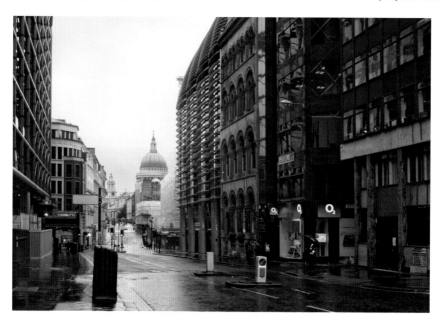

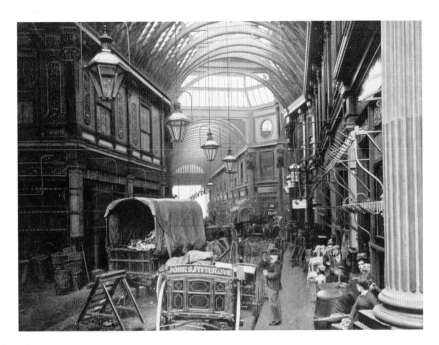

Leadenhall Market

At the time the photograph was taken for the Victorian book, the city's Leadenhall Market was 'the chief market for poultry and game in London ... well-known to the "fancy" who deal in dogs'. The poultry connection dates back to the fourteenth century, when the market was a designated place for non-Londoners to sell such produce. In 1377, the scope was widened to include cheese and butter.

In the 1666 Great Fire, the market was burnt down, together with the mansion it was named after – a hall with a lead roof. A new market centred around three large courtyards. The new beef market was so fabulous that the Spanish ambassador was moved to declare that 'more meat was sold therein than in all the Kingdom of Spain'.

The seventeenth-century market was replaced by Horace Jones's current structure in 1881 – 'one of the sights of the metropolis', proclaims the early book. The hooks outside the shops in their photograph were used to hang meat. Though now removed from the near shops, they are still there further along. The market, extensively renovated in 1991, currently hosts a variety of events and is a place in which to shop, eat and drink – including at the 200-year-old Lamb Tavern, outside which city workers are congregating in our modern photograph.

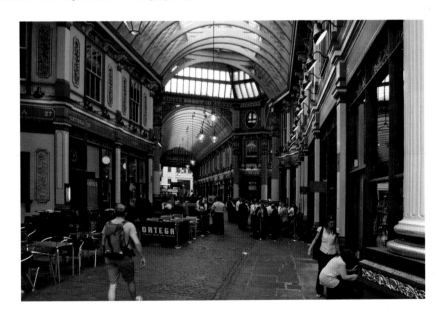

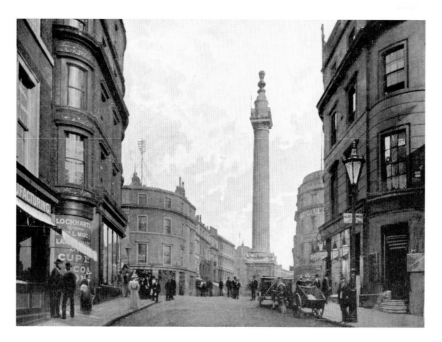

The Monument

The road names are the same, but the only feature that has survived from 1897 is the Monument itself, designed by Wren, and the tallest isolated stone column in the world. The view is from Arthur Street, with London Bridge off to the right, down King William Street.

The Victorian text states confidently that 'every schoolboy knows the Monument was erected in 1671–7 to commemorate the Great Fire, which in 1666 had destroyed property valued at between seven and eight millions; and its height, 244 feet, is supposed to represent its distance from the spot in Pudding Lane where the flames first appeared'. Pudding Lane, 202ft eastwards according to the inscription at the Monument's base, still exists. The lengthy six-year building span was as a result of difficulties in getting sufficient amounts of Portland stone of the right dimensions.

The iron cage, visible near the top in both photographs, was added in the 1840s as a consequence of the building's propensity for attracting suicides – the balcony is accessible up a winding staircase of 311 steps. Above it is a gilt bronze vase of flames. An earlier plan, to top the Monument with a statue of Charles II, was dropped after the King opposed the idea, with the reasonable observation that he had not started the fire.

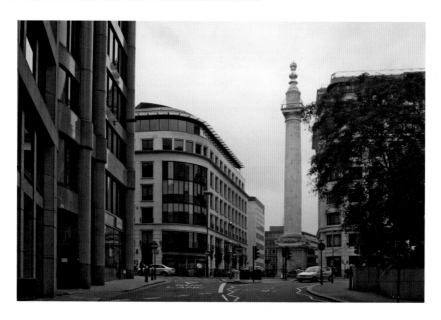

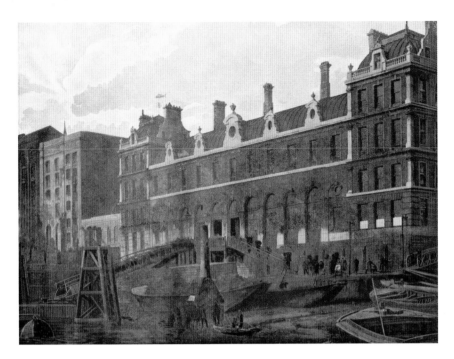

Billingsgate Market

This building dates from 1877, but there has been a market of some form here for at least 1,000 years. Billingsgate Market is synonymous with the selling of fish, and records reflecting the association go back as far as the 1200s. One reason for the market's growth was that its North Bank location is immediately to the east of London Bridge. The passage under the many-arched bridge had a reputation for being hazardous, and the more prudent course of action was to moor vessels in the wharf below it. The Victorian book describes the market thus: 'The business of the Market – which should be visited at five o'clock in the morning by those who do not object to "the ancient and fish-like smell" – is carried on in the great hall; in the wings, each surmounted by a weathercock in the shape of a gilt fish, are taverns.'

The supposed convenience of its riverside location, however, was not matched by conveniences in terms of transportation of fish beyond the market – even in the 1880s the impracticalities were noted. It wasn't until 100 years later, however, that the market finally moved to a new home on the Isle of Dogs. The old building (refurbished by Richard Rogers) is now an event management centre.

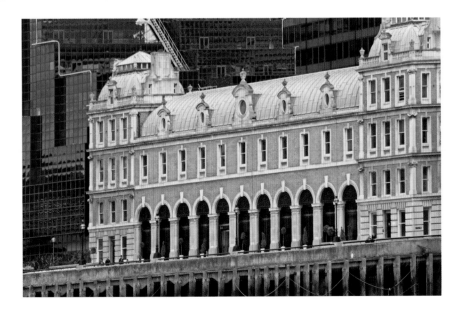

WEST LONDON

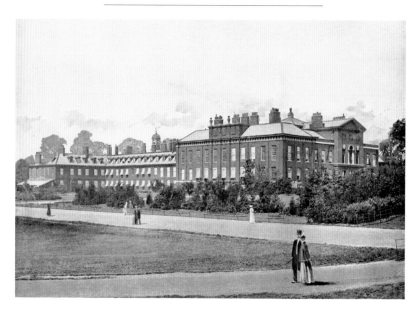

Kensington Palace

Nineteenth-century essayist Leigh Hunt described 'Windsor Castle as a place to receive monarchs in, Buckingham Palace to see fashion in, and Kensington Palace ... to take tea in'. This reflects a view of Kensington as the homely palace, or, as *Queen's London* described it, 'a plain brick building, of no particular style or period'.

On 24 May 1819, Victoria was born here and lived in the palace for twenty-two years until her Coronation. This was also where she met her beloved Prince Albert, and it was she who first opened Kensington Palace to the public in 1889. In recent times, the palace is most strongly associated with Princess Diana, who had apartments here from 1981. After her death, it became a shrine for mourners, whose flowers covered almost an acre.

Our photo shows that Kensington Palace is not looking its best right now, as it is halfway through a £12 million project to create a new landscape. 'For a long time,' the palace website acknowledges, 'the palace has been separated from its surrounding park and the tall railings that surrounded it made Kensington appear closed and even forbidding.' By the time it is completed in the summer of 2012, 'Lost views of Kensington Palace will be restored and the design will unite the palace with Kensington Gardens.'

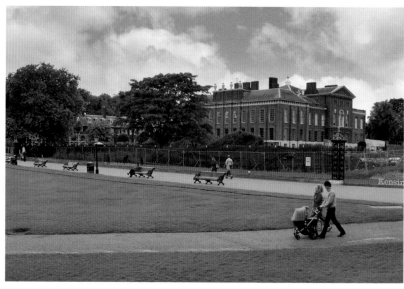

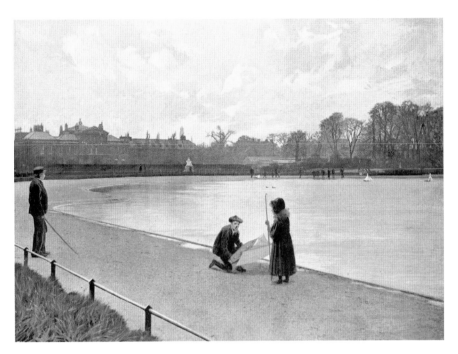

The Round Pond, Kensington Gardens

Kensington Gardens refers to the area of Hyde Park in between the Serpentine Lake to its east and Kensington Palace to its west. They have been there in some form since at least the late 1600s. The Round Pond that is the focus of both photographs, with the rear of Kensington Palace in the background, was created in 1728, the same year that the gardens were moulded into the form they still hold today, at the instigation of Queen Caroline (George II's wife), an enthusiastic landscape gardener. 'Without doubt the most popular part of the surprisingly rural Kensington Gardens is the Round Pond,' states the Victorian text. 'In the summer it is used for model-boat sailing, an amusement that has its fascination for adults as well as for children; and in the winter, when frozen over, its waters are thronged by skaters.'

Another creative member of royalty was one of Queen Victoria's daughters, the liberal-minded Princess Louise. The large, shimmering figure in the near centre of the early photograph is a statue of Queen Victoria, sculpted by Louise to commemorate her mother's 1887 Golden Jubilee. The statue, currently behind meshing, stands out less in the modern picture. Princess Louise died in the palace in 1939, aged ninety-one.

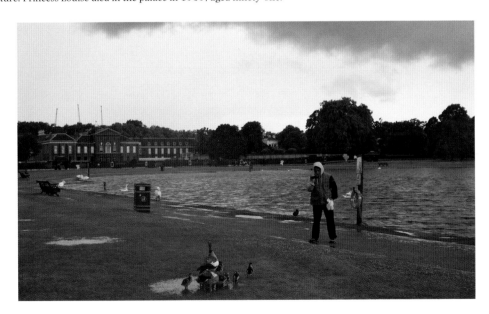

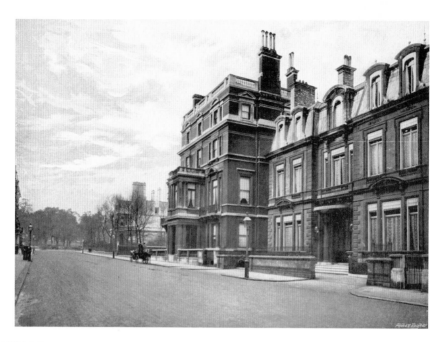

Sir John Millais's house

Millais's house in Palace Gate, Kensington, was custom-built for the successful artist in the 1870s as a family home and a studio. It is the building in the centre with the large porch. The studio was at the back, 'a large, lofty, and massive room ... with walls of Pompeian red, almost covered with Beauvais tapestry, and with oak pilasters rising to the ceiling on either side of the window and of the mantelpiece'. Millais died in 1896, probably shortly after the Victorian photograph was taken – indeed, the text refers to Millais in the present tense. The flag hanging outside the building now is the Zambian flag, for it is currently the home of the Zambia High Commission.

Beyond Millais's house in the Victorian photograph is an ill-starred building called Thorney House, which was demolished in 1905, barely thirty years after it was built and without having being used by the person who commissioned its existence, the Duke of Bedford. The block of flats that replaced it were themselves demolished in 1972. The current building contains luxury serviced apartments.

Nearest to us is a building built at the same time as Millais's house, for a young German shipping merchant called Paul Hardy Nathan. It is currently the South Korean Embassy.

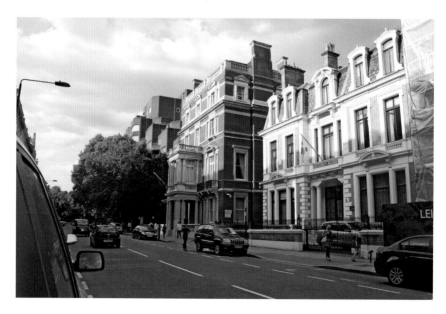

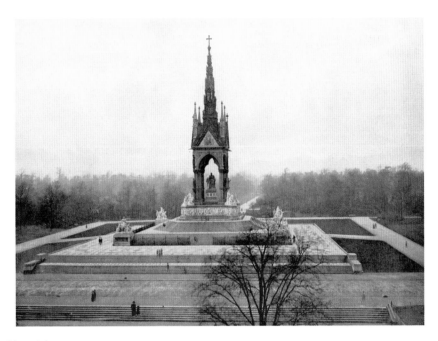

The Albert Memorial

Officially titled the Prince Consort National Memorial, this 53m-high celebration of Victorian achievement, and tribute to Victoria's beloved husband Albert, was a big hit with the authors of *Queen's London*: 'It is resplendent in every detail, a mass of gilt, mosaic, and coloured stones. The colossal bronze-gilt figure of Prince Albert himself, under the Gothic canopy, is by Foley. On the projecting pedestals of the clustered granite columns are marble groups, representative of Agriculture, Manufacture, Commerce, and Engineering.'

The Albert Memorial looks as good today as when it was unveiled in 1876. This is, however, only due to recent renovation work. The extravagant gilt on the memorial had been removed in 1914 (theories as to why this was done include: to reflect public feelings about Albert's German ancestry, and to avoid the attention of passing Zeppelins!). Following decades of neglect, by the 1980s the monument was close to collapse. English Heritage included the Albert Memorial on their first Buildings at Risk Register, published in 1991.

For most of the 1990s the memorial was shrouded in scaffolding, before being officially unveiled by Queen Elizabeth in 1998. At a cost of £11 million, even allowing for inflation the renovation had cost £3 million more than the original build. However, the results are spectacular.

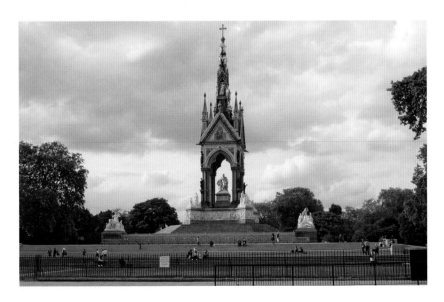

Albert Mansions in Kensington Gore

Situated on Kensington Gore next to the Albert Hall, Albert Mansions are thought to be the first purpose-built mansion blocks in London. They were designed by Norman Shaw, and built in three phases between 1879 and 1886. Unlike some other European cities, such as Paris, London had no tradition of upmarket apartment blocks – but between the start of the century and when Shaw started building, the population of London increased fivefold, and with space in Central London at a premium, a demand for apartments was created.

The Queen Anne revival style of the mansions was based on English and Flemish architecture of the early eighteenth century, built in red brick with tall chimneys and Dutch gables. The flats proved extremely popular and were widely copied across London. Their popularity endures today, particularly with overseas buyers, and this is reflected in the property prices. At the time of writing, Harrods Estates are offering a three-bedroom maisonette in the block for £7.5 million (or £21,800 per square metre), making it one of the most expensive properties in what is officially the second most expensive city in the world (to stop you wondering, Monaco is the most expensive!).

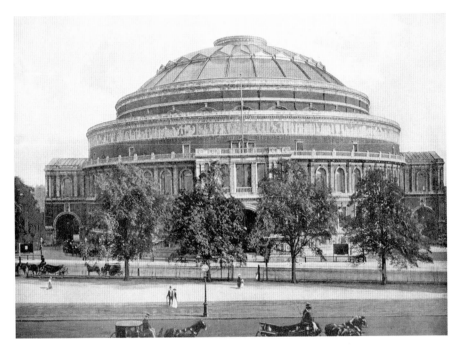

The Royal Albert Hall

'This Hall was erected for the advancement of the Arts and Sciences and works of industry of all nations in fulfilment of the intention of Albert Prince Consort.' So begins the inscription running above the 800ft terracotta frieze that encircles the building. When the Kensington Gore estate was purchased in 1852 as a site for learning and culture, to be financed from the profits of the Great Exhibition, Prince Albert envisaged the inclusion of a versatile building used for concerts, art exhibitions, and conferences. Progress was, however, slow; it was only after Albert's death in 1861 that a public fund was established to fund the Albert Memorial and Hall. The hall was finally completed in 1871 at a cost of £200,000 (including £100,000 from public subscription and £50,000 from the profits of the 1851 Great Exhibition).

Looking at the modern image, little has changed to the front exterior of the building and a Victorian visitor would instantly recognise the distinctive Italian Renaissance style, built from some 6 million red bricks and 80,000 blocks of decorative terracotta. One reason for this is that the hall fortunately suffered very little damage in the Second World War, the story being that German pilots found its distinctive shape to be a valuable navigation aid.

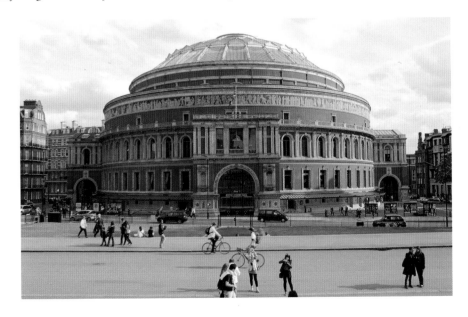

The old Royal College of Music

This building on Kensington Gore, in the shadow of the adjacent Albert Hall, was built in the 1870s under the designer's instructions that its architecture 'should be as different from that of the Royal Albert Hall as to provoke no comparison unfavourable to the school'. The frieze of cherubic characters, piping and drumming their way across the front of the building, give a clue to the school in question. Indeed, the inscription facing us in the earlier photograph, now gone, reads 'Royal College of Music'. That establishment, however, existed solely here for barely ten years. It was initially called the National Training School of Music, and when it opened in 1876 its first principal was operatic composer Arthur Sullivan. The following decade it had its brief run as the Royal College of Music, before yielding to the newly built college a few hundred yards further south in 1894. For a few years the students still used the place for practicing, until 1904 when it became the Royal College of Organists.

The RCO moved out in 1991 and the building is now privately owned. Their name, however, is still above the doorway, and the building's vertical design (resembling organ pipes) gives a hint as to its former use.

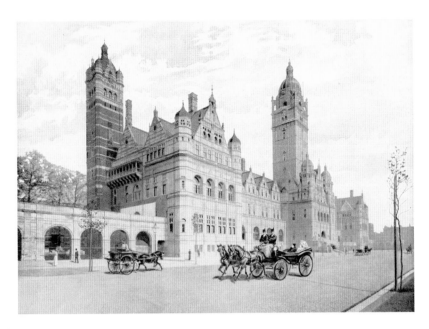

The Imperial Institute

Founded after the Colonial and Indian Exhibition of 1886, in celebration of Victoria's Golden Jubilee, the Imperial Institute was financed by public subscription and built at a cost of £350,000 by T.E. Collcutt. It is Renaissance in style, but, as befits a building intended as a symbol of the British Empire, it also included colonial influences, such as the Indian-style onion domes.

Unfortunately, the Institute was not as successful as had been hoped and, in 1899, the University of London moved in as co-tenants. In 1953, the government announced the expansion of Imperial College, and it became clear that this would involve demolition of the existing Institute buildings; only the 87m Queen's Tower was saved.

Meanwhile, the Commonwealth Institute Act of 1958 changed the name and role of the Institute, and in 1962 it moved to Holland Park. Looking at the modern image, to the left are the Imperial College and Science Museum libraries, whilst to the right is the Wolfson building, home of the Biochemistry Department. The *Queen's London* authors wrote that Collcutt had been inspired by Tennyson's words: 'Raise a stately memorial, make it really gorgeous, Some Imperial Institute, Rich in symbol, in ornament, which may speak to the centuries.' How many would look at Imperial College today and consider it to be 'really gorgeous'?

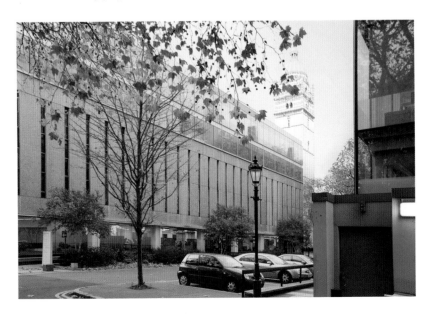

The Natural History Museum, South Kensington

The Natural History Museum, built over a seven-year period on Cromwell Road in South Kensington, opened in 1881. 'Hither were brought the Natural History collections of the British Museum,' says the 1897 book, 'in order to relieve in some measure the congested condition of the national institution in Bloomsbury.' The original British Museum collections centred around the natural history artefacts bequeathed to the museum in the previous century by the eminent collector Sir Hans Sloane. The architect of the building was to have been Francis Fowke, but he died before his plans could be realised. The project was passed on to Alfred Waterhouse, who altered the designs to create a 205m-long terracotta building.

The main change in the modern photograph, apart from the trees which have matured since 1897, is the modern building (barely visible on the extreme right). This is part of a new eastern wing, which was built in 1977. It currently houses the Earth Hall.

In the 1890s, the annual number of visitors to the museum was over 400,000. In 2009/10, the number of visitors was nearly 4.4 million. The museum's current mission 'is to maintain and develop our collections, and use them to promote the discovery, understanding, responsible use and enjoyment of the natural world'.

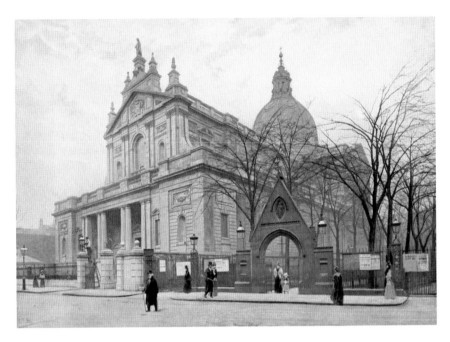

Brompton Oratory

The Congregation of the Oratory of Saint Philip Neri, or Oratorians, was introduced into England by Cardinal Newman. The community in London was founded in 1849, and they built a temporary church on this site in 1854, large enough to accommodate a congregation of 1,200 people.

In 1874, to mark the congregation's silver jubilee, an appeal was launched to build a new church. Herbert Gribble, a twenty-nine-year-old architect and recent convert, won the competition, and it was his designs that were used when building started in 1880. Whilst he would have seen the cathedral in use from 1884, Gribble did not live to see it finished. He was already ill when the southern façade was added in 1893, and he died before the dome was added in 1896. At the time it was built, Brompton Oratory was the largest Catholic church in London, and even today it is only surpassed by Westminster Cathedral. The architectural style and the atmosphere of the church was deliberately Italianate, to bring Rome to a nineteenth-century London congregation that would, for the most part, not get a chance to visit the real thing.

Looking at the modern photograph, the church still shows the benefit of a restoration project carried out in 1984 to celebrate its centenary.

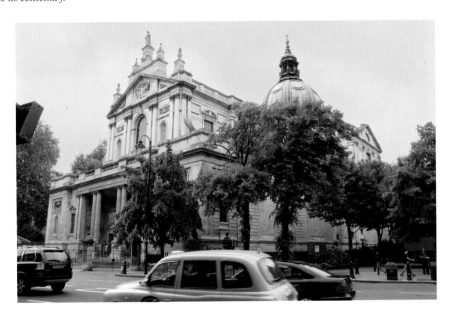

Carlyle House, Cheyne Row, Chelsea

The near house in both of these pictures – which were taken facing the river in Cheyne Row, Chelsea – is Carlyle House, named after its famous resident, author Thomas Carlyle. He moved there with his wife, also a writer, in 1834 and lived there until his death in 1881. This Queen Anne house, built in 1708 along with the others beyond it, was already well over 100 years old when he moved in. 'A right old strong, roomy brick house,' he wrote at one point, '...likely to see three races of these modern fashionables fall before it comes down.' Had he not lived there, perhaps by now it would have come down. It had, however, already become the Carlyle Museum before the Victorian photograph was taken.

'We lie safe at a bend in the river,' he also wrote, 'and see nothing of London except by day the summits of St Paul's Cathedral and Westminster Abbey, and by night the gleam of the great Babylon.' The Carlyles entertained many literary luminaries in their time there, including Dickens, Tennyson (with whom Carlyle smoked in the basement kitchen, blowing into the chimney so his wife would not take offence at the fumes) and the essayist and poet James Leigh Hunt, who didn't have to travel far because he lived next door at No. 22.

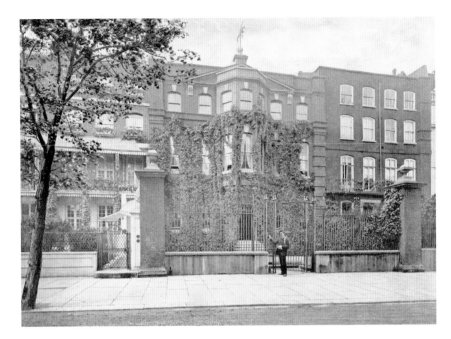

Rossetti's house, 16 Cheyne Walk

'Chelsea,' pronounces the first book, 'by reason of its old-world picturesqueness and its aspect of tranquil comfort, has at all times had attractions as a dwelling-place for authors and artists, and that riverside district of it which includes Cheyne Walk has acquired a special interest from its association with great names.'

The great name whose house is the subject of these images is Dante Gabriel Rossetti. He was a poet and painter, and was one of the leading lights of the Pre-Raphaelite movement. He moved to 16 Cheyne Walk in 1862, after the drug-related death of his wife Elizabeth Siddal. Rossetti loved exotic animals and it was nurturing this passion that helped him cope with his grieving. The back garden of the house became a zoo, and included kangaroos, armadillos, peacocks, jackasses, a raccoon and two wombats, about which he especially enthused. He described the first wombat as: 'A joy, a triumph, a delight, a madness.' The second wombat wasn't long for this world, and when it died he added this verse to a drawing: 'I never reared a young wombat, / To glad me with his pin-hole eye, / But when he was most sweet and fat, / And tail-less he was sure to die.' The wombat was stuffed and put on display in the hallway.

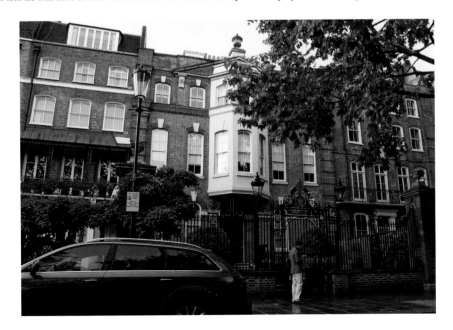

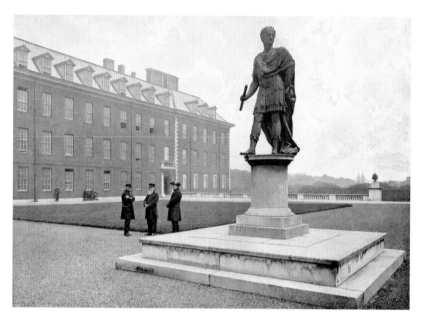

Statue of Charles II at Chelsea Hospital

Chelsea Hospital was designed by Wren and completed in 1692. It was built on the site of a short-lived building that was (at separate times) a theologian college and a prisoner-of-war camp for Dutch and Scottish soldiers. This Romanesque bronze statue of Charles II, by Grinling Gibbons, was erected in the central Figure Court the same year, seven years after the King's death.

The *Queen's London* notes sceptically that the King was induced by Nell Gwynne to found the hospital. The more official record of events is that Charles was likely influenced by Paris's Hotel des Invalides. He laid the foundation stone in 1682 for the hospital that was 'for the relief of such land soldiers as are, or shall be, old, lame, or infirm in the service of the crown'.

It is often recorded that the scarlet uniforms and tricorne hats with which the Chelsea Pensioners are associated are only worn at special occasions and if travelling more than a mile from the hospital. The pensioner we spoke to, however, said that he could wear the uniform whenever he liked, and it was only compulsory when he was over 2 miles from base.

In the distance of the 1890s' photo, mirrored now by chimneys of Battersea Power Station, are towers of the old Chelsea Suspension Bridge.

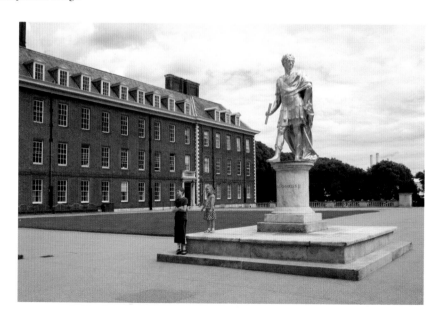

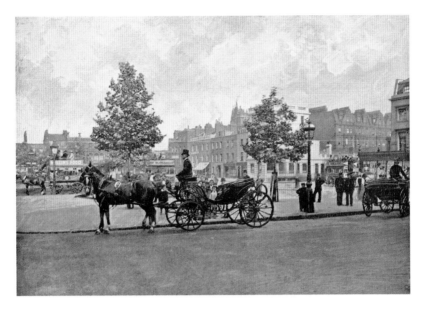

Sloane Square

These views show Sloane Square, facing towards the south-east corner. The advertising signs in the left half of the Victorian photograph (which, if glanced at briefly may appear to be above shops) are on omnibuses standing on the crossroads that existed until 1929, when the roads were replaced by paved stones and a roundabout system was created around them.

In 1897, the square was going through substantial redevelopment, acknowledged by the original book's statement that the square 'still has something of an old-fashioned appearance, notwithstanding the modern residential flats erected here and close by'. Some of these 'modern' buildings on the south side of the square can be seen behind the large central group of curious children. Behind the buildings themselves is hidden further redevelopment that was not without controversy. Around 4,000 lower-class inhabitants were displaced to make way for only 400, who in turn were separated from the 'higher' classes by a mews.

The three-arched windows above the horse's head in the Victorian photograph (just visible beyond the bus) belonged then, as they still do, to the Royal Court Theatre. It was built in 1888, replacing an earlier theatre. After a brief foray as a cinema in the 1930s, the theatre was bombed in the war and rebuilt (with the original façade intact) in 1952.

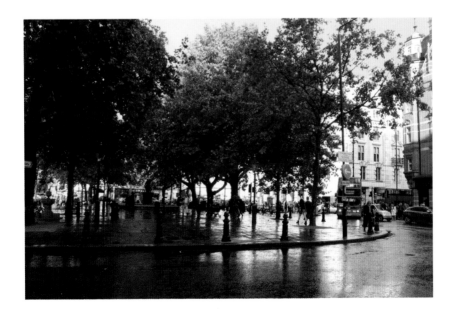

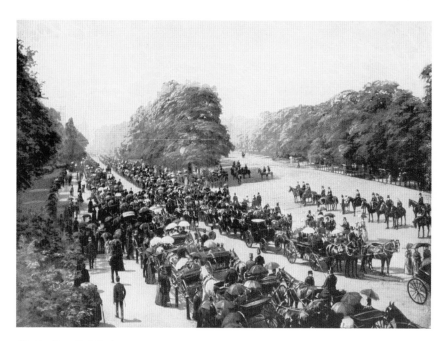

The Drive and Rotten Row, Hyde Park

'Hyde Park,' declares the 1897 book, 'is the largest breathing-space which can be fairly reckoned as belonging to London itself. It was laid out in the days of King Hal' – otherwise known as Henry VIII. The park opened to the public at the beginning of the seventeenth century, save a brief period after the Civil War, when parliament sold the park to three private buyers – one of whom charged extortionate amounts for entrance to his section. The thoroughfare on the left of our photographs was established after the Restoration. This section, South Carriage Drive, is one part of the circular drive that circumnavigates the park.

When William and Mary came to the throne in 1689, they created a processional road called 'Route de Roi', now better known as Rotten Row. Three hundred lamps hung from trees, making it the first lit road in England. This is the road on the right of the images. What looks like a one-off procession on the Drive in the Victorian picture is in fact the regular sight of 'sumptuous equipages drawn by the finest coach-horses money can purchase, and occupied by some of the best dressed and most beautiful women in the world, who drive here at stated hours'. The Row, as now, was used by those 'who prefer horse-exercise'.

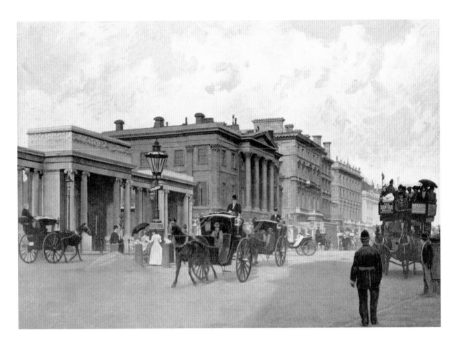

Hyde Park Corner and Apsley House

Apsley House, completed in 1778, is the central building in both photographs, now with the flagpole. It is popularly known as Number One London because, arriving from the west, it was the first house reached after coming through the last tollgate into London. In 1807 it became the property of the Wellesleys – firstly Richard and then his younger brother Arthur, the Duke of Wellington. In 1947, the 7th Duke gave the mansion to the nation, though the family retained some private rooms which they still use today.

'Next to Apsley House,' says the Victorian book, 'is the town residence of Lord Rothschild, while beyond are the mansions of other wealthy men.' Next to Apsley House now is the Park Lane dual-carriageway. Rothschild's old residence and some of the adjoining mansions were demolished in 1972.

Nearest to us – 'a part of one of the most attractive spots in London,' claims the *Queen's London* – is the entrance to Hyde Park. The gateway, built in the 1820s, was intended as an impressive feature viewed as one made the journey up Constitution Hill from the palace to the park. Since 1883, however, when the Wellington Arch was moved from near Apsley House to the top of Constitution Hill because of road-widening, it has been the arch which has stood out.

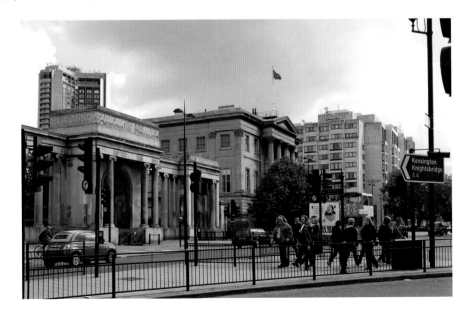

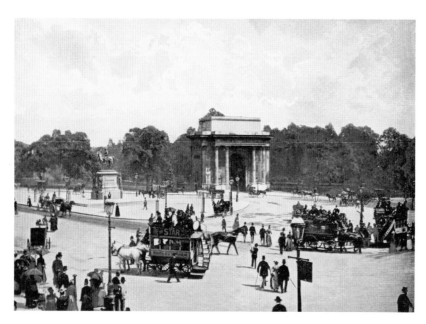

The Green Park Arch, Wellington Place

When comparing the two views of the arch, one change immediately stands out: namely, there is now a colossal bronze sculpture atop of it. Up until 1883, the arch was surmounted by a vast equestrian statue of Wellington himself. That year the arch, built in 1828, was moved a short distance across Hyde Park Corner to relieve traffic congestion. The statue, after a brief dalliance with the threat of meltdown, was moved to Aldershot. A smaller one of Wellington on a horse now stands to the left of the arch.

The present centrepiece, unveiled in 1912, was created by an under-appreciated sculptor called Adrian Jones, a former Hussar officer. His sculpture depicts Peace on a chariot, restraining four horses and their driver (a small boy representing youth) from riding to war. Prior to the unveiling of the Angel of the North, this was the largest public sculpture in Britain. The arch is now in the middle of a vast traffic island. The road layout around it was altered in the 1960s. The old photograph appears to show a carriage emerging from the arch; this is an optical illusion. All traffic, barring royal traffic, goes around the arch. If, in fact, that carriage was a royal one, it would have been let through by officers based within the arch's tiny police station.

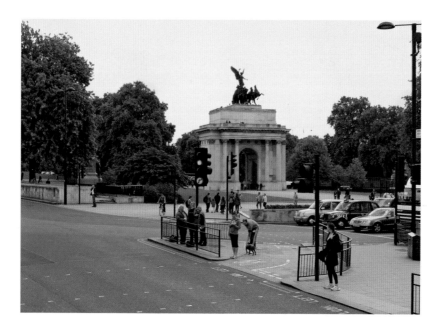

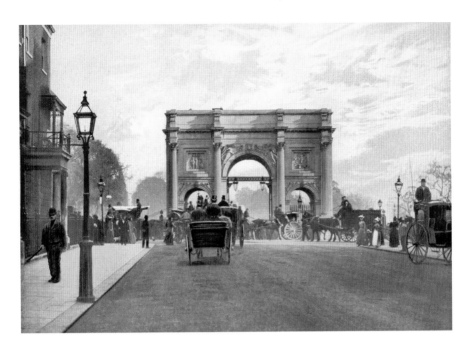

The Marble Arch

Queen's London reports that 'the dire effects of London smoke are only too obvious to all who look upon this noble structure'. In fact, it looks a lot better now thanks to restoration work carried out in 2004 to re-carve some of the broken details and clean the marble. Further renovation was carried out in 2009, to light the arch and restore the fountains, which had previously been filled with soil and used as planters to try to disguise their slide into disrepair.

Built in 1827 from Carrara marble, the arch was designed by John Nash, as a gateway to Buckingham Palace. Marble Arch was moved to its current location in 1851 to allow for expansion of the palace, and in 1908 was made the centrepiece of a busy traffic island. Over the years, the fact that Marble Arch has been left as a gate leading to nowhere, and marooned on an island which was voted in 2007 Britain's third scariest junction (only 'beaten' by Hanger Lane Gyratory and Spaghetti Junction), has led to various proposals for a second relocation. A Cambridge University research paper, for example, suggested it move to a site in Regent's Park, where 'it would serve to link the axis of Portland Place with the Broad Walk, as evidently intended by Nash'.

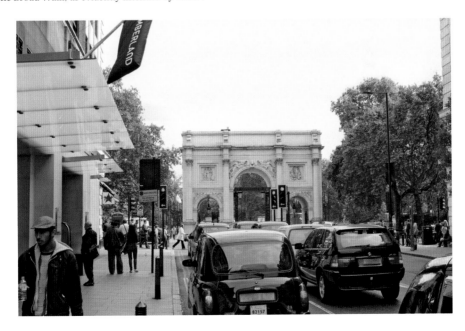

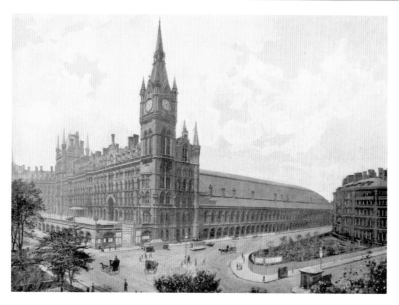

St Pancras Station: the exterior

In 1863, the Midland Railway purchased a 50-acre site for their new London terminus, and proceeded to demolish 3,000 houses to make way for the new station. Partially recycling plans that were rejected for government offices in Whitehall, Sir George Gilbert Scott designed a splendid Gothic pile festooned with towers, pinnacles and arched windows.

The Midland Grand Hotel, when opened in 1873, was considered one of the finest in the country – but, sixty years later, times and tastes had changed. The hotel was closed in 1935 and was probably fortunate to have avoided demolition before the war. By the 1960s it seemed certain that the site would be redeveloped, and then the Victorian Society got organised. 'More damage has been done to London and our other towns by "developers" and their tame architects than ever was done by German bombing,' wrote Sir John Betjeman in a newspaper article defending St Pancras Station. A vigorous and successful campaign was rewarded with a Grade I listing for the building in 1967.

The station was left looking fantastic after a complete redevelopment (2003–7) to accommodate the Eurostar trains travelling to Europe via the Channel Tunnel. The old Midland Grand has now also been refurbished, and in 2011 it reopened as St Pancras Renaissance Hotel, a five-star member of the Marriott group.

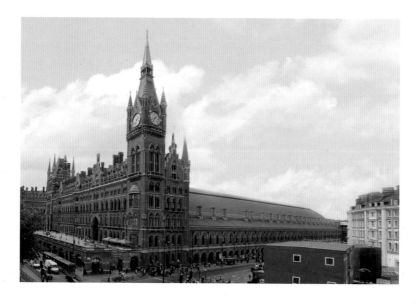

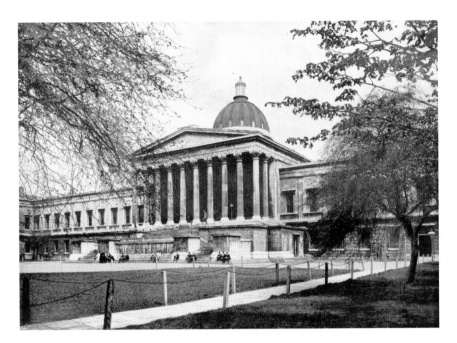

University College

Originally known by its critics as 'the godless college', University College London was founded in 1828 to provide an educational centre free of all religious tests. UCL went on to further assert its progressive credentials in 1878, when it became the first university in the UK to admit women on to its degree courses.

The photograph shows the university's main building – designed in the classical style by William Wilkins – which opened in 1828. The east wing of the college was badly damaged during the Second World War and restoration was not completed until 1954: the same year that Wilkins's building was given Grade I listing status.

In many ways, the scene is unchanged and students still sit on the steps at the front of the building. An obvious addition is the small, rather curious, domed building in the middle of the quadrangle. This is a (now decommissioned) astronomy shed.

Like many universities, UCL have set tuition fees for 2012 at £9,000 per annum. With fees a hot political topic, it is interesting to note what the position was in 1897. *Queen's London* reported that there were 1,600 students paying in fees 'not far short of £30,000'. If they had their figures right, this would equate to average annual fees of £18.75, or around £1,900 per annum, allowing for 115 years of inflation.

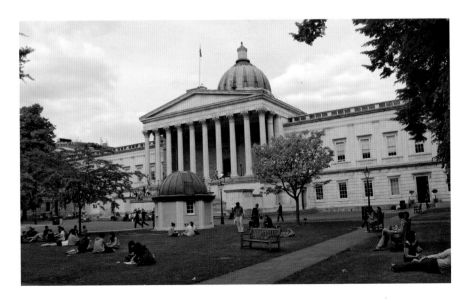

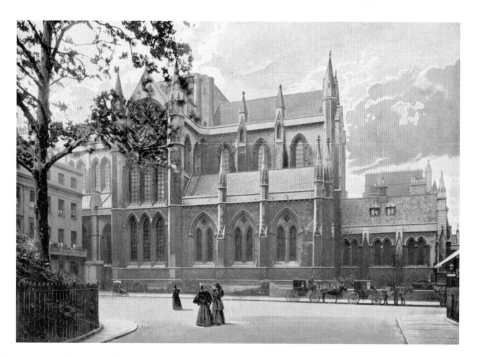

The Catholic Apostolic Church, Gordon Square

Queen's London wrote of the church: 'If the Catholic Apostolic Church at the corner of Gordon Square were only finished it would be one of the finest as it already is one of the largest modern churches in London.' One hundred and fifteen years later, and now known as the Church of Christ the King, it is still not finished (it lacks two bays at its west end, and the proposed 300ft spire that was part of original plans was never built), but it is still magnificent.

Opened for worship on Christmas Eve 1853, the church was built in just four years. Architect J. Raphael Brandon was responsible for the cruciform plans built in an Early English neo-Gothic style, while wealthy evangelical banker Henry Drummond was responsible for funding those plans on a cathedral scale.

The building on the left of our picture is Coward College, built in 1832 by Thomas Cubitt. Set up as a residential college for theology students, it was named after its benefactor, the merchant William Coward. Now split into private houses, the building appears to have survived more or less intact – although it has lost its first-floor balcony at some point over the years.

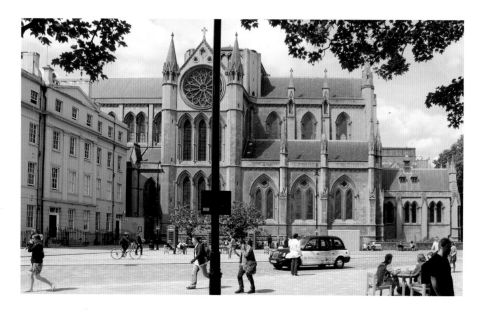

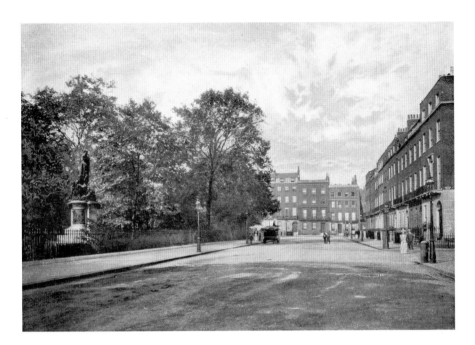

Russell Square

Our view is of the south side of Russell Square, with a bronze statue in the central garden of Francis, 5th Duke of Bedford, which was erected in 1809. Few of the houses round the square are still in private hands, and the row of Grade II listed Georgian houses on the right of our picture is now home to a number of organisations, including the Chartered Institute of Public Relations and the Migraine Trust.

 The real story here is of a hotel built after the Victorian photo and demolished before the current one. The original Imperial Hotel, designed by Charles Fitzroy Doll, was built between 1905 and 1911 – with a flamboyant façade of red brick and with terracotta ornaments, described as a 'vicious mixture of Art Nouveau Gothic and Art Nouveau Tudor'. In 1966 it was demolished, partly because of structural concerns, partly because of a lack of bathrooms but mainly, argues Gavin Stamp in his book *Lost Victorian Britain*, because it was a victim 'of changing ideas about what was considered smart and glamorous'. The Imperial Hotel we see today, standing at the end of the road, was finished in 1969; it is, according to Stamp, 'wretched and mean in comparison'. A second opinion is offered by Sir John Betjeman, who described it as 'three-dimensional chartered accountancy'.

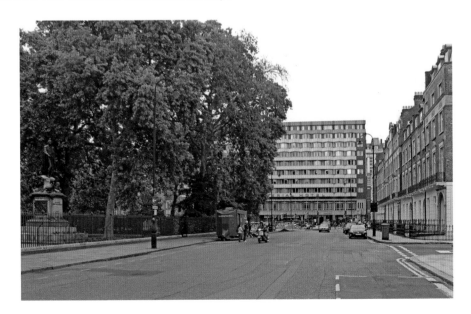

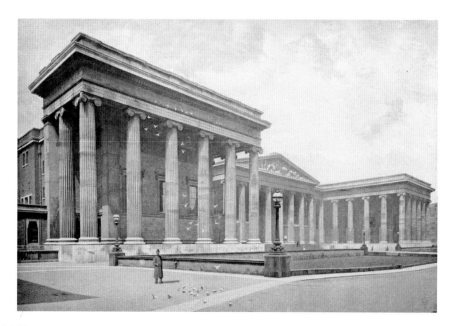

The British Museum

'Not unworthy of its priceless possessions, and that is saying a great deal,' declares the original book, 'is the structure of the British Museum at Bloomsbury. It was designed by Sir Robert Smirke, and was built on the site of Montague House in the years 1823–52.' Many of these 'priceless possessions' were garnered with the help of the navy. During the Crimean War, shipping space was acquired to transport monuments and sculptures from foreign shores.

Prior to its demolition, Montague House had been the public site of the museum since 1759 – though numbers were controlled by limited opening hours and a somewhat intricate and strict ticketing arrangement. It was only in the latter part of Victoria's reign that access to the museum became unrestricted.

The triangular pediment above the central entrance, by Sir Richard Westmacott, depicts figures symbolising the progress of civilisation. Emerging out of rock on the left, man tames the land and animals before acquiring knowledge of architecture, sculpture, painting, science, mathematics, drama, poetry and music. Finally, educated man (animals at his feet) dominates the world around him. The wings either side of the entrance, whilst also fronted by vast Greek-styled columns, are slightly less extravagant. This reflects their original usage as accommodation for the museum's staff.

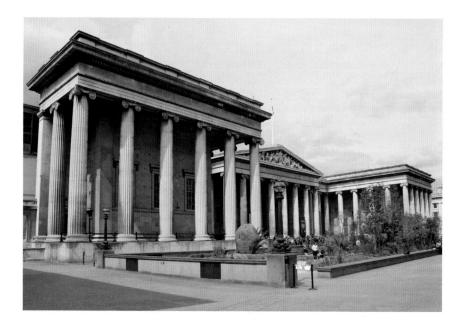

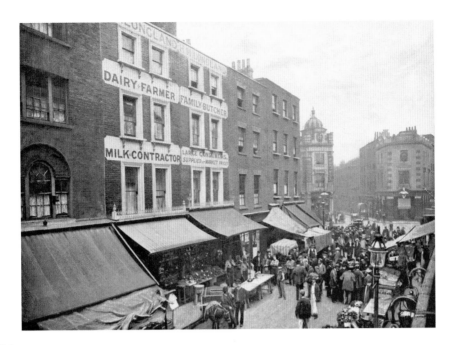

Seven Dials

Seven Dials is a junction of seven roads, converging at a single small roundabout north of Covent Garden. It was originally set out in 1693 with designs to attract a fashionable crowd to the area, but this vision never materialised and, during the eighteenth and nineteenth centuries, the district acquired a notorious reputation for being the hang-out of criminals. Seven Dials was deemed safer by 1897, probably not unconnected with the fact that the slums just north of the area had been cleared to make way for Shaftesbury Avenue a decade earlier. However, 'It is still a favourite locality for dog and bird fanciers,' states the Victorian book warily, 'and purveyors of gold fish and fried fish.'

Behind the scaffolding (unfortunately present when the modern photograph was taken) is the Seven Dials Column. This is a 1980s' copy of the original column that was in situ from 1693 to 1773, when it was removed because it had become the point of congregation for the more villainous residents of the locale – hence its absence from the earlier photograph. The original still exists on the green of Weybridge in Surrey. The narrow, domed building, centre-right of both photographs – rather dominated by the foreground buildings of Earlham Street (especially in the modern photograph) – is the Crown pub, built in 1833.

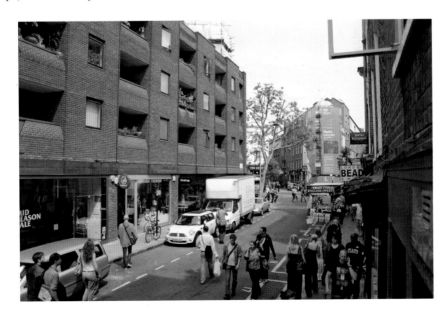

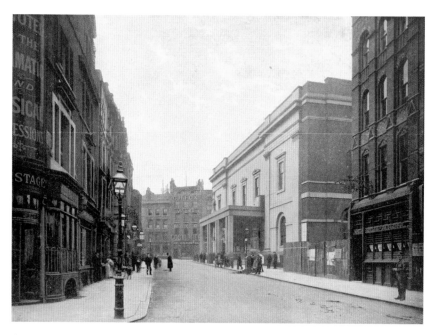

Drury Lane Theatre Royal

There has been a theatre on this site for almost 350 years. The first and third were burned down, whilst the second was demolished after 120 years' service. The present theatre was built between 1811 and 1812 by Benjamin Wyatt, and 'front of house' has changed little since.

The Victorian photograph would have been taken at the end of the reign of Augustus Harris, who ran the Theatre Royal for seventeen years, until he died aged just forty-four. Harris is credited with turning around the fortunes of the theatre almost single-handed, and his lavish Christmas pantomimes became the stuff of legend. As a tribute, a drinking fountain was placed at the front of the theatre – it can just be seen between the portico's middle two columns.

During the Second World War, the Entertainments National Service Association, or ENSA, was set up to provide entertainment for British Armed Forces, and they made their home base in Drury Lane. In 1940, the theatre received a direct hit from a gas bomb – which destroyed the rear of the auditorium, but fortunately did not actually explode. Since the war, the theatre has been mainly known for its long-running musicals, including *My Fair Lady* (five years), *42nd Street* (five years) and *Miss Saigon* (ten years). In 2005, the Theatre Royal was bought by the Really Useful Group.

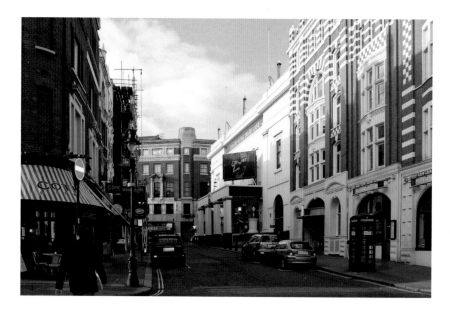

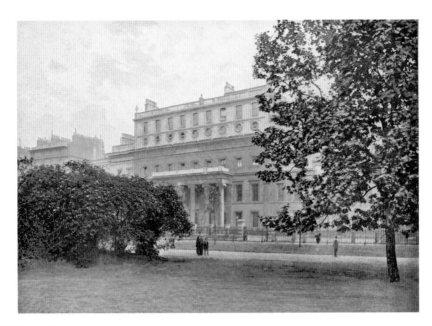

The Royal College of Surgeons

The Royal College of Surgeons building, glimpsed through the trees of Lincoln's Inn Fields in the 2012 photograph, looks like the same building seen in 1897. However, although the façade of Charles Barry's 1830s' building has survived (as well as the slightly earlier portico), much of the interior was rebuilt in the 1950s and 1960s following Second World War bomb destruction.

The college in Victoria's time – in existence in some form since the Middle Ages – was, says the original book, centred around the nucleus of 'some twenty-four thousand anatomical specimens, physiological and pathological' of the eminent eighteenth-century scientist-surgeon John Hunter. Part of the collection was destroyed by the 1941 bombs. In 1938, however, with a possible war on the horizon, the college had the foresight to strengthen the basements, within which were stored parts of the collection, thus saving some of it. Nevertheless, a significant amount was lost and the post-war rebuilding process concentrated more on providing space for research. The current Hunterian Museum housed in the building still centres around the original collection, from which about 3,500 specimens and preparations have survived. Other parts of the present collection include 7,000 historical surgical and dental instruments, teeth extracted from soldiers killed at Waterloo, and Winston Churchill's dentures.

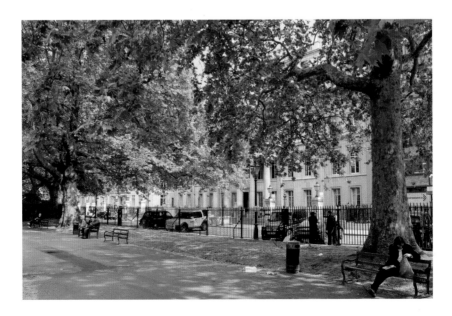

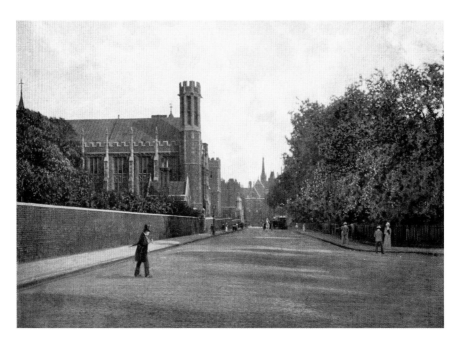

Lincoln's Inn Fields

Lincoln's Inn Fields is Central London's largest square. Originally two 'waste common fields', in the fourteenth century it was a playground for students of the adjoining Lincoln's Inn. By the sixteenth century, the Fields had become a centre of gambling and on occasion a place of execution. Over the subsequent 200 years, grand houses were built – many are still there – and the Fields was enclosed. The 1897 book reported that: 'The London County Council has lately purchased the well-timbered garden and thrown it open to the public – a boon much appreciated by the children of neighbouring slums.' The garden is still open to the public today – the lease lasts until 2555.

During the Second World War, the railings seen in the Victorian image were removed as part of the munitions effort. By the 1980s, many homeless people were sleeping rough in the gardens; in 1992, temporary fencing was built to discourage this. After the last homeless person left, the Fields was closed for a year before new railings were erected and the area was reopened to the public.

The building dominating the left of both images is the mid-nineteenth-century Great Hall of Lincoln's Inn. The windows facing our direction belong to the library. Beneath the library are the offices of the inn.

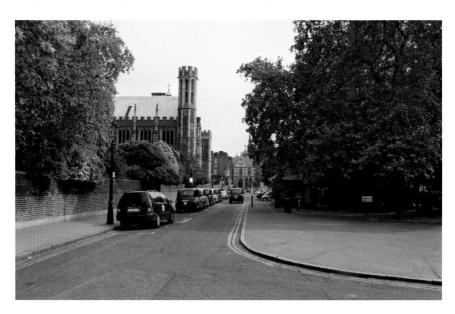

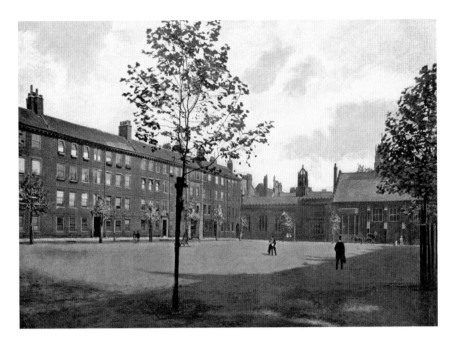

Gray's Inn Square

'Gray's Inn lies north of Holborn,' begins the first book, 'and as one of the four great Inns of Court, dates from the time of Edward III.' Being an 'Inn of Court' refers to the building's traditional function as a comfortable hostel for barristers and law students. In 1897, the inn was '...largely used for residential purposes, by married people as well as bachelors'.

The square in the images is the largest of the inn's two squares. In the central corner of both photographs is the chapel, which stands on the same site as the fourteenth-century chapel used by John le Grey, the first landlord – hence the inn's name. It was restored a couple of years before the first photograph was taken, but had to be completely rebuilt after it was destroyed in the Second World War.

On the right of the chapel is the Elizabethan Hall. This has been here since the mid-sixteenth century (its outer walls holding firm against the enemy bombs of 1941). Shakespeare's *A Comedy of Errors* was first staged here in 1594. On the left are the residential Verulam Buildings, built between 1803 and 1811, and named after the first Lord Verulam, Sir Frances Bacon, the polymathic philosopher and playwright who arrived as a student at the Inn in 1576.

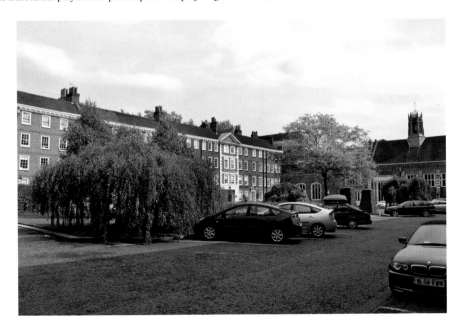

The Angel, Islington

There has been an Angel Inn on the Great North Road (now the A1) since the seventeenth century. It was the nearest staging post to London. Despite the short distance into the city, the fields in between could be dangerous areas to traverse, especially at night, so the inn was a welcome place to rest until sunrise.

The Angel in the Victorian photograph was built in 1819, on the corner of what was by then Pentonville Road and Islington High Street. It was rebuilt in 1899. The pub existed for a further twenty-two years before becoming the Angel Café Restaurant, owned by J. Lyons & Co., then noted for their three vast Corner House restaurants in the centre of London. Whilst not quite as large as the West End outlets, the Angel Café was still a popular meeting place for Islington residents and, in the post-war years, was often hired out for wedding breakfasts. It closed in 1960 and lay dormant until 1981, since when it has been a bank.

Several buildings to the right of The Angel have survived, including another pub. The Bass sign in the early photograph marks The Peacock Arms, which finally closed down in 1962. It is currently a fried-chicken outlet.

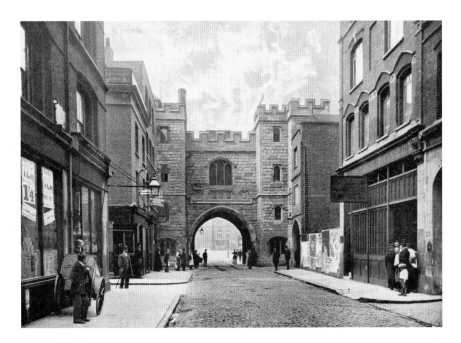

St John's Gate, Clerkenwell

St John's Gate was built in 1504 as an entrance to the long-established Prior of St John of Jerusalem. Since Henry VIII's dissolution of the priory, the gateway has been variously a coffee house, a printing works, a watch house and, in Victoria's reign, a pub called the Old Jerusalem Tavern. In 1877 the St John Ambulance Brigade originated here, and its museum and library are still housed in the building.

Through the archway in both photographs – the site of the old priory – is St John's Square. Whereas the buildings on the left of the old view have not survived, the ones on the right have – with an extra extension, incorporating part of the museum, attached running from the gateway and built in the same style. Next to it, the nineteenth-century United Horseshoe & Nail Co. now houses offices. Nearest to us in the early photograph, over an archway at No. 27 St John's Lane, are the letters 'LOV'. They are behind a sign in our modern image, but we can still read the word 'Christmas'. 'Lovell and Christmas' were an eminent London grocer's. This was the back entrance to the store, which fronted St John's Street and is now a restaurant. Modern references state that it was built in 1897, yet the photograph was taken at least one year earlier.

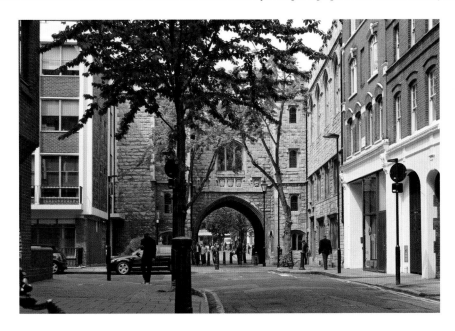

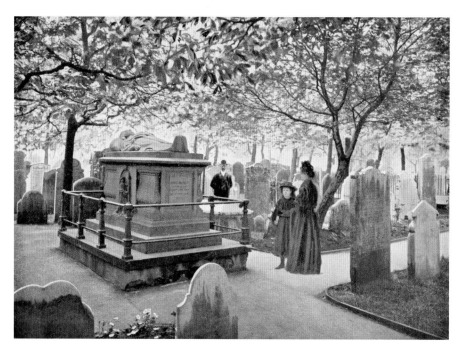

Bunyan's tomb in Bunhill Fields

Bunhill Fields is a former Dissenters' burial ground that lies between City Road and Bunhill Row. The name is possibly a derivation of Bone Hill. It is estimated that 120,000 bodies have been laid to rest here. In the sixteenth century, bones were taken to the area from the charnel house of St Paul's churchyard. It became a cemetery during the Great Plague of 1665, to help cope with the demand for burial grounds – though no records show that it was ultimately used for this purpose. The last burial was in 1854 and, after restoration, the grounds opened to the public from 1867.

'The most noteworthy tomb,' in the opinion of the Victorian book, 'is that of John Bunyan ... the great allegorist ... Like the surrounding monuments, it has suffered from the ravages of time, but it has been carefully restored, and is protected by a substantial railing.' The railing protecting the seventeenth-century tomb is still there today; though, owing to Second World War bomb damage, some of the cemetery was re-landscaped in the 1960s. The tomb's recumbent statue was added in 1862. On the date of the 1888 bi-centenary of Bunyan's death, the *Pall Mall Gazette* reported: '...there were some hundreds of visitors to his tomb ... a considerable number of whom were Americans and colonials staying in England.'

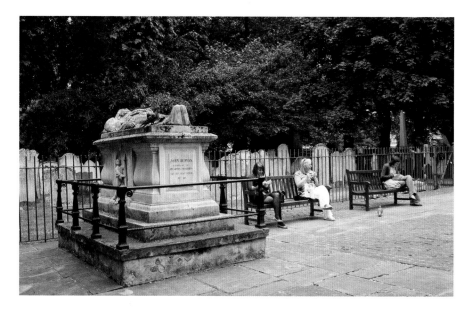

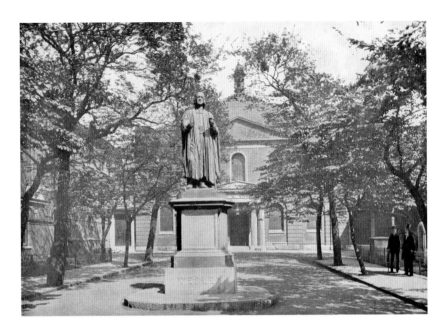

Wesley's Chapel

The seventy-four-year-old John Wesley laid the foundation stone for this chapel on the City Road in 1777, allegedly with the words: 'Probably this will be seen no more by any human eye, but will remain there until the earth and the works thereof are burnt up.' Thus far his prophecy has held firm – despite fire in 1879, alteration in 1891, bombs in the 1940s (none of which struck the chapel) and general dilapidation into the 1970s.

The earth on which the chapel stands was formerly a field, formed by soil dumped from excavations for St Paul's. Wesley lived a further fourteen years upon its completion and frequently preached here in that time, living in an adjacent house that also still exists. The statue in the foreground of both photographs was commissioned for the centenary of his death in 1891.

In the 1970s, almost £1 million was raised for the restoration of the chapel, and it was reopened with the Queen present in 1978. The small tower seen atop the chapel in the Victorian photograph has not survived into the twenty-first century; in early illustrations of the building it is also missing, so it is possible that it was one of the 1891 alterations. The chapel is now the home of a 'thriving Methodist congregation'.

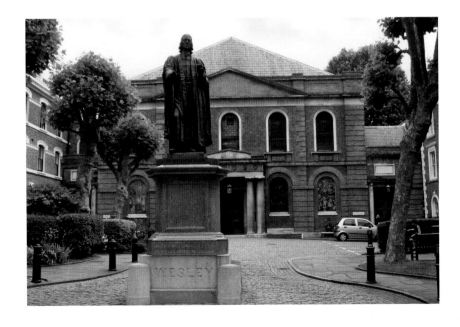

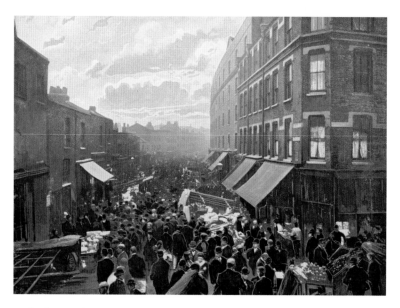

Wentworth Street on Sunday morning

'Crowds of foreign Jews flock to do the marketing which their faith prevents them from doing on their own Sabbath,' proclaims the 1897 book, before continuing somewhat discontentedly, 'It must be confessed that they are not all scrupulously clean, nor is one's sight the only sense that is offended. The noise is often deafening, and in the babel of sounds half a dozen different languages may be distinguished – French, German, Russian, Polish, Hebrew, with the Yiddish compounds of them all, and occasionally English.'

Wentworth Street still thrives with market-goers on a Sunday morning in London's East End, as the modern photograph testifies. This street and the adjoining market road, Middlesex Street (commonly known as Petticoat Lane), are both within a conservation area. The buildings on the right of both photographs (counting eight windows back) are examples of many in this vicinity that have survived from the Victorian era.

The image accompanying the text is a particularly striking example of the Victorian book's penchant for embellishing the figures in the photographs with touches of paint. There is a cloth-hat-wearing chap in front of the right-hand awning who is clearly still 'unembellished' – everyone in front of him, however, has been slightly enhanced.

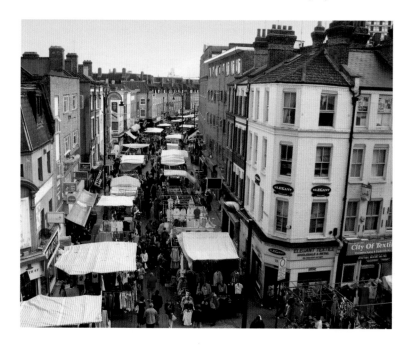

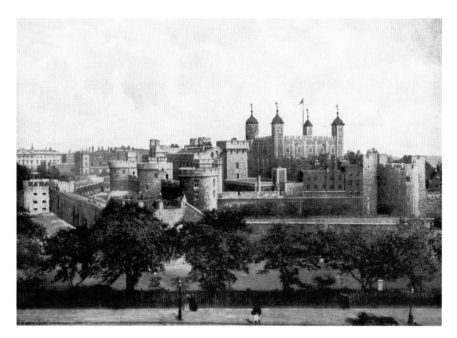

Tower of London

The structure obscuring the moat and the Tower's base in the 'now' image is the Visitors' Centre. Beyond it, bar some concealed scaffolding, the Tower appears unaltered. Building work on the central, four-turreted White Tower began in 1078, on the orders of William the Conqueror. Successive monarchs added to the fortress until the outer wall was completed during the late thirteenth-century reign of Edward I.

Over the centuries, the Tower has been used as a palace, an observatory, a menagerie, a prison and a place of execution – the last execution being that of the German spy, Josef Jakobs, in 1941. That same year, Rudolf Hess was imprisoned here after his crash-landing in Scotland. Two of the last internees were the Kray twins, in 1952, who marked their first day of national service at the Tower by planting a right hook on their NCO's chin. Because it wasn't clear who threw the punch (apparently Ron), they were both confined to the guardroom for a week.

Since the early 1300s, the Tower has housed the Crown jewels. They were moved from Westminster Abbey because of fears of theft. This, however, didn't deter Colonel Blood who, in 1671, failed in his attempt to steal the crown itself. Strangely, he was not hanged or even imprisoned, but granted a modest annual pension.

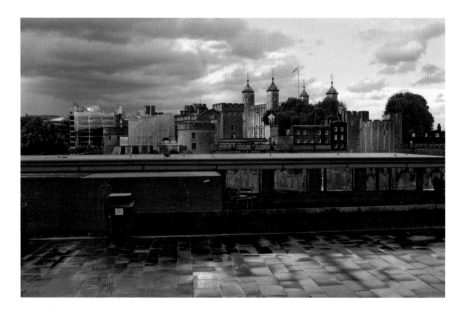

St Saviour's, Southwark

The Church of St Saviour's, Southwark (as it was in 1897) is now Southwark Cathedral. There has perhaps been a church here since the seventh century. The current building, whilst much renovated and extended over the years, dates from the early thirteenth century. The Victorian photograph shows the cathedral at the tail-end of its last major renovation. The nave, on the left, had been rebuilt in 1840 'in so wretched a fashion,' bemoans the 1897 book, 'that it had to be replaced by another, from the designs of Sir Arthur Blomfield ... with a view to St Saviour's becoming a cathedral for South London.' Indeed, although officially still a parish church, it was already being used as a cathedral in the year of the Diamond Jubilee, obtaining full cathedral status in 1905. The scaffolding that we can see is on the south transept, which received minor renovation at the same time as the nave's more drastic rebuilding.

In the modern photograph, it is hard to ignore the fact that a restaurant obscures most of the cathedral. This old factory building, on the north edge of ancient Borough Market, has in fact been here since 1897, as the date inscribed above its windows testifies. The Victorian photograph was probably taken from 'inside' the building a few months before it existed.

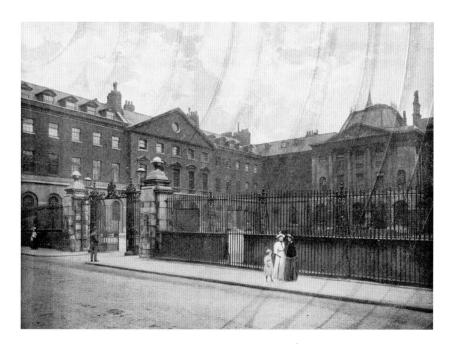

Guy's Hospital

In the modern photograph, the traffic aside, there is one very striking addition to the building landscape of Guy's Hospital. The thirty-five-storey tower block (the world's tallest hospital tower) that looms from behind the old hospital was built in 1976, 250 years after the original hospital buildings were completed, the pillared structure on the right of both photographs being part of these buildings. The original east wing, on the left of our views, was built a few years later, and was completely rebuilt after destruction in the Second World War.

In the quadrangle, slightly more visible in the present-day photograph under the sturdy branch of the right-hand tree, is a statue of the hospital's founder, Thomas Guy. He was seventy-seven when, in 1721, he acquired this plot of land south of London Bridge with the specific intention of founding a hospital; he died in December 1724, one month before the hospital's opening. He left all of his considerable wealth to Guy's Hospital.

'Guy's has on average 411 beds occupied every day,' states the 1897 book precisely, 'but is able to accommodate 500 patients and in the course of the year some 5,000 in-patients and 70,000 out-patients are treated.' In 2010, according to their annual report, Guy's had fewer beds (just 265), but, in combination with St Thomas's Hospital, treated 680,000 patients.

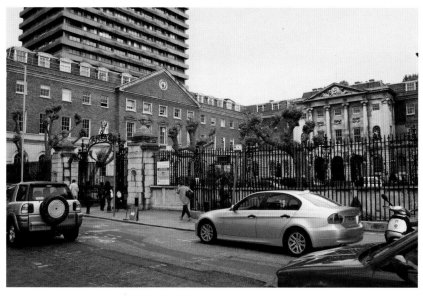

The George Inn, Borough

There has been a George Inn on this site since at least 1542. The current building, modelled on its predecessor, was built in 1676 after a fire destroyed the previous inn and most of the adjacent Borough High Street. The section seen in both photographs is part of the southern section – the only side of the building to have survived into the twenty-first century and the only example of a galleried coaching inn remaining in London. It originally had three sides.

The 1897 book describes the inn as a 'quaint, old-fashioned place'. At that time, although only the photographed side was the inn proper, the other two sides still existed. The eastern side was mainly made up of stables, and the northern side housed offices of the Great Northern Railway Co. The original *Queen's London* in fact describes the inn as being in a courtyard used by the railway company as a depot, and it was at the company's directive that two of the three sides were pulled down in 1899. That same year, George Duckworth, working for the social researcher Charles Booth, recorded in his notes for George Yard: 'On the south side the old inn remains, an old family hotel with small leaded diamond window panes, balustraded balconies. Old four-poster bed seen through upper window.'

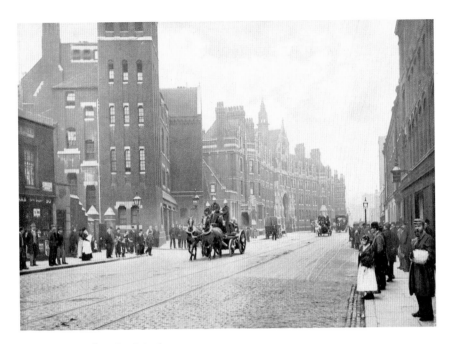

Headquarters of the Metropolitan Fire Brigade

The tower that dominates the left of the Victorian photograph, taken on Southwark Bridge Road, still stands, as does the building with the white-rimmed roof seen jutting out just beyond it. They are both now part of the London Fire Brigade Museum and a training centre, which have been in the old Fire Brigade Headquarters site since the HQ moved to Albert Embankment in the 1930s. The 1897 text describes how, from the summit of the 'lofty tower ... a constant watch is kept', this being a time when the average householder did not have a telephone. The current training tower is just visible through the trees of the modern photograph. The fire station was built in the 1860s, alongside an existing building called Winchester House, which became the home and workplace of the Chief London Fire Officer. The house, also now part of the museum, is still there, set back from the road and out of view beyond the old fire station.

One other building remains. The furthest premises visible on the same side of the road as the fire station is the old Fox & Hounds pub, built in 1884. It can still be seen now beyond the line of trees. It ceased to be a pub many years ago and is currently divided into flats.

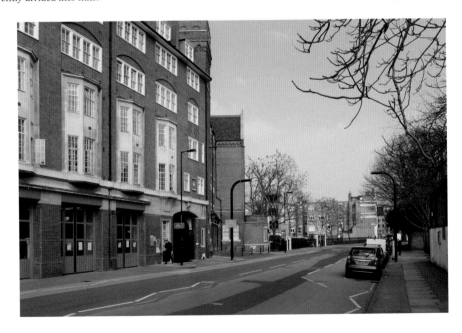

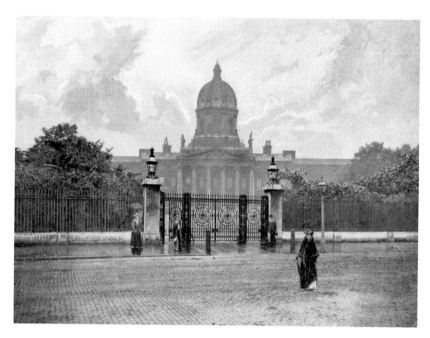

Bethlehem Hospital

The original text states: 'Bethlehem Hospital, colloquially known as Bedlam, has been a madhouse since the time of Henry VIII.' In fact, the history of the hospital can be traced back a further 300 years. It had an itinerant existence before 122 patients were moved by hackney coaches from its then Moorfields location to this Lambeth building in 1815. Especially built for the hospital, the building replaced the Dog & Duck tavern, the medicinal spring of which had attracted much attention and extra custom since 1642. The building's dome, incidentally, which covered the hospital chapel, was added twenty years later.

The large guns aimed straight at us in the modern photograph give a strong clue regarding the building's current use. Since 1936 it has been the Imperial War Museum, following the museum's brief existence in Crystal Palace and South Kensington. The guns, from different British battleships, both saw service in both world wars. The dome is now the museum library. Up until the early 1930s, the building had long east and west wings – the beginning of the extra length of the western wing can be seen in the Victorian photograph. These were demolished to make way for the present park.

The Bethlem Royal Hospital (note not *Bethlehem*) still exists. In 1930, it reopened in new buildings near Beckenham in Kent.

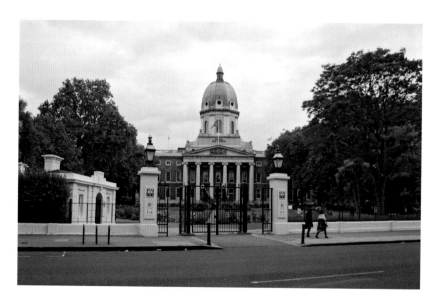

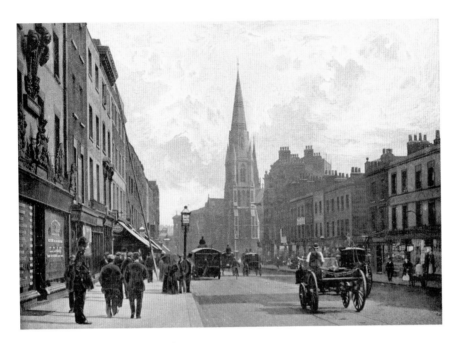

Westminster Bridge Road, with Christ Church

The Victorian text concentrates, unsurprisingly, on the church in the centre of our photographs. It stands on the corner of Westminster Bridge Road and Kennington Road, and was opened on 4 July, on the centenary of American Independence. 'The greater part of the fine tower and spire, which is two hundred feet high,' reports the first book, 'was built at the expense of Americans, who in this fashion expressed their gratitude for the sympathy with the Union manifested by Dr Newman Hall and his congregation at the time of the War of Secession.' Much of the church was destroyed in the Second World War, but the tower survived. This, and the modern buildings around it, are now a centre for the Christian charity Oasis.

The lamp post on the left in the old photograph belongs to the Lambeth Baths, which were situated here from 1853 until the early twentieth century. They were open in the summer for swimming (the first cross-Channel swimmer Matthew Webb trained at the pool), and in the winter the water was drained out and the place used for, amongst other events, temperance meetings, newspaper readings and concerts. In 1868 it was used both as a practice space for the Surrey Cricket team and the venue for the South London Industrial Exhibition, attended by the Prince of Wales.

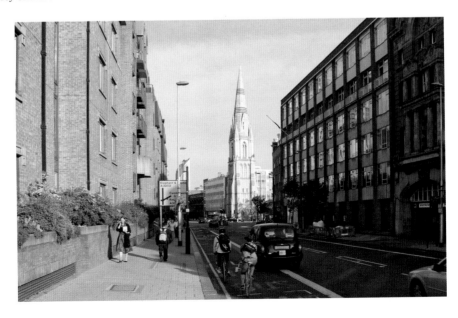

OUTER LONDON AND BEYOND – THE NORTH

High Street, Watford

'The broad High Street is quite a sight on market days,' says the 1897 book, 'when there is a lively business done in corn and live stock.' Indeed, the part of the High Street in the distance, adjacent to the Rose & Crown pub on the right, is called Market Place. The pub itself ceased trading in 1968, when its final physical incarnation was demolished. In its place there is now a NatWest bank.

The five-chimney building on the left of both photographs, built in 1889, also has a banking connection. In 1897, it was the Bucks & Oxon bank. In the twentieth century, it became a Lloyds bank. Lloyds have now moved next door and, when our photograph was taken, the building was a Madhouse clothes store. It was redeveloped in the 1980s but its exterior features, which are listed, were preserved.

Watford's prominent position on the London to Birmingham rail route – the first Watford railway station opened in the year of Queen Victoria's Coronation – was instrumental in its population increasing ten-fold during Victoria's reign. The rail and the nearby Grand Union Canal came to Watford for the same reason that the High Street did many centuries before: as an easy route over the surrounding Chiltern Hills.

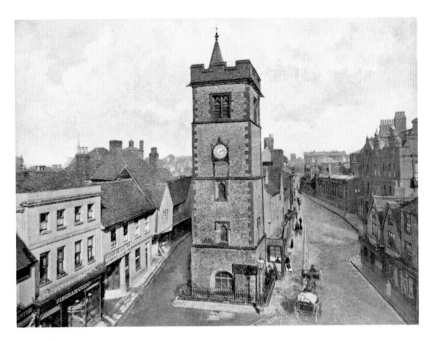

The clock tower, St Albans

Originally built between 1402 and 1411, this clock tower almost didn't make it to the Victorian picture. By the 1860s it had fallen into a bad state of repair, and was nearly demolished before restoration work was carried out in 1864. As befits a building more than 600 years old, the tower has led a varied life, including being a semaphore station during the Napoleonic Wars (1808–14). Operated by a shutter system, messages could be relayed from the Admiralty in London, via sixteen relay stations, to Great Yarmouth (a distance of more than 130 miles) in around five minutes.

The shop on the left was run by Mr Bingham Cox, a true Renaissance man of Victorian life in St Albans. Brewer, politician, grower of magnificent facial hair and football fan, his name lives on with the Bingham Cox Cup, which he founded in 1892 (Potters Bar Crusaders 'dominated from the first minute' to beat Inn On The Green 3-0 in the final).

Today, the Grade I listed clock tower is seen fresh from a facelift completed in April 2011. Not just the tower, but many of the surrounding buildings have survived intact, including the two pubs: the Fleur De Lys on the left (now obscured by foliage) and the Boot Inn on the right. If Mr Bingham Cox were to return today, he would be in familiar surroundings.

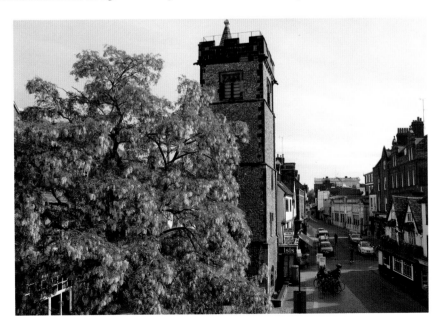

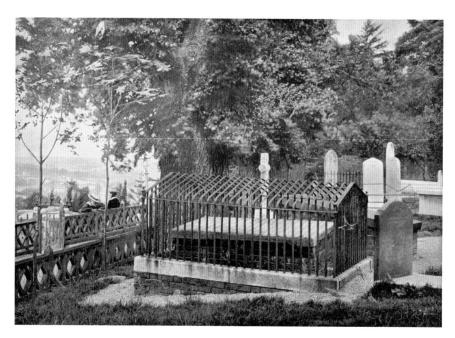

Byron's Elm, Harrow

St Mary's Church is positioned at the very top of the hill in Harrow. The majority of the building dates back to the fourteenth century, but parts of the tower are from the original church, which was built in 1094. The romantic English poet George Gordon Byron was apparently very drawn to this spot whilst a boy attending nearby Harrow school. The *Queen's London* reports that: '...in the churchyard, southwest of the church, is an altar tomb (enclosed by iron rails to protect it from the initial-cutting fraternity) on which Byron was fond of sitting during his school-days, and which is repeatedly mentioned by him both in letters and in his poems. Close to it is a noble elm, which is known locally as Byron's Elm.'

The elm has gone and the view is now obscured, but the tomb of John Peachey, an old Harrow resident, is still there – albeit almost covered by the encroaching undergrowth. Since 1905, the grave has been marked by a memorial (erected by Sir C.T. Sinclair Bart, the son of one of Byron's school friends), on which is written Byron's poem, 'Lines Written Beneath an Elm in the Churchyard of Harrow'.

As an example of the Victorian photographer's art, note how this picture has been 'enhanced', not only with a pair of Harrow schoolboys, but also some small birds.

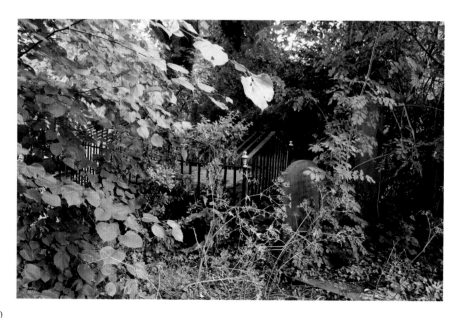

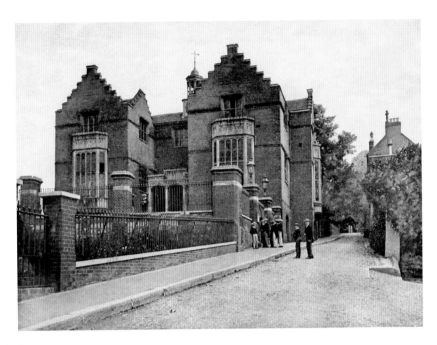

The Old School, Harrow

The buildings that formed the 'Old School, Harrow' were completed in 1615. They included the prominent building in these photographs, the Fourth Form Room – the original classroom used by the first Harrow schoolboys. The 1897 book states that inside the room, on oak-panelling, '...may be seen the names of Byron, Sir Robert Peel ... and of many other Harrovians known to fame, cut with a pen-knife'. The name W.L. Spencer-Churchill is also carved here. The 1897 book's omission of his name possibly has less to do with Churchill then being unworthy of note and more to do with the fact that his name may have been added at a later date by another's hand. The legitimate carving of names was discontinued in 1840.

Another addition since the 1897 book is visible. On the lower part of the building that juts out to the road is a plaque. It relates how 'Anthony Ashley Cooper ... while yet a boy in Harrow School, saw with shame and indignation the pauper's funeral, which helped to awaken his life-long devotion to the service of the poor and the oppressed'. Anthony Ashley Cooper became the 7th Earl of Shaftesbury, the famed philanthropist who is celebrated by the Eros memorial in Piccadilly Circus.

The headmaster in 1897, incidentally, was Revd James Welldon, formerly Honorary Chaplain to Queen Victoria.

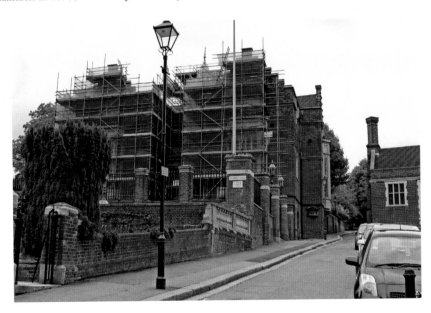

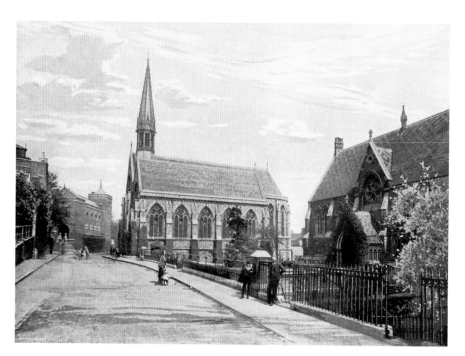

Harrow School: The chapel and library

'From the playing of Harrow Football to the famous straw hat, Harrow's way of life is steeped in tradition.' This sentiment from the school's website, combined with a Grade II listing placed on the chapel in 1968, suggest that we should not be surprised that the scene in our modern photograph, complete with boater-wearing pupils, is such a familiar one.

Both buildings were the work of prolific architect Sir George Gilbert Scott, with the Gothic chapel completed in 1854 and the library, which is in the Decorated style, finished six years later. The chapel, the library, the school speech house (the building with a short, square tower beyond the chapel), and the majority of the boarding houses built during this period, all reflect the enormous expansion which took place at Harrow under two progressive Victorian headmasters in the second half of the nineteenth century: Clergyman Charles John Vaughan (after whom the library is named) and most especially classicist and Old Harrovian Henry Montagu Butler. Before Vaughan became head in 1845, pupil numbers had dropped to below eighty. By the time Butler left in 1885, they had risen to more than 500.

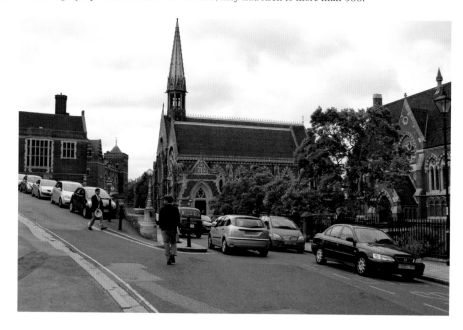

Mill Hill School

The school house seen in our photograph was designed by Sir William Tite in 1827 and built in the classical style, with an imposing 'hexastyle pedimented Ionic portico' (six columns supporting a low-pitched triangular gable). The building was Grade II listed in 1950.

Mill Hill School was set up in 1807 on the site of plant hunter Peter Collinson's botanical gardens. Established by a committee of non-conformist merchants and ministers for the sons of the Protestant Dissenters, it would be fair to say that the school's founders were not big fans of London life. They located the school outside the city because of the 'dangers both physical and moral, awaiting youth while passing through the streets of a large, crowded and corrupt city'.

For the first 168 years, Mill Hill was for boys only, but in 1975 they welcomed girls to the sixth form, and since 1997 have been fully co-educational. Mill Hill's most famous teacher was Sir James Murray, the original editor of the Oxford English Dictionary. Murray started work on the dictionary in 1873 and estimated that it would take until 1891 to complete. This forecast turned out to be a little optimistic, and although he remained as Chief Editor for the rest of his life, the OED did not finally get finished until 1928, thirteen years after his death.

The Alexandra Palace

'What the Crystal Palace has been to the south,' states the original book, 'it was thought Alexandra Palace would prove to the north of London. The former was built of materials used for the Exhibition of 1851; the latter, of those employed for the Exhibition of 1862.'

The 1862 exhibition in question was an international exhibition, part-financed by profits from 1851's Great Exhibition, but whereas the reconstituted Crystal Palace existed for eighty years before being consumed by fire, the original Alexandra Palace lasted only sixteen days before succumbing to the same fate. However, it is the North London palace that has prevailed. Rebuilding commenced at once and the new structure was opened in 1875. It took time to find its feet. Attractions included dog, flower and fruit shows, music festivals and sporting events. The 1897 book, however, states that, 'for some years now, with the exception of an occasional short season, the Palace has unfortunately been closed'.

Amongst the palace's early twentieth-century tenants were German prisoners of war, some of whom helped redesign the grounds. By the 1950s the palace was famously associated with the burgeoning television industry and the BBC. Another fire in 1980 necessitated complete rebuilding, but now the building once again numbers shows, live music, sport and fairs amongst its many attractions.

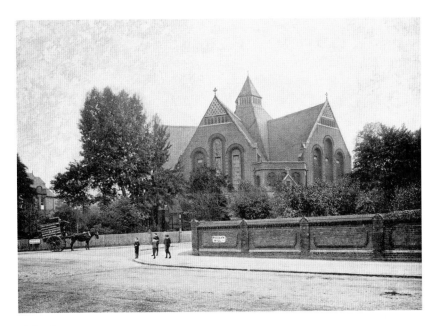

Lyndhurst Road chapel

This former chapel in Hampstead was designed in 1880 by Alfred Waterhouse, the Liverpudlian architect who designed the Natural History Museum, amongst many other prominent English buildings. It was built for Revd Robert F. Horton, a preacher and writer of some note who remained at the church's helm until 1930. During his time there, a school and a lecture hall were added. Throughout the twentieth century, however, numbers attending the services and lectures gradually fell, and the church finally closed in 1978. The unlikely holder of the church's last service (or perhaps lecture) was Joe Jagger, father of Mick. Since 1992 the building, now called Lyndhurst Hall, has been the home of Sir George Martin's Air Recording Studios. It was opened with a performance of *Under Milk Wood*, attended by the Prince of Wales.

'With exceptional acoustics,' says the studio's website, 'stunning architectural features and natural light, Lyndhurst Hall is flexible enough for full symphony orchestras, chamber music or choirs ... Holding up to 100 musicians with 300 choir [the hall] is one of the largest recording studios in the world.'

Incidentally, the horse-drawn delivery vehicle grabbing the attention of the children on the corner of Rosslyn Hill, in the Victorian photograph, belongs to the Great Eastern Railway.

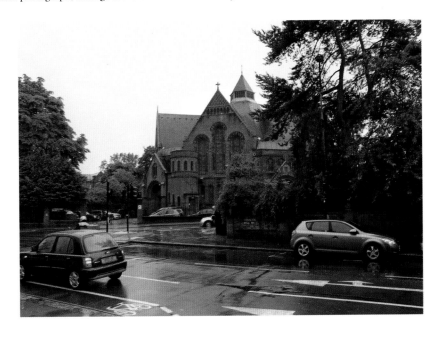

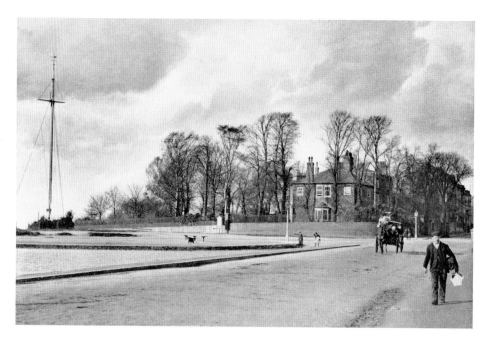

Hampstead Heath: the flagstaff, with approach to 'Jack Straw's Castle'

Described by Arthur Mee as 'about the best medicine a Londoner could have', Hampstead Heath is 325 hectares of parkland north of Camden. The flagstaff seen in our photo stands 131m above sea level, and marks the site of a fire beacon used in 1588 to give warning of the Spanish Armada. In the early 1800s, a new technology was applied to the same idea when, during the Napoleonic Wars, this became a relay station for the semaphore telegraph which ran from the Admiralty to Great Yarmouth. Fast forward to the 1890s and the *Queen's London* advises that the best views from here are to the west, where on a clear day Windsor Castle is distinctly visible. This was not, however, to last, and in 1932 Harold Clunn lamented that the growth of the metropolis had long since obliterated such views.

Jack Straw's Castle was named after one of the leaders of the 1381 Peasants' Revolt, and it has been the site of London's highest pub for 300 years or more. The current Grade II listed building is surprisingly new, having been rebuilt in 1962 to replace the building destroyed by bombs in 1941. More surprising still, somebody sold the pub to private developers, who have converted it into flats.

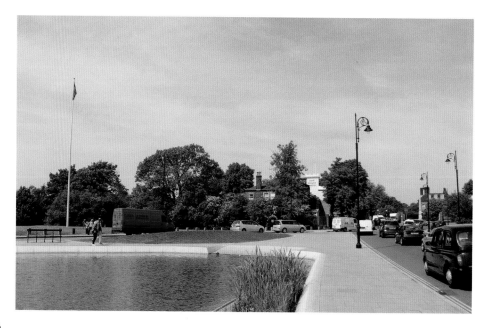

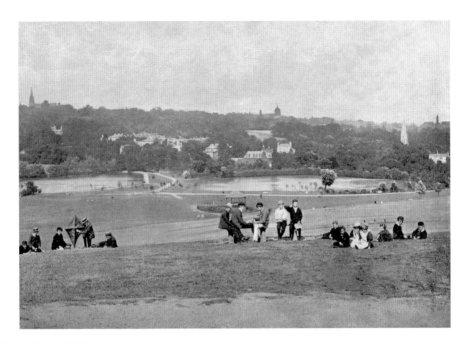

View from Parliament Hill, looking north-west

The name Parliament Hill dates back to the English Civil War, and is derived from the fact that the parliamentary generals planted cannon here in defence of London. Go back a little further in time and it was also known as Traitors' Hill, because it was on this spot, on 5 November 1605, that the conspirators of the gunpowder plot gathered in vain to await the expected explosion.

Comparing the two views, there are still many reference points which can be made. To the left, still clearly visible, is Highgate church – although naturally the Swains Lane radio mast alongside it is a new addition. The dome in the centre belongs to the Catholic church, St Joseph's Retreat, and the spire closest to the park on the right-hand side is St Anne's Church. The boating lake and swimming ponds are still there, but are now all but screened by the trees that have grown around them. Whilst this is a very nice view, it is a bit of a mystery why the *Queen's London* authors did not decide to turn their cameras to the south to capture what was then, and still is today, one of the capital's most spectacular views of Central London.

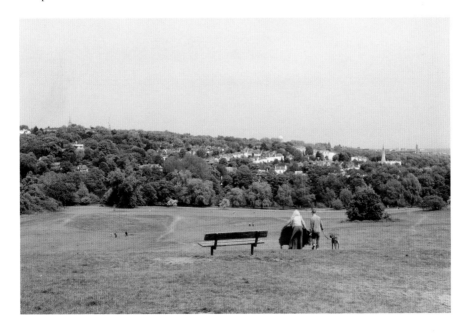

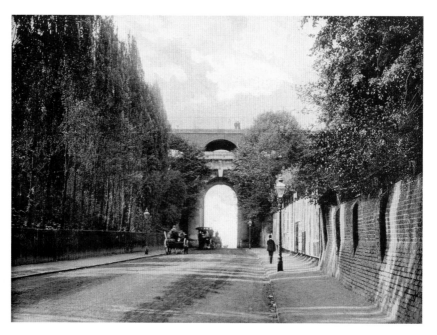

Highgate Archway, looking northwards

Highgate Archway was built by John Nash in 1813. Its purpose was to carry Hornsey Lane over the cutting which had been created to lessen the steep gradient of Highgate Hill's approach into London. The archway was 36ft high and 18ft wide: enough to allow two carriages to pass. By the time our Victorian image was taken in 1897, this was no longer sufficient to cope with traffic, and the need to widen and improve the road meant that the bridge's days were numbered. Between 1897 and 1900, Nash's bridge was replaced with the present Grade I listed cast-iron structure.

From the top of the bridge, the fantastic views across London make it a popular spot for photographers. It is not, however, the photographers that give Hornsey Lane Bridge its more common name. For many years, 'Suicide Bridge' has attracted those wishing to end it all. To try to prevent people throwing themselves from the bridge, work was done in 2004 to raise railings on the bridge parapet and fit spikes at each end. Perhaps as a result of this, there were no incidents for five years – but three in late 2010 have once again drawn attention to the problem, and led SANE chief executive Marjorie Wallace to accuse authorities of doing far too little to stop the deaths.

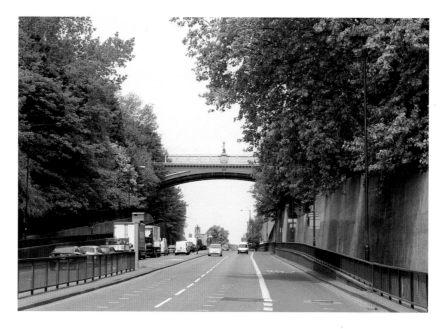

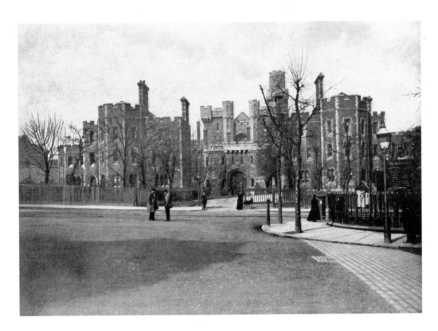

Holloway Gaol

Holloway Gaol was opened in 1852. In 1897 it was still a mixed-sex prison – two years earlier, Oscar Wilde had been held here for five weeks, following his arrest for 'acts of gross indecency with other male persons'. The Victorian book informs us that, as well as holding those awaiting trial, the prison also 'offers hospitality to debtors [and] to female convicted prisoners' – before adding rather randomly, 'It is a curious sight to see the women who have served their sentences discharged from the main gate.'

Since 1903, Holloway Gaol has been a women-only prison, including those sentenced to death. Five were hanged inside the prison walls – most infamously Ruth Ellis in 1955, the last woman executed in Britain. Fewer people remember Amelia Sach and Annie Walters, who were hanged on the same day in 1903. They were said to have killed as many as twenty babies.

When the prison was demolished in 1970, the five dead women were exhumed from their burial ground in meadows behind the prison and reburied – Ellis in Amersham and the others at Brookwood Cemetery in Surrey. Nothing has survived from old to new in our modern photograph of the prison – except the road layout, which gave us a strong indication of the positioning of the first photographer.

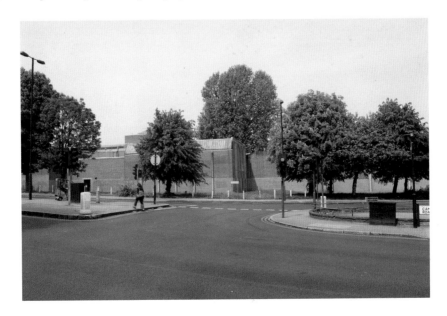

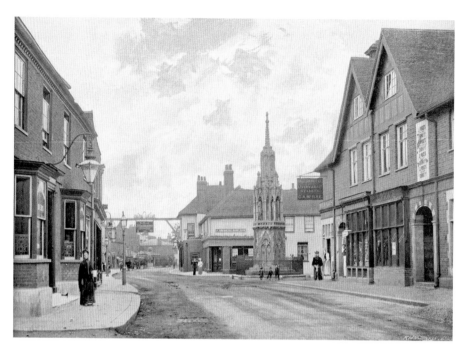

Waltham Cross (Eleanor Cross)

'Three miles west of Epping Forest is Waltham Cross,' states the first book, 'one of the three ... which are all that remain of those erected by Edward I to mark the spots where a halt was made when the dead body of Eleanor of Castile was being conveyed from Nottinghamshire to Westminster Abbey.' The cross, erected in 1294, has been restored and reinforced so many times since that it is barely the same structure. The town named after it has been the focus of some unkind comments over the years. A 1796 writer noted: 'this cross, which is almost the only thing worthy of notice in the place, adjoins the Falcon Tavern,' before vaguely deriding the cross itself by mentioning that the Society of Antiquaries 'have twice interested themselves in preserving this curious remnant of antiquity'.

A contemporary observer writes that the cross 'stands in the middle of an ultra drab English 1960s shopping centre', though the date is questioned and rightly so. The building on the right, newly built behind the rebuilt Falcon Inn in 1897 (demolished again in 1974), has survived on the outside at least. The 'Four Swans' signboard (spanning the street on the left of the Victorian image) states, 'Ye Olde Foure Swannes Hostelrie. 1260', and is still there, hidden behind the two trees.

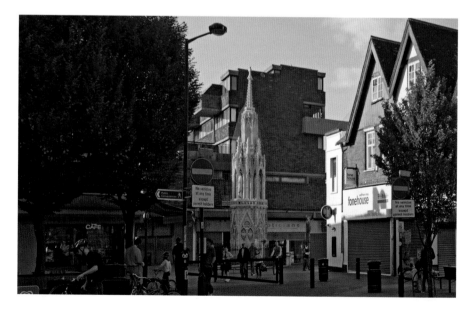

Queen Elizabeth's Hunting Lodge, Chingford

The Lodge, in Epping Forest, originally known as the Great Standing, was built for Henry VIII in 1543 as a viewing platform. Guests could either follow the hunt from its high vantage point or participate by shooting their crossbows at passing game.

In an account not supported by any other source, *Queen's London* reports that: 'As everybody knows, Queen Elizabeth was a devotee of the chase, and according to tradition she was wont, when visiting the Lodge called after her, to ride up the broad stairs inside without dismounting, a difficult though quite possible feat.'

Until the 1870s, there was virtually no tourism around the forest, but a number of events helped to change this. Firstly, in 1878 the railway which had reached Chingford in 1873 was moved closer to Epping Forest. In the same year, the Lodge was acquired by the Corporation of London, who have run it as a tourist attraction ever since. Thirdly, in 1882 Queen Victoria announced that the forest land was to be made open to the public. Finally, in 1890 the Royal Forest Hotel opened, situated next to the hunting lodge and convenient for both the forest and the train station. The Royal Forest is still there today, although it is no longer a hotel and the original building burned down in 1912.

Chingford old church

All Saints' Church in Chingford dates from the late thirteenth century. The church tower was added in the fourteenth century and the porch in 1547, apparently paid for by the pawning of the church plate. By the early 1800s, much of the building was overgrown with ivy; as a consequence, it became known as 'the green church'. In 1844, a new parish church was opened and the old church was only used for occasional services. Its decay continued and gradually the church became little more than the picturesque ruin we see in the Victorian photograph. In 1904 the roof of the nave and south aisle collapsed, wrecking the arcade.

Chingford church was, however, brought back from the brink of total loss. In 1905, the chancel (that had always been better preserved) received further repairs and most of the ivy was stripped from the church walls. With the aid of a £6,000 donation from a Miss Louisa Heathcote, a full restoration of the church was completed in 1930 and, with its original contents restored to it, All Saints' reopened. At the start of the twenty-first century, further restoration work has been carried out; the result is this pristine reminder of Chingford's past which we see today.

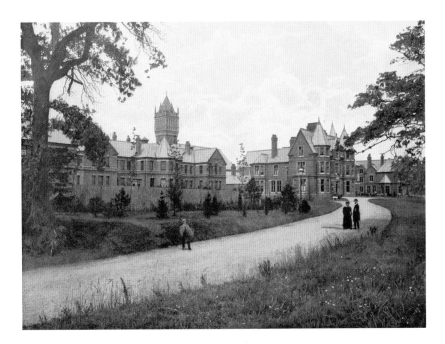

Claybury Asylum

Claybury Asylum in Essex was opened in 1893. '[It] was built to accommodate eight hundred male and twelve hundred female pauper lunatics,' informs the 1897 book rather bluntly. 'To the left of our picture is the men's wing, the water tower rising behind it. In the house with turrets, which hides the chapel, are the administrative offices, and beyond is the superintendent's house. All modern improvements are to be found at Claybury, which has workshops, a recreation hall seating a thousand persons, an isolated hospital for infectious cases, and a separate building capable of accommodating some fifty private patients.'

By the 1930s, the hospital had a renowned reputation. Building expansions occurred around the same time. It initially continued to thrive after its amalgamation with the newly created National Health Service in 1948. Since the 1980s, however, with the focus on treating people in their homes rather than institutions, the hospital's fortunes declined and it closed in 1997. Most of it has survived demolition and, now called Repton Park, has been converted into prestigious housing. The hall and the chapel are, respectively, a gym and a swimming pool. The eight-storey water tower (which, like other buildings, would still be visible if we had taken photographs in the winter) is now a single dwelling, threaded with a metal spiral staircase ... and a lift.

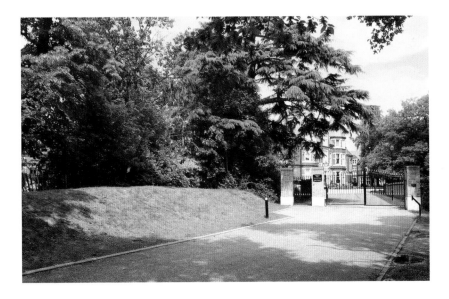

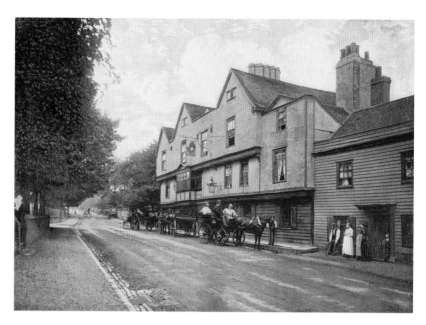

The King's Head, Chigwell High Road

Fifteen miles from the centre of London, and on the outer extremities of the Central line, is the Essex village of Chigwell. Whilst the population of the village has doubled and much has changed over the intervening years, this particular scene remains very familiar. When searching for information on Chigwell, the King's Head, and particularly its association with Charles Dickens, feature very prominently indeed. Dickens apparently wrote that Chigwell 'is the greatest place on earth', and he considered the King's Head to be a 'delicious old inn'. So delicious that he immortalised it in minute detail in his novel *Barnaby Rudge* (although, confusingly, he named it the Maypole, after a different pub in the village).

When comparing the two photographs, the first thing we notice is that the building has been significantly extended over the years; the second is that it actually looks more old-fashioned in the modern picture than in the Victorian one. At some stage between 1925 and 1950, the Victorian sash windows were replaced with smaller lattice ones and the building's render was removed to reveal its half-timbered frontage.

In 2010, the listed building was sold to Chigwell luminary Lord Sugar, and its 600 years as an inn were brought to an end when, under the management of his son, it was converted into a Turkish restaurant.

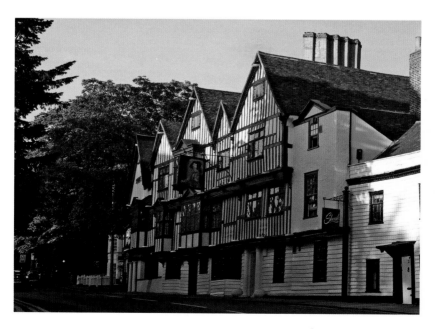

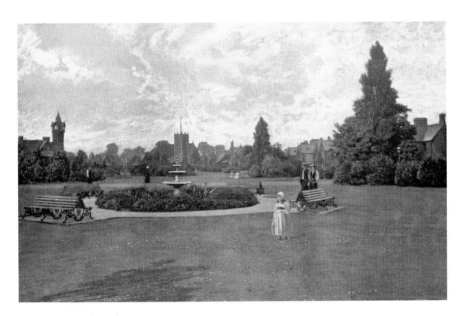

Dr Barnardo's homes at Barkingside

Thomas Barnardo came to London from Ireland in 1866. So appalled was he to see a multitude of children sleeping rough and begging for food that, aged only twenty-one, he set up a Ragged School in East London's Stepney. He opened up the first home, for boys, in Stepney in 1870. One night, an eleven-year-old, John Somers, was turned away because the place was full. He was found dead two days later. Thereafter, the home displayed the sign: 'No Destitute Child Ever Refused Admission.'

The Girls' Village Home in Barkingside, the subject of our photographs, was opened in 1876. 'In these thirty or more Homes,' states the *Queen's London*, 'thousands of girls have been trained for domestic service in such a thorough fashion that there is always a great demand for them ... The girls are received here from infancy onwards, and most of them remain until they have attained the age of seventeen.' After the Second World War, the home became mixed. It is presently Barnardo's Head Office.

The orphanages and homes ceased operation in the 1960s. Now the charity runs myriad projects across the UK, helping children and their families deal with issues such as drug abuse, crime, domestic violence, homelessness, sexual abuse, disability and mental health.

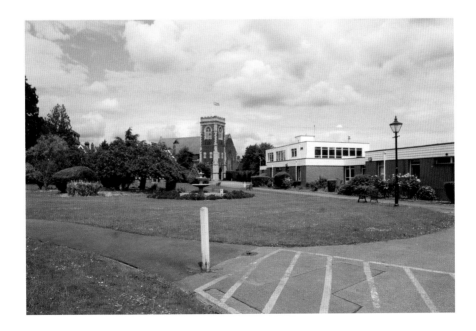

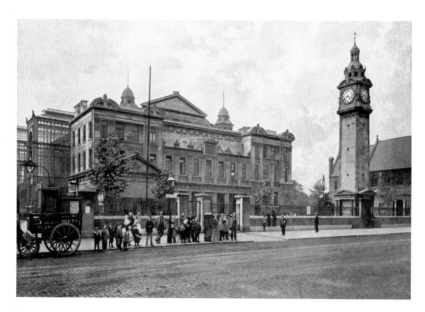

The People's Palace

The People's Palace on Mile End Road was opened by Queen Victoria in 1887. Envisaged as a 'palace of delights', it was a place of education and recreation for East End working-class men; it also included 'Concerts and Entertainments', according to the sign on the left of the first photograph, behind the wagon. The glass building behind the sign housed the library and reading rooms. Next to it, out of shot, was a swimming pool. On the right, behind the clock tower, were 'the fine technical and trade workshops, in which the Drapers' Company … take a lively and generous interest'. Apparently, 1.5 million people a year visited the institution.

Despite the obligatory presence of trees, the central building and the clock tower are still recognisable today. This is now the main campus of Queen Mary, University of London, one of Britain's main research-based higher education establishments. It still has a close relationship with the city's Draper Company.

The inscription on the 1890 clock tower is presumably referring to the clock when it states that it was 'Presented to the trustees of the People's Palace for the benefit of the people of London...' – though it might also be alluding to the two water fountains at the tower's base.

Incidentally, North London's Alexandra Palace now advertises itself as the People's Palace.

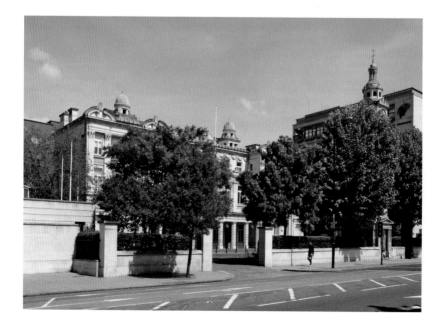

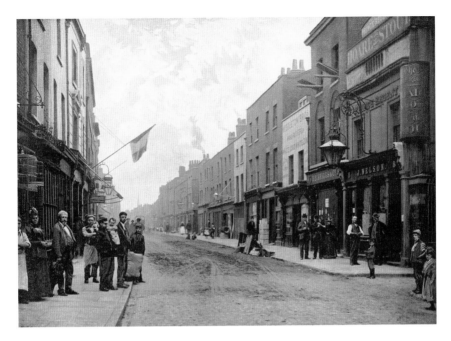

St George's Street (Ratcliff Highway)

'The old name of Ratcliff Highway,' states the 1897 book, 'still clings to the unlovely St George's Street, which lies to the north of the London Docks ... Once upon a time fair elm trees on both sides of the Highway gave it a dignity which it has long lost.' The trees, now mainly plane trees, have returned. The buildings, however, are all gone – bar one. Indistinguishable in the old photograph, and barely less so now behind a revolving advertising hoarding (showing Harry Hill in our image), is the Old Rose pub, which pops up in old sailors' songs as much as it does in the nineteenth-century criminal proceedings of the Old Bailey.

In the Victorian photograph, the Prince Regent on the right was on the corner of Virginia Street. Opposite it, on the corner of Neptune Street (seemingly a little further east than the present Wellclose Street), perhaps where the flag flies, was the Cock & Neptune, which doubled as a prison for the local courthouse. The silver-haired chap nearer to us, with his hat in his right hand, is reputed to be John Hamlyn, naturalist and 'actual importer of rare foreign birds and animals direct from our Indian, Australian and African Empires'. A birdcage from his shop, at No. 221 St George's Street, hangs at the very left of frame.

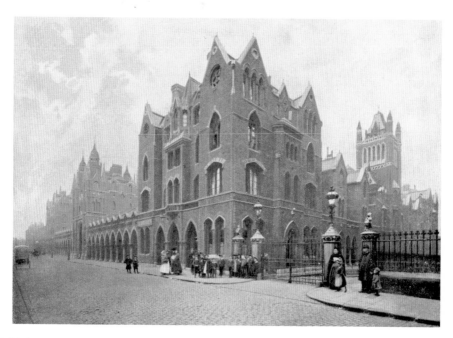

Columbia Market

The £200,000 cost of Columbia Market in Bethnal Green was financed by Baroness Burdett-Coutts, perhaps the leading philanthropist of her age. Arthur Mee enthused: 'She had the great idea of building a market to help the poor people of East London. She set about it as if she were building a great cathedral. The great opening took place in the spring of 1869, and from the first it was a tragedy, for the market failed.'

Opinions on why it failed differ. Mee alludes darkly to the 'vested interests' of Billingsgate Market, whilst others think it was just something of a white elephant. Either way, as the *Queen's London* puts it, the market 'never prospered', and by the time this photo was taken it had been closed for ten years, with the building let as warehouses.

Columbia Market was demolished in 1958, but, whilst the buildings have gone, the market lives on as a popular street flower market every Sunday. Although there is no building, a true 'then and now' photograph is still possible thanks to the railings which remain outside the Columbia Market Nursery School. The tower block that now stands on the site of the market is Cuff Point. Approved in 1972, the block stands 40m high and contains fifty-five flats.

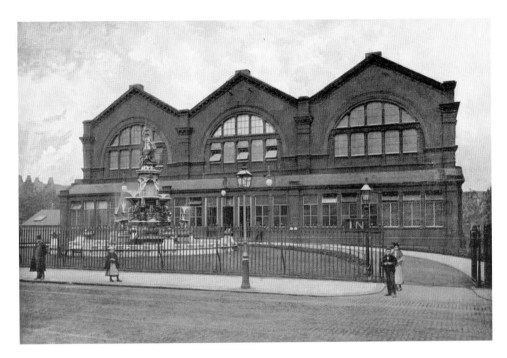

Bethnal Green museum

'South Kensington Museum,' states the 1897 book, 'has a branch at Bethnal Green.' The 'South Kensington Museum' is now known as the Victoria and Albert Museum, and its branch (coincidentally, considering three of the figures standing in front of it in the early photograph) is the Museum of Childhood. The building was opened by the Prince of Wales – the future Edward VII – in 1872. The Victorian writers tell us that the museum 'owes its establishment to the untiring efforts of various workers among the poor in the East End', though it was the female inmates of Woking Jail in Surrey who are now most noted for their efforts during the actual building of the museum, for they laid the interior's mosaic marble floor.

In 1897, the museum's exhibits had 'to do mostly with animal and waste products, food and entomology'. By the 1920s, the fountain and statue outside the museum in the old photograph had fallen into disrepair and were removed. Things inside the museum were equally jaded. Arthur Sabin, the head curator, noted the bored and distracted children frequenting the place, and set about making the experience more appealing for them – one of his gambits being to exhibit more child-related objects, though it has only been the Museum of Childhood since 1974.

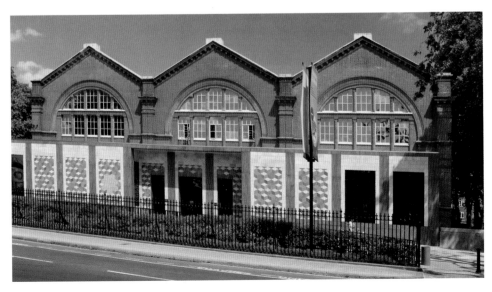

OUTER LONDON AND BEYOND – THE SOUTH

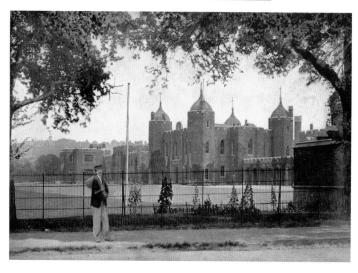

The Royal Military Academy, Woolwich

Located on the south-west side of Woolwich Common, the Royal Military Academy (RMA), known as 'the Shop', was established in 1741 to produce officers for the Artillery and Engineers. The buildings seen in our photographs are by James Wyatt, and were completed between 1805 and 1808, then extended in 1862. Famous graduates of the RMA include Major-General Charles Gordon (aka Gordon of Khartoum) in 1852 and Horatio (later Lord) Kitchener in 1870. A second academy, known as the Royal Military College (RMC), was opened at Sandhurst, Berkshire in 1799, to train officers for the Infantry and Cavalry. Both were closed at the start of the Second World War in 1939. Following the war, the Royal Military Academy Sandhurst opened in 1947, as an amalgamation of both institutions.

The Woolwich site continued to operate as a museum for the regiment until May 2001, when the collection of artillery was moved to new premises within the gates of the Royal Arsenal, and opened under the new name of 'Firepower, The Royal Artillery Museum'.

In 2006, the RMA site was sold by public tender to a property developer, and 'The Academy' is now being converted and extended into 334 houses and apartments. As their marketing video likes to put it: 'Yesterday's quadrangles and parade grounds will become friendly boulevards and refreshing open spaces.'

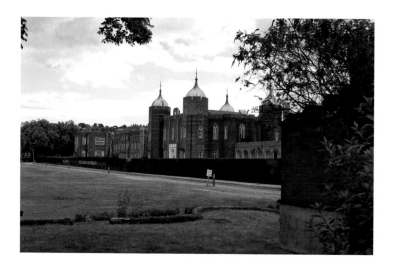

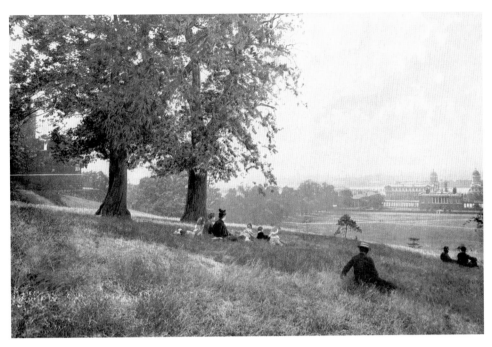

Greenwich Park

'Greenwich lies but six miles from London Bridge,' states the original book, 'One can get there by steamer in less than an hour – and in the summer months it is a favourite resort of Londoners.' Now, the journey by boat is twenty-five minutes, and in the summer months – in fact, all the year round – it is a favourite resort not only of Londoners but of visitors worldwide. 'There is a splendid view of the Thames,' the book continues, 'and away to the left, on a clear day, one may see the towers and spires of London.' And today, in the case of towers at least, that is still so – though it is now the towers away to the right that dominate the skyline, previously the prerogative of the Royal Naval College and the Queen's House.

There has been a park here since 1433, when Henry VI created London's first royal park by granting his uncle, Duke Humphrey, 'licence to enclose two hundred acres of their land, pasture, wood, heath ... and gorse thereof to make a park in Greenwich'. Before that date, this piece of land was still part of Blackheath.

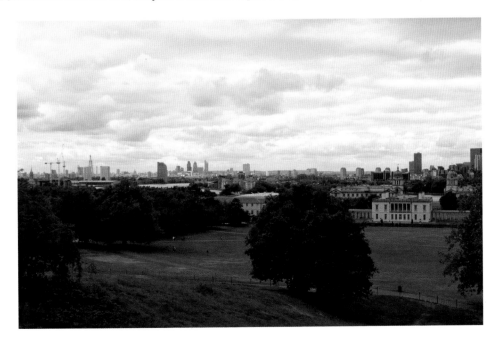

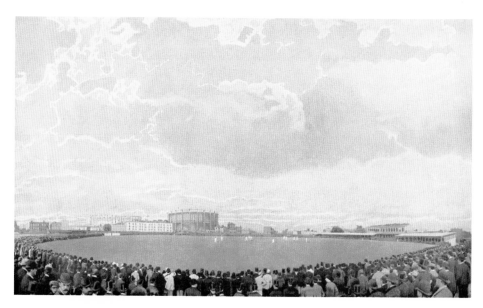

Cricket at Kennington Oval

This oval patch of land ('almost circular in shape', points out the original book) was formerly a market garden. The *Queen's London* also states that the ground 'is now exclusively devoted to the national summer game', a reference to the fact that, up until 1892, the Kennington Oval was host to other sports, especially football – notably as the venue of FA Cup Finals for all bar one of the competition's first twenty years.

The now iconic gasholder, dominant in both of the photographs, doesn't get a mention in the nineteenth-century text. The gasworks to which it, and three others, belonged were established in 1875. At least two of the holders existed in time to overlook the first home test match between England and Australia in 1880.

The pavilion on the right in the first image was demolished shortly after the photograph was taken, and was replaced in 1898 by the present building. The floodlights illuminating the modern 20-20 match (Surrey v Essex) were installed in 2009, though there are records of matches being lit by gas lamps as long ago as 1889. Just visible to the right of the modern gasholder (the 'smaller' tower), still under construction in 2011, is the Shard. The dimensions are deceptive. Upon its 2012 completion, at 310m it will be the tallest building in Western Europe.

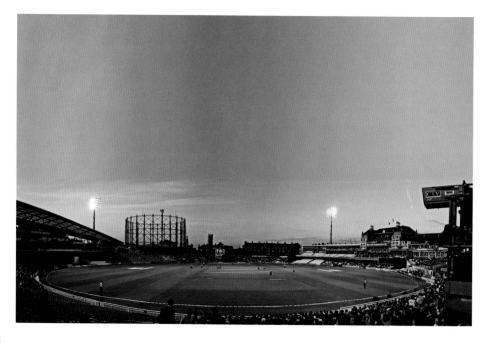

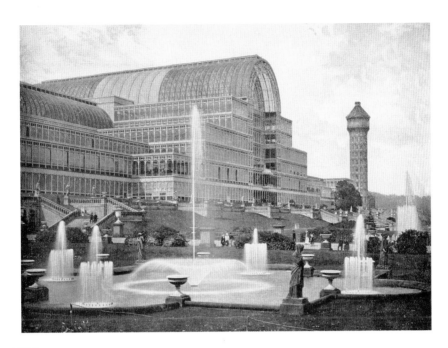

The Crystal Palace

The Crystal Palace, made entirely from glass and iron, was originally built for the 1851 Great Exhibition in Hyde Park. It was taken down the following year and reassembled (enlarged) on Sydenham Hill, South London – the surrounding area subsequently taking the name of the vast glass structure. For eighty years the building was used as a theatre, an exhibition space, a concert hall and a menagerie. The Victorian photograph shows 'the Upper Terrace, the Central Transept, and the northern Water Tower'. There were two water towers, both built by Brunel. Their purpose was to power the fountains, driving the water 76m into the air – high enough to be seen from many miles around.

In the 1930s, the technological pioneer John Logie Baird opened workshops and television studios in the grounds and the palace. He wasn't there for long – the palace burned down in 1936. The towers survived, but were both demolished during the war, because it was thought that German pilots could use them as a navigational aid. Today it is another tower – a legacy of the brief time Baird spent there – that dominates the skyline. The Crystal Palace transmission tower opened in 1956. The tower – 219m high, including its base – is built near to the site of the old north tower, and broadcasts to a 40-mile radius.

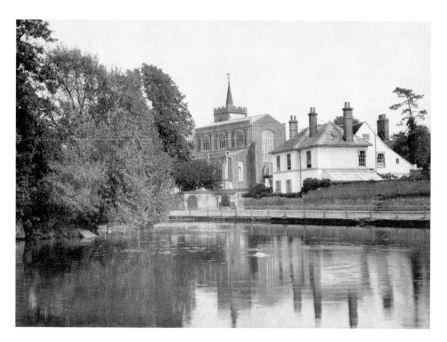

Carshalton church

Queen's London describes Carshalton as 'a charming old-world village in Surrey' and reports that 'it once proudly claimed to be warmer and healthier than any other place in England'. Whether these claims of temperature and well-being would stand up today is debatable, but the view across Carshalton Ponds is still charming, despite the fact that the A232 runs through the middle.

All Saints' Church, in the centre of the picture, dates back to the twelfth century, but it was extensively remodelled in the early 1890s, with a new nave added. Rector John Thewlis does not seem altogether convinced of the result. In his history of All Saints' Church, he writes of the 'modest Arts & Crafts touches to an otherwise worthy but unexciting piece of Victorian gothic' and describes the overall effect as 'quaint rather than beautiful'.

The house to the right of the church was called Queen's Well House – named after Anne Boleyn's Well. Legend has it that the spring burst from the ground when Anne Boleyn kicked against a stone as she rode from Carew Manor to Nonsuch Palace. On this occasion legend is wrong, as Anne's husband had beheaded her before Nonsuch Palace was built. The Queen's Well House met its own demise in the 1960s, when it was demolished.

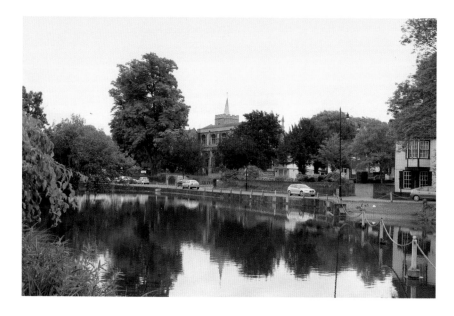

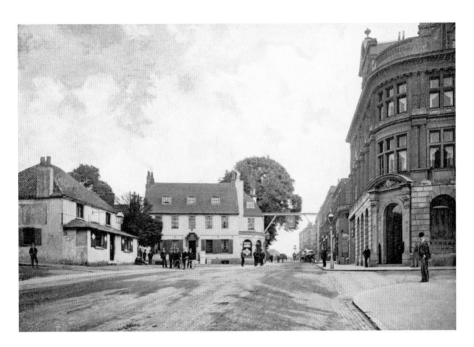

High Street, Sutton

It was the coming of the railway in 1847 that turned Sutton from a coach stop on the London to Brighton road to one of London's first commuter towns. Between the Censuses of 1861 and 1871, Sutton's population doubled.

Whilst considering it to be 'one of the most delightful places in Greater London', the *Queen's London* authors were also concerned that 'its old-world charms have been somewhat marred by the modern villas and other buildings which have been erected to meet the requirements of city men who have been attracted to it by its invigorating air and picturesque scenery'. Whatever would they think now?

Right to left, the three most prominent buildings in the Victorian scene are the Sutton branch of the London and Provincial Bank, the Cock Hotel and a beer house called the Cock Hotel Tap. The Cock Hotel Tap was the first to go, demolished in 1896 to make way for a hotel called, imaginatively, the New Cock Hotel. This, in turn, was knocked down in 1961 and replaced with the brick and concrete box called Old Inn House, seen in our current photograph. The Cock Inn was demolished in the same year as its newer namesake, so today only the bank remains, now a branch of Barclays Bank.

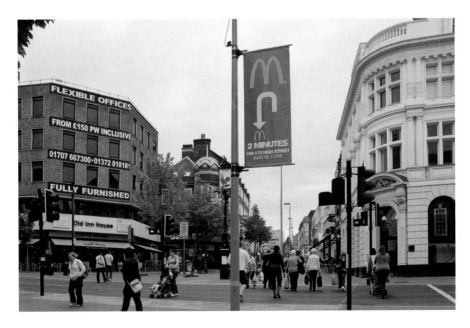

Nonsuch Park, near Cheam

Finished in 1806, the mansion in Nonsuch Park in Surrey was designed by Sir Jeffrey Wyatt. This was Wyatt's first attempt at the Tudor Gothic style, which he would use to great effect in his improvement works at Windsor Castle in the 1820s. The Farmer family, for whom Nonsuch was built, owned the mansion until 1937, when it was sold to the local authorities. During the war, the park was farmed by land girls and was a base for the local Home Guard.

In 2007, there was alarm when it was announced that Nonsuch could be sold off to private developers as Surrey County Council were concerned about growing overheads. Following a fourteen-month campaign it was saved, and the running of the park and mansion was handed over to Sutton and Epsom Councils on a 125-year lease. They, in turn, awarded a contract to private caterers Bovingdons to run the venue, and today Nonsuch describes itself as 'one of Surrey's most treasured celebration spaces'.

Nonsuch Park extends to some 120 hectares, and lies in the centre of a densely residential area to the north-east of Ewell. Growth in housing density would have already started at the time of Victoria's Jubilee, but the pace of change has increased over the years, particularly since the Second World War.

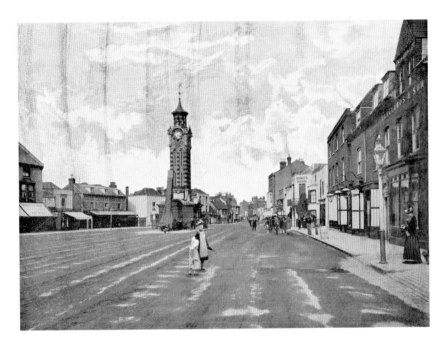

High Street Epsom, with clock tower

Queen's London describes Epsom as 'an interesting town, with a character of its own. It consists for the most part of a long, straggling, but broad High Street, with a rather striking clock tower, which also serves the purpose of a fire brigade station.'

The clock tower, built in the late 1840s, is still there, although it no longer fulfils its secondary role. The structure that can be seen parked in front of the clock tower of the Victorian image is a mobile fire escape, donated in the 1870s by the Royal Society for the Protection of Life from Fire. The society was formed in 1836 and its principal role was to place fire ladders in London streets in the interests of life safety.

Also notable in the Victorian picture is the King's Head pub – Epsom's first major building, with records stretching back to 1662. It is reported that, following the ceremony to lay the foundation stone for the new clock tower on 19 November 1847, the rebuilding committee 'retired to a sumptuous dinner at the nearby Kings Head'. The pub served its last 'sumptuous dinner' in 1957 and was pulled down to make way for shops. A branch of Barclays Bank now stands on the site.

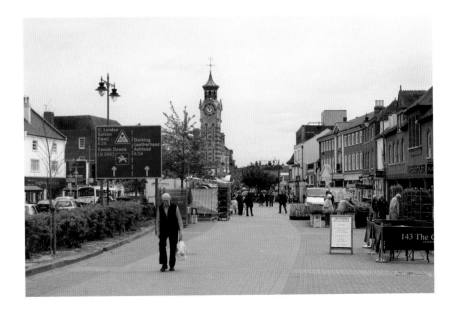

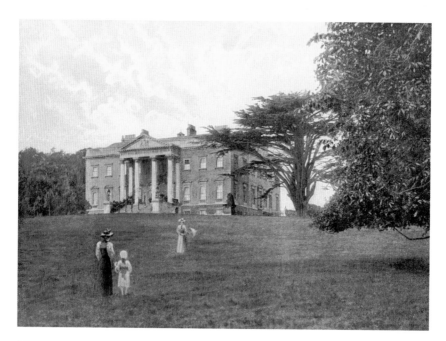

Claremont, Esher

Claremont is a Palladian-style house built in 1774 by 'Capability' Brown for Lord Clive ('of India') at a cost of £100,000. The house is red brick, with dressings and a Corinthian portico of stone. In 1816, the house was sold to the government for £66,000 – bought as a wedding present for Princess Charlotte on her marriage with Prince Leopold of Saxe-Coburg. Sadly, Charlotte died here in childbirth the following year, but the house remained in royal ownership until 1922. Queen Victoria spent time at Claremont both during her childhood and after her marriage to Prince Albert.

Claremont should have passed to Victoria's grandson, the Duke of Saxe-Coburg, on his mother's death in 1922, but his inheritance was disallowed as a result of him serving with the German army in the First World War. Instead, Claremont was sold and returned back into private hands.

In 1931, a school for girls from Christian Science families moved into Claremont and adopted its name. They amalgamated, in 1978, with Fan Court School in Chertsey to form Claremont Fan Court School. In between, 50 acres of the grounds were acquired by the National Trust in 1949. The fact that the scene remains virtually unchanged between our two pictures probably reflects the Grade I listing that applies to both house and grounds.

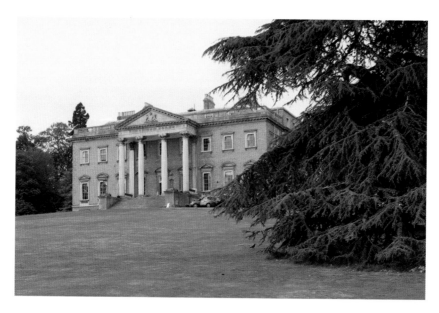

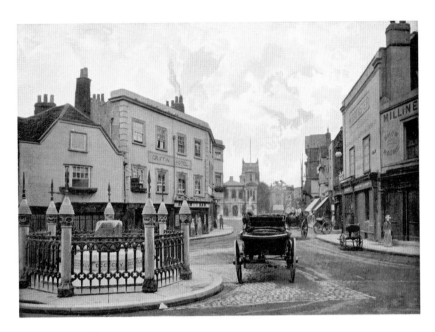

The Market Place, Kingston-on-Thames

Kingston-on-Thames was, according to the original book, 'much frequented by boating parties and cyclists, and by the country folk who come to market'. It continues: 'In the foreground of our view ... is the stone on which, according to tradition, seven Saxon kings ... were duly crowned in the tenth century.' This stone, along with the surrounding railings and small pillars, is now set a few metres further back, behind the position from which the modern photograph was taken, outside Kingston Guildhall. Incidentally, good attendance at Kingston Market was probably in no small part connected to the fact that a centuries-old royal charter forbade other markets from operating within a 7-mile radius.

The current Guildhall, built in the 1930s, replaced the 1838 Market Hall as the town hall. The latter building is visible in the centre of both photographs, in front of the parish church tower, and now hosts art exhibitions and trade fairs, amongst other events. The church tower belongs to All Saints' Church, the construction of which began in the twelfth century – 'there are several curious monuments within,' reports the 1897 book.

In the foreground of the Victorian photograph is the Griffin Hotel. We can see that this early/mid-nineteenth-century building still stands, though much of its innards have now been transformed into shops.

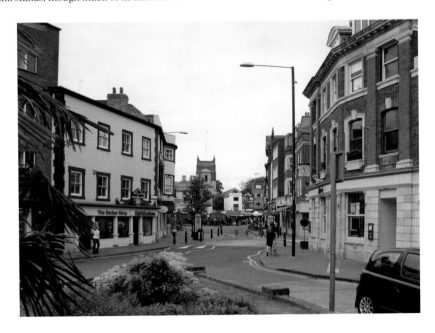

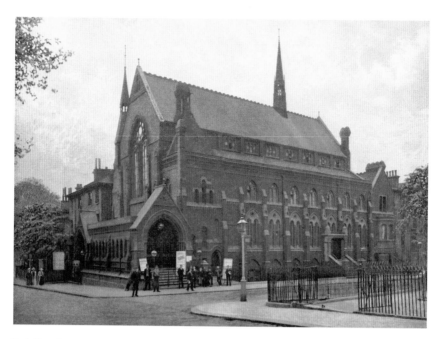

Westbourne Park Chapel

Westbourne Park Chapel was opened by Revd John Clifford in 1877, and, around the time of the Victorian photograph, the chapel was at the height of its popularity. Attendance figures for a Sunday in 1886 are given as 1,023 for the morning and 1,456 for the evening.

Revd Clifford (1836–1923) was just twenty-one when he came to Paddington, and preached there for an incredible fifty-seven years. Aside from his work in the church, he was a Liberal politician, a leading pacifist opposed to the Boer War, and even had time to found the Westbourne Park Building Society. Arthur Mee wrote of Clifford: 'He was one of the most remarkable Londoners of his day and generation. A man of boundless energy and of fiery zeal, nothing could withstand his crusading spirit when he was greatly moved.'

In 1944 the chapel was destroyed in a bombing raid, and services moved to the nearby Clifford Memorial Hall. In 1962, services were back on this site after the new 300-seat church (now called Westbourne Park Baptist Church) was completed. It may not be long until the third church is built on this site, as the church website reports that they are: 'working with a joint venture of two architects' firms to design a brilliant new building.'

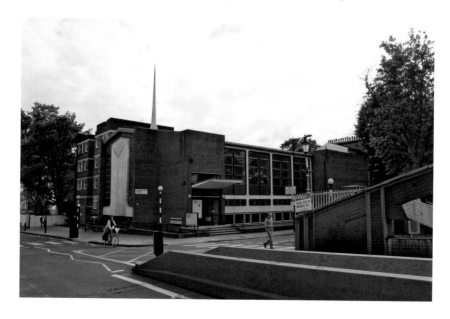

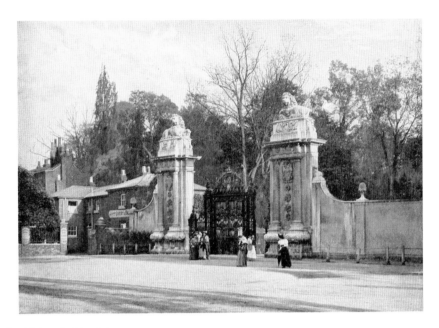

Hampton Court Palace: the Lion Gates

After Richmond, Bushy Park is the largest of London's royal parks, covering 445 hectares. Henry VIII had the park enclosed and used as a royal hunting reserve, but, following his death in 1547, the fences came down and the public were allowed in.

The Lion Gates, on Hampton Court Road, mark the boundary between Bushy Park and the more formal gardens of Hampton Court. The gates were commissioned by Queen Anne, and come at the end of the park's Chestnut Avenue, which was built in 1699 by Sir Christopher Wren as part of his design for a grand approach to Hampton Court Palace. Midway along Chestnut Avenue is a fountain and statue of Arethusa, one of the nymphs of Diana, goddess of the hunt. Whilst part of Wren's design, Bushy Park only received this fountain third-hand; it had originally been created for Somerset House, and then moved for a time to Hampton Court Gardens.

The *Queen's London* authors felt that 'the presence of an inn and other buildings somewhat detracts from the dignity of this really noble entrance to Hampton Court'. They would no doubt have approved, therefore, of the way that the wall has been extended to mask these buildings (at least on the side visible in our picture).

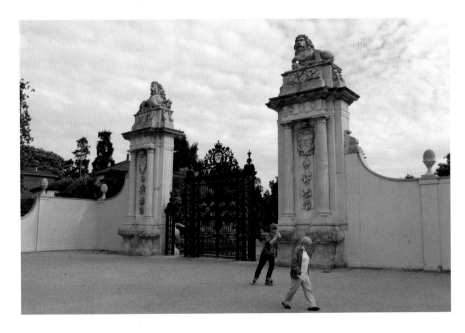

High Street, Hounslow

The somewhat desolate scene in 1897 accurately reflects the situation Hounslow found itself in during the second half of the nineteenth century. At the time of Queen Victoria's accession in 1837, 500 stagecoaches a day passed along the High Street – Hounslow being the first major stopping point after leaving London to travel westwards, and the last one before arriving in the metropolis. Today, a few miles further north, the M4 Heston Services provide the modern traveller with the same service.

In 1840, the Great Western Railway opened and, almost at once, the inns, stables and blacksmiths that had been serving a multitude of travellers for centuries ceased trading. The Crown & Cushion (seen in the Victorian photograph), one of the few remaining pubs, closed down shortly after the picture was taken. Its position at No. 84 is now taken by the Asal Superstore.

By the early twentieth century, however, further train services, the tube, and in 1920 the building of the Great West Road (now known as the A4), helped industry return to the town. Although no buildings from the Victorian photograph remain in our picture (with the possible exception of the one with the sloping roof, at the end of the street beyond the pub), the road still seems recognisable.

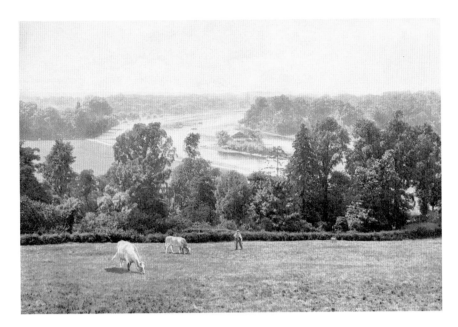

View from Richmond Hill

This view of the Thames from the summit of Richmond Hill has long been a source of inspiration for artists and writers. William Wordsworth and Sir Walter Scott wrote about it, while Joshua Reynolds and J.M.W. Turner painted it. At the time of the first photograph, popular opinion was realising the importance of the vista, and moves were already underway to protect it for the future. In 1896, the trustees of the Earl of Dysart leased Petersham Meadows to the Richmond Corporation in order to preserve the view.

Glover's Island had been purchased by Richmond waterman Joseph Glover for £70 in 1872. In 1898, Glover sought to cash in on the preservation mood by offering the island to the Corporation for £4,000. If they did not buy it, he threatened, he would instead sell the island to an advertising company. Whilst the Corporation wanted it, they felt that they could not justify such an inflated price tag, and attempts to engage the public in an appeal were ineffective. In 1900, businessman and philanthropist Max Waechter stepped in, purchasing the island for an undisclosed sum, before gifting it to the council. In 1902, this became the only view in the country to be protected by Act of Parliament, with the passing of the Richmond, Petersham and Ham Open Spaces Act.

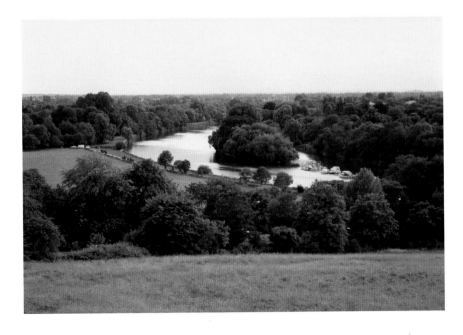

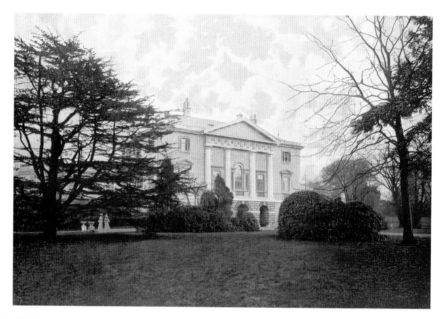

White Lodge, Richmond

Since 1956, White Lodge, in the centre of Richmond Park, has been home to the Royal Ballet School. In 2010, a £22 million expansion programme was completed, providing extensive new facilities and, as part of the programme, opening the building to the public, with the creation of the White Lodge Museum.

Before ballet took over, White Lodge was home for many years to members of the royal family, including Queen Victoria. At the time of the first photograph, the Duke and Duchess of Teck lived there. In 1891 their daughter, Princess Victoria Mary, became engaged to Prince Albert Victor, second in line to the throne. Tragically, he died of pneumonia the following month, and, perhaps brought together by their shared grief, Mary became close to Albert's younger brother, George. Two years later they were married; when he succeeded to the throne as George V in 1910, she became Queen Mary. Their eldest son, the future Edward VIII, was born at White Lodge on 23 June 1894.

In 1923, the newly married Duke and Duchess of York (the future George VI and Queen Elizabeth) came to live at White Lodge. They are responsible for the most significant change in our pictures – the addition of the large external staircase leading to the door, known as a perron.

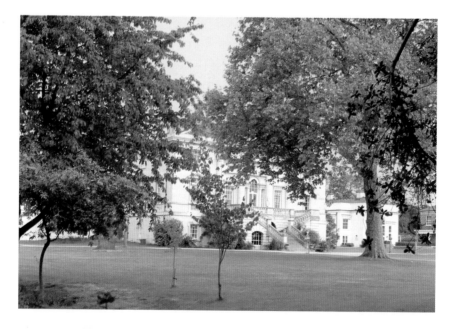

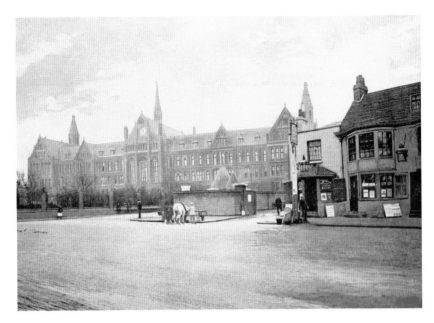

St Paul's School, with the Old Red Cow

All that is left of the Hammersmith St Paul's School are the surrounding railings (with stone pillars) and a small, cone-shaped building built into the surround – possibly a tool shed. Completed in 1884, it was the fourth home of the school since its 1509 foundation in a building opposite old St Paul's Cathedral. Originally providing free education for 153 pupils, it was the largest school in England.

The Hammersmith building (designed by Alfred Waterhouse) suffered Blitz damage. The school grounds then became limited after the widening of Talgarth Road. Needing more space, the school moved again in 1968, to Barnes. The Hammersmith building was flattened and is now a public gardens, though a couple of other school buildings have survived.

'The inn hard by is over 200 years old,' states the 1897 book, before adding rather sniffingly, 'and was more famous in the old coaching days than it can now pretend to be.' This Old Red Cow building was demolished in the same year, but in the 1970s its successor, now the Red Cow, had its fame revived as a prominent venue in the early days of punk music, hosting such bands as The Jam, The Stranglers and pre-Clash 101ers. It closed in 1978 and was replaced by the current building shortly after.

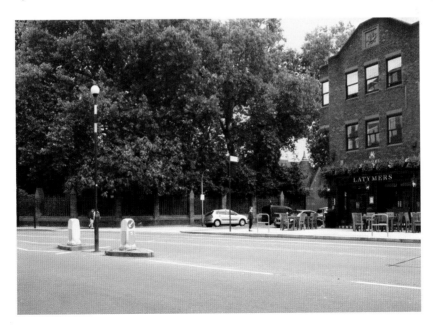

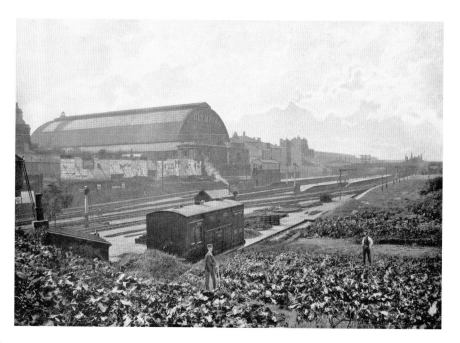

Olympia

The still-thriving Olympia venue in Kensington opened in 1884, with the aim of being Britain's largest covered show centre and 'To provide healthy amusement and reinvigorate by brilliant demonstrations the national love of athletic exercises and contests of skill; to raise the tone of popular taste by entertainments and displays which shall be of the purest and highest character; to educate the masses, aye, and even the "classes" by exhibitions of art, science and industry.'

The huge glass and iron structure had fixed seating for 9,000 people. One of its first events, in 1887, was an 'Exhibition of Sporting Dogs by Mr Charles Cruft'. Subsequent attractions in early years included Barnum's 'Greatest Show on Earth', the annual International Motor Exhibition, the International Horse Show and the Ideal Home Show.

During the First World War, Olympia was briefly used as a civil prison for German nationals. In 1923 a new hall, nearest to us in the modern photograph, was opened. At the far end now, slightly jutting out, stands London's first multi-storey car park, built in 1937. The tube platform in the foreground of both photographs is Kensington Olympia Station, known as Kensington Addison Road Station up until the Second World War.

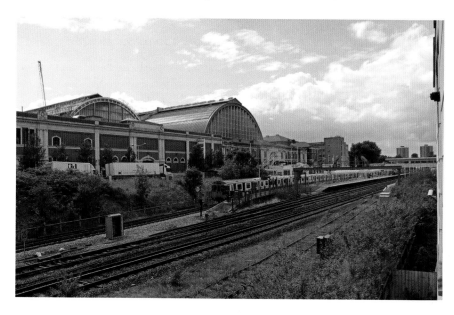

BIBLIOGRAPHY

Books/periodicals

The Queen's London: A Pictorial and Descriptive Record of the Great Metropolis, Cassell and Company Ltd, 1897

Ackroyd, Peter, *London: the Biography*, Chatto and Windus, 2000

Ashton, Rosemary, *142 Strand*, Chatto and Windus, 2006

Barker, Felix and Peter Jackson, *London, 2000 Years of a City and its People*, Macmillan, 1983

Barker, Felix, *Greenwich and Blackheath Past*, Historical Publications, 1993

Bolland, R.R., *In the Wake of Three Men in a Boat*, Oast Books, 1995

Clunn, Harold P., *The Face of London: The Record of a Century's Changes and Development*, Simpkin Marshall Ltd, 1932

Croot, Patricia E.C., *History of the County of Middlesex: Volume 12: Chelsea*, Victoria County History, 2004

Davies, Philip, *Lost London 1870–1945*, Transatlantic Press, 2009

Duncan, Andrew, *Secret London*, New Holland, 1995

Duncan, Andrew, *Walking London*, New Holland, 1996

Ellis, Malcolm (Ed.), *The Avicultural Magazine*, Avicultural Society, Nov. 2007

Elrington, C.R., *A History of the County of Middlesex: Volume 9: Hampstead, Paddington*, Victoria County History, 1989

Fitzgerald, Percy, *Victoria's London: Volume II: The Suburbs*, The Leadenhall Prefs Ltd, 1983

Fry, Herbert, *London*, London, 1889

Gaskell, Elizabeth, *The Life of Charlotte Brontë*, Penguin Classics, 2004

Gater, G.H. and E.P. Wheeler, *Survey of London: Volume 16: St Martin-in-the-Fields 1: Charing Cross*, 1935

Halliday, Stephen, *Making the Metropolis: Creators of Victoria's London*, Breedon Books, 2003

Hannavy, John, *Victorian Photographers at Work*, Shire Publications, 1997

Henry, Mrs Robert, *London*, Dent, 1948

Lucas, E.V. & Christopher Hibbert, *London Revisited* (Revised), Methuen & Co., 1926

Mee, Arthur, *London: Heart of the Empire and Wonder of the World*, Hodder and Stoughton, 1937

Roberts, Sir Howard and Walter H. Godfrey, *Survey of London: Volume 22: Bankside (the Parishes of St Saviour and Christchurch Southwark)*, 1950

Roud, Steve, *London lore*, Arrow books, 2010

Saunders, Ann, *London County Council Bomb Damage Maps 1939–45*, London Topographical Society, 2005

Shepherd, Thomas, *London in the Nineteenth Century*, Bracken Books, 1983

Sheppard, F.H.W., *Survey of London: Volume 38: South Kensington Museums Area*, 1975

Stamp, Gavin, *Lost Victorian Britain*, Aurum, 2010

Steele, J., *The Streets of London: The Booth Notebooks, South East*, Deptford Forum Publishing Ltd, 1996

Thornbury, Walter and Edward Walford, *Old and New London*, 1878

Weinreb, Ben, *The London Encyclopaedia* (Third Edition), Macmillan, 2008

White, Jerry, *London in the 19th Century*, Vintage, 2008

White, Jerry, *London in the 20th Century*, Vintage, 2008

Winn, Christopher, *I Never Knew That About London*, Ebury Press, 2007

London and Middlesex Archaeological Society, London and Middlesex Archaeological Society Transactions, Museum of London, 1990

Websites

www.abandonedstations.org.uk

www.airstudios.com

www.archbishopofcanterbury.org

www.artinfo.com

www.bankofengland.co.uk

www.barnardos.org.uk

www.bbc.co.uk
www.bbcel.co.uk
www.biblesociety.org.uk
www.bloomberg.com
www.bobulous.org.uk
www.british-history.ac.uk
www.britishlistedbuildings.co.uk
www.bromptonoratory.com
www.buildinghistory.org
www.camden.gov.uk
www.cantillon.co.uk
www.carshaltonallsaints.org.uk
www.christtheking-ulac.org.uk
www.cityoflondon.gov.uk
www.citypubs.co.uk
www.claremont-school.co.uk
www.closedpubs.co.uk
www.clsb.org.uk
www.college-of-arms.gov.uk
www.deadpubs.co.uk
www.eco.co.uk
www.english-heritage.org.uk
www.epsomandewellhistoryexplorer.org.uk
www.estatesgazette.com
www.europeanaction.com
www.fco.gov.uk
www.graysinn.org.uk
www.greenwich.gov.uk
www.gresham.ac.uk
www.guardian.co.uk
www.guildhall.cityoflondon.gov.uk
www.guysandstthomas.nhs.uk
www.hampsteadheath.net
www.harrowobserver.co.uk
www.harrowschool.org.uk
www.heritage-images.com
www.historyworld.co.uk
www.hrp.org.uk
www.independent.co.uk
www.infobritain.co.uk
www.iwm.org.uk
www.kcl.ac.uk
www.lambeth.gov.uk
www.lincolnsinn.org.uk
www.london.gov.uk
www.londondrum.com
www.london-fire.gov.uk
www.marxists.org/archive
www.methodist-central-hall.org.uk
www.millhill.org.uk
www.morelondon.com
www.nationalarchives.gov.uk
www.nationaltrust.org.uk
www.nhm.ac.uk
www.nonsuchmansion.com
www.ourbroxbourne.org.uk
www.parliament.uk
www.qmul.ac.uk
www.rcseng.ac.uk

www.reptonparkwoodfordgreen.co.uk
www.richmond.gov.uk
www.rohcollections.org.uk
www.royalexchange.co.uk
www.royal.gov.uk
www.royalparks.org.uk
www.rsc.org
www.skdocks.co.uk
www.skyscrapernews.com
www.soane.org.uk
www.splf.org.uk
www.standrewbythewardrobe.net
www.stmaryabbotschurch.org
www.suite101.com
www.sutton.gov.uk
www.tate.org.uk
www.telegraph.co.uk
www.thamesdittonisland.co.uk
www.theacademy-woolwich.com
www.theatrestrust.org.uk
www.theboatrace.org
www.thecommonwealth.org
www.themonument.info
www.the-river-thames.co.uk
www.the-shard.com
www.thetemplebar.info
www.thisislondon.co.uk
www.towerbridge.org.uk
www.unesco.org.uk
www.vam.ac.uk/moc
www.wesleychapel.org.uk
www.westbourneparkchurch.org.uk
www.westendatwar.org.uk
www.westminster-abbey.org

INDEX